PRAISE FOR *BARBARA H.*

MW01487696

"Across nearly fifty years, Barbara Hammer produced a pathbreaking body of feminist filmmaking that forever transformed how sexuality, selfhood, community, and history could be explored through cinema. Finally, in Sarah Keller's passionate and erudite monograph, we have a comprehensive, inspiring guide to the achievements of an artist whose relevance continues to burn bright."

—Erika Balsom, reader in film studies, King's College London

"Meticulously researched, gorgeously illustrated, and comprehensively covering Barbara Hammer's extensive body of films, as well as its wide-ranging treatment by Hammer and others, Sarah Keller's *Barbara Hammer: Pushing Out of the Frame* celebrates a lesbian feminist career and legacy that, while diverse and adaptive, always evidences Hammer's credo: 'Art is Energy!' With tender attention to many of Hammer's 100+ films as well as her copious and careful archives, Keller allow us time to sit with this oeuvre, built and enjoyed over decades, while unobtrusively making her own claims—in conversation with Hammer—about feminist, queer, and experimental cinema, as well as feminist and lesbian art, history, and archives. Drawing on Hammer's creative output across decades, themes, and artistic approaches, Keller provides new shape to Hammer's definitive 'eclectic curiosity and roving interests,' her 'radical openness,' and her 'medium promiscuity,' as she takes up a range of radical forms to make visible her radical concerns: with self (and other); the female body, sexuality, and illness; queer and lesbian identity, community, and interactivity; and cinema and archival form and herstory. Hammer's powerful commitments also include feminist, lesbian, and queer legacy, including her own. 'You want a book? You ask for it,' she informed Keller in a late-life interview. Keller delivers, and how."

—Alexandra Juhasz, Distinguished Professor of Film, Brooklyn College CUNY

BARBARA HAMMER

BARBARA HAMMER

Pushing Out of the Frame

Sarah Keller

Wayne State University Press
Detroit

ISBN 978-0-8143-4858-1 (paperback)
ISBN 978-0-8143-4859-8 (hardcover)
ISBN 978-0-8143-4860-4 (e-book)

Library of Congress Control Number: 2020945838

Wayne State University Press rests on Waawiyaataanong, also referred to as Detroit, the ancestral and contemporary homeland of the Three Fires Confederacy. These sovereign lands were granted by the Ojibwe, Odawa, Potawatomi, and Wyandot Nations, in 1807, through the Treaty of Detroit. Wayne State University Press affirms Indigenous sovereignty and honors all tribes with a connection to Detroit. With our Native neighbors, the press works to advance educational equity and promote a better future for the earth and all people.

Wayne State University Press
Leonard N. Simons Building
4809 Woodward Avenue
Detroit, Michigan 48201-1309

Visit us online at wsupress.wayne.edu

CONTENTS

ACKNOWLEDGMENTS

My recollection is that I met Barbara Hammer when I learned of her film *Maya Deren's Sink*, which I was researching in connection with another project. She graciously agreed to talk with me about it and about Deren's influence on her work. From that moment, she became a tireless ally in my research. It would not have been possible to write this book without her generous assistance and openness to all of my questions. She gave me unfettered access to her archive before she sold it (and she even lent me her galoshes when it snowed while I was staying in her studio to peruse it at length). She was unstintingly generous with information and access to her work and her person. It would be impossible to overstate my gratitude to her.

In addition, I continue to benefit from the support and kindness of Barbara's partner and the love of her life, Florrie Burke. Barbara was blessed down to her toes by Florrie's attention to detail, her willingness to serve as executor over an unwieldy amount of Barbara's art from the many decades of her career, and her beautiful care of everything Barbara.

Barbara put me in touch with many people who have been generous with their time and expertise. I'm deeply grateful to Jennifer Lange at the Wexner Center for the Arts, who met with me to talk about Barbara's partnership with them. Karl McCool at Electronic Arts Intermix patiently fielded my requests for access to Barbara's screening copies as well as more complicated questions about her work. At the Academy of Motion Picture Arts and Sciences, Mark Toscano offered guidance and invaluable accounts of Barbara's working method and film materials. His generosity with his time and knowledge steered this project in productive directions. Thanks, too, to Edda Manriquez, who was helpful in assisting with copies of Barbara's films at the Academy.

Several conferences and seminars allowed me to present parts of this work, and I am grateful to the organizers as well as audiences who offered their thoughts and suggestions. Vanessa Haroutunian organized a program of Barbara's work at MoMA that helped me in thinking about Barbara's legacy through her grant. Dan Streible, as ever, was a true scholar and gentleman as he helped organize a presentation of Barbara's work for the Orphans Symposium in 2018. And I remain especially grateful to Ron Gregg, Laura Stamm (who organized us), and Greg Youmans for being excellent interlocutors, colleagues, and a support system when we all presented work on a panel at the Society for Cinema and Media Studies about Barbara's work on the day before she died in March 2019.

Colleagues from the University of Massachusetts Boston in the College of Liberal Arts Dean's Office, the Art Department, and the Cinema Studies program provided material support for research and helped me to host two memorable visits from Barbara Hammer on campus—one in person and one virtually. These visits shaped ideas about this book at key points in its development. I also owe a special thanks to several students and colleagues at Colby College and at the University of Massachusetts Boston who attended talks by Hammer and engaged with her work; their enthusiasm and insights influenced my thinking and helped me to see the vital exchange Hammer's work invites.

Ongoing thanks to Katharina Loew and Ariel Rogers, my fellow writing partners and brilliant friends, who have long been supportive of this research. Special thanks to Kyle Stevens, who read and commented on parts of the book with his characteristic insight and brio; I am indebted to him for his thoughtful comments and general encouragement just when I needed it. To the many others who influenced the development of this project at key moments—including Ken Eisenstein, Anjo-mari Gouws, Amelie Hastie, Erik Levine, Tasha Oren, Jennifer Peterson, Lynne Sachs, Rox Samer, Girish Shambu, Tess Takahashi, Haidee Wasson, Patricia White, and Mike Zryd—I am grateful to be a part of this magnificent community, with access to the thoughts and support of so many excellent scholars and artists.

A big shout out to Louisa Bennion, who went above and beyond in transcribing all of my interviews with Barbara and Florrie. She engaged with their words and ideas with a sympathetic ear and helped me to see patterns and other items of interest I might otherwise have missed.

My thanks to Annie Martin, Marie Sweetman, Kristin Harpster, and Carrie Teefey at Wayne State University Press for shepherding this project to completion so kindly and so capably. And my heart to David Gerstner, who tirelessly supported this work, reading and commenting on drafts, sending snippets of news or information pertaining to Barbara's work, and always offering the very best of himself, which really is the very best.

And finally, love and thanks to my extended family and especially to J, G&H, who watched Barbara's films, shared ideas and love for her work and her person with me, and who buoy me every single day.

INTRODUCTION

Barbara Hammer tends to be best known for her work from the 1970s. In those years, she radically represented female subjects and subjectivity in a series of films that are both part of and ahead of their time. Films like *Dyketactics* (1974), *Menses* (1974), *Superdyke* (1975), and *Multiple Orgasm* (1976) explore lesbian sexuality, feminist identity, and social activism. Hammer recorded nonactors (including herself) in frank acts of lesbian sex, showed parts of the female experience (and anatomy) usually elided in filmic depictions of women, staged rituals portraying women in various attitudes of empowerment, and subsequently provided models for feminist action and power. Granting exposure to a decidedly feminist and lesbian sensibility starting with these early films, Hammer has frequently and rightly been seen as a pioneer of queer cinema. If her productivity had been limited to the 1970s, her importance to queer film and art histories would still be assured, though perhaps skewed (even more so than now) toward frameworks of identity for understanding her artistic commitments.

In fact, Hammer's oeuvre began before and long outlasted the 1970s. She continued to make important works of art until her death in 2019. Hammer's work has begun to achieve widespread recognition not limited to a focus on the 1970s. In the last few years of her life, her work increasingly received attention for the whole span of her complex, fifty-year-long career as an experimental filmmaker and visual artist: a show at Company Gallery in New York City focused on her photography; one at the Leslie-Lohman Museum for Gay and Lesbian Art surveyed her films, painting, performance pieces, and artifacts of her creative process; and she gained international exposure in career-spanning exhibitions and screenings around the world, for instance at the Tate Modern in London and a retrospective at the Seoul Women's International Film Festival.

Considering this recognition in the art world, one would think that accounts of her work would likewise acknowledge her remarkably extensive multimedia productivity. Frequently, however, that has not been the case. Often privileging the 1970s films, critical responses have hewed to the importance of identity issues in Hammer's work, which are particularly evident in (but not limited to) that decade of her creative output. While her campaign for making queer identity more visible remained important throughout her career, her art transcended, subverted, and even

sometimes avoided that orientation too. This complexity is as true of the work of the 1970s as it is of the later work, where the full range of her engagements may be better seen. Her artwork was formally daring and intermedial. While she returned to moving images over the whole course of her career, she also regularly looked to other arts and aesthetic strategies. Her art commingled life and art, the self and others, and film and other media.

Taking into account the multiple stances Hammer adopted across the second half of the twentieth century to make her work reflective of (particularly women's) individual experiences, it is clear that she took seriously the notion that, as she put it, "radical content deserves radical form." For content, Hammer's work centered on people, things, and phenomena that had not been conventionally portrayed in her primary mediums; for form, Hammer adopted a curious, playful, personal, and experimental approach. Like many of the feminist artists making experimental film and art starting in the 1960s and 1970s, it was Hammer's artistic mission to seek out fitting forms for her roving artistic interests—forms radical enough to embrace an ethos both resilient and flexible. Her work is driven by intellectual and emotional curiosity about the world and the camera that frames it. The vital, mobile dynamic of Hammer's films and artworks makes them feminist, queer, *and* something that pushes outside of the center of those notions. They are experimental in the most expansive sense of that term.

The feminist issues Hammer reflected on as well as those theorized outside of her work have ever been in flux. The purview of cultural expressions of feminist thought has been complex, sometimes even contradictory, and mutable from the beginning—and it continues to be so. The role lesbian representation plays in this context only further intensifies the issue of how we read Hammer's work and its innovations. In the realm of film history, as Susan Potter has noted, "nascent forms of modern lesbian intelligibility" have been in play since the earliest cinema; Hammer takes these forgotten forms and renders them newly visible, tracing and renewing them over five decades alongside larger shifts in cultural understandings of sexuality.[1] The case study of Hammer's work allows us to see why a broader notion of feminist art that takes this fluidity seriously is necessary, because representations of queer identity alone hardly begin to cover the ambit of queer art making. While in the 1970s, Hammer's work enthusiastically explored dimensions of personal experience—as Masha Gessen put it to Hammer in a late interview, "very few people document enjoying their body as much as you have"[2]—in the 1980s, she took a hard turn away from depictions of the empowered female body to other subjects and approaches. For instance, a very short film from 1983, See What You Hear What You See, removes bodies and even the

filmed world from the equation altogether. Hammer taped various graphic patterns onto clear film (so the image is nonphotographic), then duplicated each pattern and printed it on the part of the film strip where sound is read by the projector. So one literally hears the pattern (translated from image to sound by the projector) that is simultaneously shown. It would take a clever stretch of the imagination to connect the content of this film to the female intimacy depicted in *Dyketactics*. Instead, *See What You Hear What You See* would seem to belong more properly to the realm of structuralist concerns, in which Hammer became increasingly interested as she made a shift geographically from the West Coast to the East Coast in the early 1980s.[3] Such a film does not quite make sense if our notion of Hammer's interests fixates on issues of identity. Just as Hammer and many other feminist artists shifted course from their first and often highly provocative works of the 1970s into explorations of the formal and medium-specific aspects of film in the 1980s, the ensuing decades were also marked by changes in strategy and interests corresponding with cultural transformations, the personal ambitions of the artists, and the audiences they sought out. Thus by the 1990s, Hammer mainly turned to documentary forms, including for one of her best-known films, *Nitrate Kisses*, while in the 2000s and up until her death in 2019, she sought to assert her legacy, secure a place for her archives, establish awards to support new queer experimental artists, and make the complex dynamics of her films and artworks more legible. In short, she changed tack several times and also shaped how her work would be remembered.

Many feminist and queer artists evolved in multiple ways beyond the early years for which they are best known; however, our notion of their work has not yet caught up to them. What follows aims to narrow that gap. In expanding our understanding of Hammer's body of work, I argue for expanding the parameters of feminist and queer art to show how it seeks out a renewed set of forms, themes, and technologies/media/methods to express itself. It behooves us to eschew the limitations of accounts that associate the artist with a specific identity and to make room for the unique individuals who bring dynamic, changing ideas and forms to bear on their artworks. The following chapters trace innovations and transformations within Hammer's moving image work and assert the significance of its place in film history. I aim to establish the nature of experimental film from the perspective of an artist who worked and lived in conscious relation to larger social, cultural, and philosophical film movements, an artist whose work was influenced but not thwarted, for instance, by theory's resistance to work that would portray women's bodies and experiences joyously. We must restore the importance of such work—with individual experience at the center but also pushing outward into new territory—to histories of avant-garde and feminist thought from the 1970s forward.

Doing so provides a more inclusive and truer sense of the diverse contexts for and artistic expressions within the cinema, a significant part of our cultural heritage in multiple senses.

While there are several topics and themes that Hammer returned to across her work—including granting lesbians greater visibility, highlighting the female body in both vibrant health and in age and sickness, and demonstrating a lineage of feminist artists and concerns across history—what might characterize her work most of all is its eclectic curiosity and roving interests. As a working artist, she capitalized on present experiences to make art shaped by the places and contexts she inhabited as well as by the people with whom she interacted and, sometimes, collaborated.[4] When she was invited to South Korea, South Africa, or the south of France, she wanted to learn more about people living there and their histories, and so she made films to maximize her time and resources corresponding to these visits. Wherever she went, she filmed. Her friends, her lovers, her life, and sometimes her own earlier work became the subject of films. In these ways, she extended what Karl Schoonover and Rosalind Galt have identified as the power of queer cinema to cross global boundaries through individual registers of desire, identification, and community in that Hammer sought out kinship in local populations wherever she went and returned the favor of that kinship by making films that reflected it.[5] Fond of declaring "Art Is Energy!" Hammer demonstrably had no shortage of either.

Hammer's sense of her work's categorization as lesbian and/or queer also shaped her work. As Clara Bradbury-Rance has pointed out, the distinction between notions of lesbian and queer cinema matters for the contextualization of recent work; she argues that the terms "lesbian" and "queer"

> do not fulfil their imaginatively political potential equally, nor do they perform the same theoretical function. To write definitively about lesbian film under the banner of queer theory reduces queer's potential to move beyond the norms of difference; yet to write instead about queer film, without specifying lesbian difference, loses sight of the ways in which social and cultural structures of normativity and marginality have structured the terms of lesbian representation.[6]

Bradbury-Rance argues that in part because lesbian cinema was becoming less rare through the end of the 1990s—that is, lesbians were gaining visibility in films, a fact due in part to Hammer's contributions—theoretical formulations of the term associating it with invisibility (as with Terry Castle's *apparitional lesbian*) were becoming

less descriptive of the times as they changed. However, after the rise of queer theory, she suggests, lesbians became less visible again, in that they were subsumed in the broader category of "queer." For Bradbury-Rance, the shift demonstrates the need for (borrowing from Schoonover and Galt) "radical openness"[7] in engaging with recent lesbian films.[8] While she sometimes passionately argued for retaining the specificity of her personal identification as a lesbian (rather than as part of the larger category of "queer"), and several of her films directly advocate for making the lives of lesbians in particular more visible, Hammer also adhered to a broader queer, feminist, and/or universalist perspective—or shied away from any of these labels.[9] Keeping multiple categories in mind—maintaining radical openness—is necessary for a full accounting of her art.

Working with or against categorization of her work has been part of Hammer's mercurial method: she tried out new ideas, categories, genres, and, when needed, nimbly shifted gears to address issues in different ways. In addition to a steady schedule of making films, she wrote down ideas in notes, journals, and essays, compiling an impressive set of writings that chronicle the more or less private experience of a public artist as she contemplated ideas and her identity.[10] She also took photographs, organizing a handful of them into series, capturing images of herself, her lovers, locations around the world, and objects and textures that interested her.[11] Across many years she performed with her moving image works, casting them into new environments and bringing them to different audiences. Among these were *T.V. Tart*, a video piece shown on a candy-bespeckled monitor alongside a long table of sweets that Hammer would serve to the audience (1989) and *Changing the Shape of Film*, in which she projected images onto a moving weather balloon, forcing her audience "into continuous action."[12] Other performance pieces incorporated her films and/or paralleled their themes, including *The Great Goddess* (performed at the Skylight Studio in Berkeley as well as the Women's Building in Los Angeles in 1978), in which, as she put it: "I wondered if a fetus dreamed before she was born, and so I brought the community together to ponder this question during a ritual of candles, balloons, and, of course, the naked body!"[13] *Available Space* was also both a film and a performance piece, and each one harnessed the language of its medium to express Hammer's unrestrainable creative energy—an energy that could not be fully contained by any single medium and had to push out over the edges of its apparent boundaries.[14] Hammer took over spaces and claimed them as her own, transforming them with her ideas and art.

Her reclamation of a space for lesbian identity and art across fifty years of making films depended on more than just the time and place. A film like *Superdyke*, in which

lesbians commandeer the public spaces of the Bay Area in the mid-1970s, also demonstrates a model that, as Jack Halberstam puts it, "locates sexual subjectivities *within and between* embodiment, place, and practice."[15] In its eclectic collection of hijinks across places, it communicates Hammer's visions of lesbian activity, which offer alternative relations to public and private spaces. Her films both express a personal subjectivity and an objective visibility. They both look into the mirror and are the object of that looking. The *both-and* formulations of queer embodiment are not atypical to marginalized artistic expressions. In the realm of experimental art to which Hammer was drawn, the contradictions and collisions of a range of abstract binaries are the form and/or content of many works. Looking both to the conventions of the medium and the ways in which that medium might be challenged, changed, elaborated differently, or mobilized for a radical point of view, Hammer developed her craft embracing the experimental mode's alternative temporalities and spatialities. Thematically and theoretically, Hammer's work is enhanced by the idea of pushing out of the conventional boundaries of time and space within her medium, an idea that emerges especially in her uses of radical form related to the body.

Experimentation in the First Films

Hammer initially addressed these issues even before she determined filmmaking would be her creative calling. She noted that in this period she "was filled" with the idea "of the artist's unique individual gesture."[16] In short order, she began to envision the kind of artist she might become, experimenting with poetry, ceramics, and especially painting before picking up a camera. In her first experiments with film from 1968 to 1970, many of which are loose sketches of cinematic ideas, she was in the process of seeking an artistic outlet for her interests. Hammer's first films are exuberant in their experimentation. In particular, they explore the boundaries of moving images; they are interested in the formal possibilities inhering in the medium. In their content, they also are harbingers predicting her later work's interests and demonstrating her emerging sense of herself and her vocation as a queer film artist.

Hammer first picked up a camera in the late 1960s. Living with her then-husband in a house they built on wooded land in the vicinity of Occidental, California, and the legendary rural commune at Wheeler's Ranch, Hammer filmed around their property and started a journey of discovery of what the camera could do. When late in her life, she salvaged several of her earliest, thought-to-be lost films as she sorted through her studio to prepare her archive, she remarked on how that sense of novelty she found with the camera drove her at the beginning: "I was smitten with what I could do with it, what it could record, the portability and, especially, the intimacy—how film could

express who I am in a way I hadn't yet found."[17] In her earliest films such as *Schizy* (1968) and *Barbara Ward Will Never Die* (1968), exploration of her environment and the camera are key. They blend disorienting, abstracted shots of nature that reconstruct the landscape according to a viewpoint strongly tied to the cameraperson's (Hammer's) viewpoint. For instance, in *Barbara Ward Will Never Die*, her camera goes in and out of focus on leaves blowing in the wind and smoothly follows the arc of a bird circling in the sky before it turns to explore a rustic graveyard, where it isolates and fragments words from the grave markers and introduces shots of Hammer's own foot trampling on flowers and gravestones. Adding a subjective layer to her presentation of these images, her camera glimpses her own body at several points in these early films—a foot here, a shadow in motion there—as she brings the camera around local habitations and the surrounding environment.[18] Her method recalls filmmaker and theorist Jean Epstein's observation about the subjective intimacy of close-ups:

> Just as a stroller leans down to get a better look at a plant, an insect, or a pebble, in a sequence describing a field, the lens must include close-ups of a flower, a fruit, or an animal: living nature. I never travel as solemnly as these cameramen. I look, I sniff at things, I touch. Close-up, close-up, close-up.[19]

Hammer takes her audience on similar adventures in perception. While she is out and about exploring nature, she does not leave her body behind. With a restless camera, she revises conventional ways of observing her pastoral setting and introduces an embodied, sensuous way of living in and representing the world.

These aspects—exploring her environment and introducing her embodied perception of that environment—provide a prelude to the concerns that will shape the oeuvre she makes over the decades to come. Several films from this period specifically address issues of identity that Hammer was beginning actively to work through in her life. For instance, *Barbara Ward Will Never Die* ironically articulates queer presence and absence in Hammer's person and work. "Barbara Ward," Hammer's married name in the 1960s, may not exactly die, but she is, rather, commuted into the artist who blends her identity with organic being in the world. The ability of the camera to capture change as it happens might well have appealed to someone for whom lesbian identity did not come into full flower until well into her adulthood, and then through the process of making moving image art.

Other early work like *Aldebaran Sees* (1969) stakes a claim to the vision of an emergent artist. In that film, Hammer adopts the "light-seeing eye" of Aldebaran, which is the brightest star of the Taurus constellation.[20] (Hammer, by the way, was a Taurus.)

The world the film shows is constituted of projected light; it envisions and re-envisions worlds, and in the process, Hammer makes a new visual experience, layering vivid colors and abstract, prismatic patterns (figure 1). Through nonrepresentational signs, Hammer visualizes latent inner thoughts, memories, and feelings. Similarly, she described her film *Death of a Marriage*, made the same year, as

> my first psychodrama—finding images and filmic methods of portraying my interior emotional being. I had built by hand with my husband a home in the woods, made my own horse corral, and had an art studio yet the alternative lifestyle didn't erase the feeling of entrapment, proscribed role, and constrictions I felt.[21]

In these films, one witnesses the colors, objects, themes, and experiments with the camera that we see developed more fully in her later films. Also like her later films, she initiates these experiments to investigate complex interior states that are not readily visualizable.

In these first experiments, Hammer investigates how her camera might provide images of the world and specifically of women that are unlike those proffered by the mainstream film industry. *Contribution to Light* (1969) anticipates the personal nature

Figure 1. Abstract light patterns in *Aldebaran Sees*

of many of the films that will follow. Shot on Super 8 while she was still living with her husband in the California woods, it briefly depicts her husband (encapsulated for a moment in a metonymic close-up of his sexual difference) and then spends most of its time exploring her own perspective, presenting abstract patterns of lights and movement—for example, a kaleidoscope of small rectangular lights seesawing diagonally across the frame, possibly a reflection in car windows or lens flares but definitely a rhythmic dance of lights—as well as experimenting with images of herself. In one such image, she is fleetingly reflected in glass. The status of her filmed body is elusive: is it captured directly, is she filming a reflection, or is it a combination of the two? When a hand moves across the frame in front of the reflection, we realize it must be both. Hammer contemplates the nature of her own image, which is by no means straightforward.

Soon after, the film cuts to her studio to show her painting a self-portrait on a large canvas. The camera moves in for several close-ups of the painting, homing in on the thick paint on the canvas and the eyes of the person pictured there. It highlights qualities of both mediums and their individual recognition of and efforts to mitigate their two-dimensionality, extracting from both mediums a gesture toward four dimensions. For the painting, this effort takes the form of emphasis on the thick paint acclivities raising the flatness of the surface and attention to the swaths of paint, suggesting the action (that is, the duration of execution) of painting; for the moving image, it takes the form of movement around the painting, compensating for the screen's lack of depth by traversing with the camera the depth of the object imaged and also adding duration through the time of filming. Hammer has reflected on her early transition from experimentation with other arts to become primarily a filmmaker, noting that through the guidance of her painting teacher, she discovered she was drawn most to expressing movement and time, for both of which she found a better outlet in the formal elements of cinema.[22]

The detour to the painting studio in *Contribution to Light* also allows Hammer to examine the nature of the content—representations of the female/artist's body—depicted by the film and the painting. As a feminist coming into artistic and radical consciousness in the 1960s, Hammer was a forerunner for redressing the imbalance of represented perspectives in film. Her earliest work squares with what Maggie Humm among others has described as the first track for feminist consciousness, in which creative/cultural expression and activism ramped upward through the 1960s and into the early 1970s, with goals that included increasing visibility, fighting for equal rights, and recognizing and reversing the power structures that oppress women.[23] Hammer engaged in these goals very quickly, and her first step in that

direction was to develop the specific terms of her creative work. To do so, she made films in which she represents a personal, embodied point of view, hewing to a strategy adopted by several other figures in the wave of North American experimental artists from the same period (for example, Gunvor Nelson, Joyce Wieland, Storm de Hirsch, Carolee Schneemann), in which by dint of the artist's intervention the female self serves as legitimate subject. As Judith Mayne has pointed out, such self-representations critically scrutinize "the very components of subjectivity."[24] Not least of all, they trouble the notion of the artist as author of a film by making her also the subject of the film. Notably, all of these artists also have in common that they experiment in other mediums, including dance, performance art, and painting.

These commonalities—self as subject and medium-promiscuity—point to the potent trend of women's filmmaking in this period that depends on co-opting the tools of expressivity from what Chris Holmlund and others have noted are "male-dominated contexts of 1960s experimental film" for new purposes.[25] While for a variety of reasons it would be a mistake (as Holmlund argues) to apply a blanket notion of a "feminist" form of art across these artists' complex oeuvres, they each in their specific way work to do what John Sundholm has claimed motivates Gunvor Nelson's work: conceptualize and articulate "that which can never be conceptualized or clearly articulated,"[26] as well as that which simply *hasn't* been conceptualized or articulated. For several emerging female artists in the late 1960s, including Hammer, this process embraces fluidity and the organic becoming of an idea/perspective that derives from a specific point of view uncoupled from traditional modes of telling a personal story. That is, it is self-oriented, and it shape-shifts as the filmmaker discovers new outlets for expression based on lived experience. Each artist expresses this experience differently, but their work has often been lumped together as a single feministic heap. Nelson, among others, chafing at the labels of "feminist" and "experimental" filmmaker, rejected both monikers. She proposed "personal films" as an alternative; nonetheless, what she had in mind as a way of categorizing her work still fittingly eludes a single definition's constraints:

> Everyone seemed unsure of what to call it. It is difficult. Are you really so "avant-garde"? Experimental films sounds like something incomplete. I have made both surrealistic and expressionistic films, but I prefer the term "personal film." That is what it is about. Even if many don't understand the meaning of the term. One the other hand, it can be easier to refer to them as avant-garde films. But I like the description "personal film" since it stems from one person.[27]

Terming the work "personal" makes it as flexible and as complex as the person from whom it derives and may be a good alternative as a name for work such as that made by Hammer in this earliest period as well as into the 1970s and later. Of course, it is also experimental, and in the most expansive terms possible, in order to better address the personal.

In the second wave of feminist activity that dovetails with this period, the issue of naming is no small matter. As B. Ruby Rich argues, there is as much danger in misnaming as in not naming or being oblivious altogether to the feminist work in front of us.[28] Despite her work to mitigate it, the issue Rich raises remains, partly because of a widespread temptation to make sense of the work as a whole—to corral art made by women into one wholesale feminist holding pen—and partly because of a lack of imagination about being able to allow for the individuality of the works in question, not just work across filmmakers but even across a single filmmaker's body of work. The matter is complicated by the filmmakers' "distrust of traditional modes of articulation," such that categorization may be somewhat beside the point.[29] Hammer and others draw from but change the terms of experimental film language to fit their individual expression. Multiplicity—a rather loose collection of specific, idiosyncratic work often steeped in the community that is both motivation and support for it—is key to the work Hammer accomplishes as she enters a lifetime of feminist, queer, personal work.

Recognizing this individuality while keeping an eye to the trends of the times underscores Rich's recuperation of specific careers in the 1970s in order to (re-)write early feminist film theory with its complexity and specificity intact. Hers is an important intervention in this body of scholarship, one that is engaged in "learning how to negotiate across difference, and reconciling the personal with the professional—if not always the political."[30] Justifications for the removal of the personal in academic studies have a long history that has affected the way women's contributions to the arts have been valued.[31] Because the gatekeepers of access to the means of production in cinema have traditionally been male, a fairly robust side-tradition of women working in experimental forms and in alternative narrative forms developed, particularly in this period when theory, practice, and politics commingled regularly.[32] Creative work of a singular or personal nature found widespread disparagement in the formulation of a feminist film theory, though not a feminist film practice, in the 1970s.[33]

Revivifying the milieus of personality and individual investments in art during this period is a first step for describing the arc of Hammer's work from this period forward, whether these milieus directly contribute to aspects of that work, as they frequently do in the 1970s and 1990s, or whether a retreat from the personal presses her into new

directions during the 1980s. Her oeuvre, all the way up to her last works, develops in constant negotiation with questions about the role the personal should play. (And it is within an attitude of play that these questions often find articulation.) *Contribution to Light*'s embrace of painting and film demonstrates her interest in multiple means of expression fixed on self-representation. Hammer turns the camera to her own body as she paints the abstract portrait, making herself the object of exploration. Representation of herself as dual subject/object finds elaboration in the shots that follow. In *Contribution to Light*, moving away from the painting/painter images, she cuts to an image of herself filming with the camera. She then moves out a bit to reveal that she is filming into a mirror: we see her filming and what she films within a single shot (figure 2).

Like a number of women making experimental film, Hammer mobilizes mirrors and reflections as a way of (literally, figuratively) reflecting on the agency of the women depicted on screen. The mirror recurs as a challenge to and reconfiguration of the identificatory pattern of classical narrative cinema, which conventionally relegates the female figure to a passive position. Hammer's move joins her to the work of several women who film their own bodies. For instance, in Maya Deren's *Meshes of the Afternoon* (1943)—a film Hammer saw early in her film school education and took as a lodestar for the possibility of embarking on her own experimental film practice[34]—Deren's character multiplies into four identical iterations of herself.[35] A wide range of other artists/filmmakers presage or follow from Hammer's example, including Schneemann as well as a veritable multitude of others, including Sadie Benning, Cheryl Dunye, Yvonne Rainer, Ngozi Onwura, Chantal Akerman, Adrian Piper, Lorna Simpson, and

Figure 2. Camera, self, and mirror in *Contribution to Light*

Agnès Varda. All use their own bodies on camera as a conduit to conduct the film from individual to diverse larger issues. When Varda released *The Beaches of Agnès* (2008), a film that makes herself as filmmaker the key subject and object of the film, she commented in interviews that the mirroring operations that result from being both behind and in front of the camera are complex but need not be solipsistic: "The tool of every self-portrait is the mirror. You see yourself in it. Turn it the other way, and you see the world."[36] In addition to filming her own image in *Contribution to Light*, like Varda, Hammer frames the cinematic self within the world. She tips the camera upward to regard the tree canopy above her, providing context for the perspective she has just elaborated and asserting her interest in things beyond the bounds of her own being—a being that blends into that environment through shadows, reflections, and representations of itself out in the world.

This early Hammer film investigates images of herself in a rich variety of forms. When she cuts to the painting again, her shadow is cast onto it—an overlay of an outline of the self collaged with a representation of the self, which is created by the actual, art-making self. It elaborates the self-as-multiply-imaged motif. All of the shots are brief, but the exploration of representations of the self is layered and complex. Despite its short length (less than five minutes), in its formal and thematic material, this and other early films set up most of the issues Hammer will address and the strategies she will employ through the next decade. Indeed, several of Hammer's first points of entry into filmmaking navigate representation of the self from a unique perspective. A film like *Schizy* (1968) likewise exemplifies the dual nature of that perspective. It ruminates centrally on Hammer's role before and behind the camera. Again she films herself filming herself—that is, her image, holding a camera to her eye, is reflected in a bucket nestled between her feet on the sidewalk. That image uniquely collapses the body filming and the body filmed and condenses the act of refraction and reflection required for making moving images in the first place. Within the image, her feet are filmed; her face is filmed too, but it is a reflection between her feet, putting her head down where her feet belong; and together, the folding of feet and face into one space suggests a creative vision that allows the rebuilding of bodies in new configurations. This work takes the maker and viewer on an adventure in perception.

The next years witness Hammer finishing a number of short films that similarly explore the creative capacities of her camera. In addition to working with both color and black-and-white film stock, she experiments with sound and silent formats of Super 8 and 8 mm film; by 1973, she starts using 16 mm as well, and by 1976, video. One of the things most striking about Hammer's work is how quickly and ceaselessly she sought new outlets for her curiosity and creativity. Even in some of these earliest

films—*Schizy, Yellow Hammer, Clay I Love You II, Cleansed II, Elegy, Contribution to Light, The Baptism, Aldebaran Sees, Death of a Marriage*—there is a search for meaning through experiments in form. She tries blurring images, superimpositions, microscopic images; she looks for the play of light on a car fender or through a bottle or a prism; she delights in bright colors, yellow flowers, red lights, bodies, shadows, movement. Of course, there are differences between the first work and her later films. For instance, many of the images of the first films are more abstract than her later films, and the editing seems raw and less coherent with no overall schematic for the film, like *let's just see what this looks like*. However, the seeds of further work appear here that flower in later films. From the emphasis on light and color in abstract shapes to the reconfiguration of the natural world to resonate with personal elements—such as the use of the so-named flower variety "Yellow Hammer," which she conflates with her own person standing amid a vast bed of flowers in this eponymous film—Hammer finds subjects that advance her technical abilities with film and that allow her to think at oblique angles from what she had already seen expressed cinematically. Oblique angles of articulation interested Hammer in the 1960s. In her "appropriation of popular visual and narrative styles" (which Ellis Hanson has suggested is a strategy for expression in queer art) and her inclusion of queer subjects, she developed an aesthetic that situates her work in a continuum of feminist, queer, and personal films.[37] With ambitions to be an artist and an attraction to the flexibility of the film medium for aesthetic, theoretical, and political purposes, the particularities of these early films function as an entrée to her subsequent career.

Ambition and Legacy

Through forms of self-expression and the representation of underrepresented bodies and lesbian experience, Hammer establishes herself as a pioneer of queer experimental film in the 1970s. Building from there, she makes concerted efforts to solidify her legacy and her place in history. Of her unique contributions, one of the most important to her aesthetic is engaging the notion of *sensuous* experience through her films, which we see in the nonrepresentational explorations of the 1960s and in multiple ways in her later films. Emphasis on sensation and touch advances her aim to activate bodies on and off screen.

The centrality of sensuous experience to Hammer's aesthetic is evident across the periods of her early, middle, and late works. In her earliest work, identity issues provide the foundation for coming to terms with sensuous experience, for which she marshals multiple senses and sensations. Her perhaps most famous film, *Dyketactics*, makes sensation both the method and the theme. In the 1980s, despite downplaying women's

bodies as the central focus, she sustains an interest in sensuous aesthetics. For example, noting that "the basis for a lesbian aesthetic is the perceptual connection between sight and touch," she describes the motivations for her 1981 film *Sync Touch*, remarking on its expression of the "heightened . . . sense of touch," its "appreciation of textures, the tactility of the physical world," and its return to the awareness of the relationship between touch and sight.[38] In her documentary films of the 1990s, like *Nitrate Kisses* (1992), she puts her camera into empathic relationship with others to underline the connection between her vision and the sensation of touch. As she reflects back on her career in the 2010s, she describes the idea and actuality of sensuous engagement as one of the cornerstones of her thought. Films over the course of her career, from *Schizy* (1968) to *Evidentiary Bodies* (2018), experiment with the expression of sensuous experience on these multiple levels.

Another persistent interest in Hammer's work is the interaction among artist, artwork, and audience. The early years demonstrate the ways Hammer engaged her initial audiences. Her work from the 1970s developed in relation to the supportive network of women who buoyed her work and provided a foundation for its reception. Early on, Hammer aimed to "activate" the audience through her stylistic or thematic choices—to initiate a reaction that would motivate action. As she noted in a late interview, by the end of the 1970s, she sought (literally) to move her audience to action: "By 1979, I was already tired of showing my films to a passive audience. I thought, *How can they make political choices if they aren't active?* To get them out of their seats, I made a film called *Available Space* where I projected from a wheeled rotary projector table, which I took around the architectural space. The audience had to move to see the cinema."[39] Energizing the spaces and scope of cinema becomes one of Hammer's key motifs; in her experimental practice of film art, she expanded the boundaries of cinema in its subject matter, themes, audiences, and exhibition. It is no mistake that the images Hammer projected in *Available Space* include a woman she describes as "pushing out of the frame"—an apt description of Hammer's project more generally for the entirety of her career (figure 3). Indeed, the usual parameters of cinema could hardly contain her.

Even before she incorporated it into a screening performance, *Available Space* as a stand-alone film meditates on the question of symbolic and cinematic space in a way that is emblematic of Hammer's oeuvre. Throughout the film, Hammer measures spaces within the frame in a variety of ways, drawing attention to the fact and act of framing in cinema. The first shots are trained closely on a space of sand, into which Hammer walks in bare feet. In close-up, she moves within the small area to which the camera is confined before sitting down at the top of the frame and then folding her

Figure 3. Pushing out of the frame in *Available Space* (1979)

naked body toward the camera so that she is scrunched up into the space of the frame. She fits her body to conform to the small space afforded her. The next shots pull back to expand the view. The camera sits farther away and above Hammer down on the sand, offering a wider scope so that her full body occupies only a tenth or so of the available space. All the same, she charts out this space again with her body, walking from the bottom corner of the frame to the top corner, up and down across the vertical stretch of the frame until she has fully traced the space; then she recommences the action, only along the horizontal stretch of the frame, from left to right and back again, filling it in.

While in some sense, her action sketches the confinement of the frame, other elements shrug off that confinement. For instance, the expansion that happens from the first to the second shot indicates what lies beyond the frame edges Hammer's body navigates in the first shot. One imagines larger vistas still after the second shot. And indeed, in the next short sequence, Hammer scans the horizon with a pair of binoculars to imply the sense of the distance she bridges with the binoculars. The lens of that vision-enhancing technology mirrors that of the camera, and the film's fast-motion, stop-motion animation, and time lapse photography call further attention to that technology. Hammer points the viewer to the moon, which rises into the clouds as

night descends; this is compressed into a time-lapsed moment, and the moon exits the frame at the top, in its natural trajectory through the night sky. Her film suggests the limits of cinema—it has frame edges that won't budge; its conventions picture women in ways that are limiting—but also its capacity to transcend those very limits.[40] She pushes through the limits not only in the gesture toward what lies beyond the frame but also in how the cinema might transform what is in the image through its other devices. Thus for example she blurs the image in action via stop motion when she leaps on a bed she measures inch by inch with her body later in the film. Throughout *Available Space*, Hammer is framed (as one must always be on film), but all the while, she calls attention to that frame as an arbitrary marker of what is included and what is not included in the image. She offers an image of her naked body pressing out of that narrative, geometric, and representative frame. As we have seen, with this film, Hammer began to branch out into performance art, screening *Available Space* as part of a performance piece, combining it with live presence and activity. She would mount a projector onto a 360-degree rotating table so that it could move around the room and energize the space where the film appeared. Moreover, in this performance context, beyond the edges of the frame is the audience, with whom she aimed to connect. Coordinated with the footage of the film, this performance pushed outside the boundaries of what has conventionally been available to women and to film screenings, an impulse she gave free rein in the following decades.

Over time, the relationship Hammer investigated with her audiences deepened. By the end of the 1970s, Hammer aimed to expand her exhibitions' domains, from women's clubs into the realm of the museum and gallery. In addition to that art audience, she broadened her reach by encouraging a view of her films that would incorporate male audiences encountering a feminist cinema. In film school, she found herself in the position of having to justify a feminist aesthetic to a cadre of male professors, whom she claimed did not value that aesthetic sufficiently to grant her a master's degree without writing a supplemental paper underlining her accomplishments.[41] Part of her mission through her career was to demonstrate the importance of her work to a larger audience. Highlighting her films as works of art through the 1980s helped to secure a place for her work in film history. As her work continued in the 1990s and 2000s, she increasingly included talk-backs with the audiences for screenings of her films and allowed her engagement with these audiences to shape the work.

Hammer's films engage positive thinking about the roles women have played on the margins of the cinema industry. As much as her films address disparities of power and visibility for women in history, they are also unabashedly joyous. While keeping the larger map for orienting oneself in the world in mind, Sara Ahmed notes that ways of

"going astray" offer productive paths for forging forward in queer cultural and artistic work: "If orientations point us to the future, to what we are moving toward, then they also keep open the possibility of changing directions and of finding other paths, perhaps those that do not clear a common ground, where we can respond with joy to what goes astray."[42] Hammer's films take up the charge of responding with joy amid the reorientations her queer art negotiates. Indeed, this element of Hammer's work distinguishes it in its approach as well as in its reception. Her films' unabashed representation of lesbians enjoying themselves together, as well as the communal responses these films inspired when they were screened, represents a leap from the more solitary types of spectatorship outlined for example by Patricia White for Hollywood's representations of lesbians in its studio heyday.[43] All the same, the pleasure of seeing and identifying with such images may well be related. The interdynamics of power, aesthetics, and women's roles and representations are taken up in Hammer's work from every angle, and while it demonstrates a joyous leap forward, it operates along a continuum of representations and formal experimentation that precede her as part of cinema's history.

For example, as I have noted in the experimental film work of one of Hammer's avowed antecedents, Maya Deren, an emphasis on process, fluidity, and unfinishedness allows different modes of expression for artists who are working on the margins of the film industry and who are invested in the vicissitudes of affect, the ephemeral, and the communal in their work.[44] Eve Kosofsky Sedgwick's work underlines the way we might think of such art in terms of new configurations of relationship. In her preference for the spatial preposition "beside" (rather than "beyond," for instance), she allows the possibility for women not to be subsumed by their relationship to other things within a discipline—aesthetic activity in this case—nor to see their work as moving primarily in a temporal or teleological fashion (pushing *beyond* something rather than existing *beside* something). Instead, she argues, considering work in a variety of fluid relationships with many things offers a nondualistic mode for thinking: "*Beside* comprises a wide range of desiring, identifying, representing, repelling, paralleling, differentiation, rivaling, leaning, twisting, mimicking, withdrawing, attracting, aggressing, warping, and other relations."[45] (Notably, all of these verbs resonate with Hammer's mode of expression.) Exploring the alternative paths opened by such thinking, we see how work that comes from different places and people, and that moves toward different futures, might allow us to envision a different world, one that would give support to marginal bodies whose nondominant interests, in Ahmed's words, "make them appear oblique, strange, and out of place."[46] In dialogue with these positions, I aim not to centralize radical feminist art but to argue for the value of what drifts and is not at the center—and may never wish to be.

Finally, one of the most important and enduring aspects of Hammer's oeuvre is her own advocacy for her work and legacy. Even as she struggled with her health in the last decade of her life, she worked tirelessly to secure that legacy. She organized her papers, films, and ephemera into a massive and multifaceted archive now housed at the Yale University Beinecke Rare Book and Manuscript Library in New Haven, Connecticut, and the Academy Archive in Los Angeles, California.[47] Hammer meticulously curated her work and shaped the way she wanted it to be remembered in film and cultural histories through this archive as well as in interviews, appearances at universities and museums, her website, and her own writings. This book benefited from her attention to her legacy; she personally facilitated access to her archive for me while it was in transition to its permanent home, offered access to her person for a series of interviews, answered numerous questions in person and via email, and responded to any requests that might help continue her legacy in a book devoted to her work. Whether Hammer's work would be assured a place in those histories without her own efforts is a moot point; the fact is that she had a hand in procuring that place and defining the nature of her contribution within it. Moreover, her perception that such cultivation of that recognition was necessary derived from years of striving to gain it during her lifetime. Like many experimental artists working on the margins, Hammer's papers are rife with requests for recommendations and grants, write-ups of her creative activities, and letters nurturing relationships with representatives of universities, galleries, festivals, and museums where she hoped to show her work or make an appearance. Some part of her success as an artist follows from her appreciation of what energy was required to guarantee that success *outside* of the work itself.

Part of the aim of this book is to introduce readers to a selection of the works that earned Hammer her reputation as a foundational artist for queer experimental film. However, because in the end, she made close to one hundred films, a detailed chronicle of all of her work will not be possible here. Nonetheless, the fact of her extensive productivity influences the account I provide. That is, the multifarious nature of work she produced—representing a vast range of experiments with the medium of film and other artistic and technological forms—makes it well neigh impossible to classify her work in a singular way. Thus while I cover the full scope of her history as an artist, beginning in the late 1960s and continuing to her death in 2019, I engage with representative examples of her art as well as some of the more eccentric works and the diverse contexts that inspired them over that whole history. The notion of a prototypical Barbara Hammer work is necessarily multiple if one is to embrace her tireless and wide-ranging interests, expertise, curiosity, and enthusiasm about a great many things.

Hammer was not just a pioneer of lesbian cinema but one of the trailblazers who emerged as an artist within a male-dominated experimental film context. She contributed to poetic as well as political, experimental, and documentary filmmaking practices. For Hammer and others emerging at the crest of second wave feminism, working in multiple contexts—at the intersections of aesthetics, affect, identity, history, and culture—provided a productive space for the mobile, volatile, and radical aesthetics they embraced as their work transformed over time. As Hammer cautioned, perhaps as much about how to read her own work as how to avoid an oversimplification of theories that shaped history and culture: "Many political forms are outmoded, unchanged since their inception. Feminism must guard against this rigidity that can leave it culturally bound to the 70s and irrelevant to the 80s and beyond if it is not open to change and process."[48] What follows addresses the volatile relationship between hegemonic norms in the art world and the interventions of Hammer's work that happen at an angle to those norms. Like its subject in encompassing several related fields of study, this book marshals an eclectic approach to address a dynamic subject whose endeavors intersected with many interests.

The Chapters

The chapters of the book center on shifts in focus, interests, forms, themes, and types of engagement in Hammer's work and unfold chronologically with approximately a decade covered by each chapter. Starting with the first films she made in the late 1960s and continuing up until her death in 2019, each chapter provides a sampling of some of the key and lesser known works in Hammer's oeuvre and analyzes their dynamics within their historical moment. The first chapter introduces the issues that initiate Hammer's investigation of the world and herself after she first takes up a camera. It explores the tensions in the late 1960s and 1970s between representation of women's bodies (which tended by feminists to be seen as naively embracing an essentialist perspective) and contemporary feminist theory (which drew attention away from bodies to the systems and structures—including cinematic narrative structures—that kept women in repressed conditions). I provide context for the emergence of an eclectic but artistically committed cohort of women making moving image and experimental artworks during this early period.

The second chapter charts the physical and artistic moves of Hammer's 1980s. The physical move—she packed up and moved from the Bay Area and West Coast to New York City, where she felt she might better be able to exercise her ambitions for artistic recognition—resulted in shifts in her artistic mode, at least on the level of the look of her films. She and others have characterized the key marker of this shift as a move

away from lesbian bodies and a move toward the subjects and forms of the larger experimental film scene, with geographical rather than anatomical landscapes taking a central position in the imagery of her films. During this decade, she noticeably expanded her work's purview and entered the marketplace of artistic accolades that led to new projects and subjects.

In the third chapter, I turn to Hammer's primarily documentary work from the 1990s. While she expands the length and genre of her films during this period, several continuities in themes, intentions, and modes of experimentation are evident as well. I consider the way her work engages with the places she travels, the people she meets, and the histories she explores through both places and people. The documentary emphasis of this period does not negate Hammer's inventive or experimental ethos. Indeed, that ethos finds purchase in her representations of the world in a way similar to her treatment of lesbian cultural activity in the 1970s even while it differs in its main purpose for exploring this new territory. She brings her creative vision to bear on rewriting history.

The fourth chapter of the book takes a longer period—from 2000 to 2019—to consider the final film works of Hammer's career, which both combine the methods and ideas of the earlier decades and help to solidify her legacy. During this period in particular, Hammer attempted to ensure herself a place in the cinematic hereafter. As such, the chapter also considers her efforts for building, cataloging, and selling her archive as well as establishing a foundation for administering an annual grant in her name. Further, it addresses the manner in which she put her work in the hands of trusted others to sustain her legacy. As she increasingly observed the span of her own career from the outside and the long view, she again activated the *both-and* mode of working through the issues closest to her as she made her final films. She had a strong hand in shaping the ways the work should be remembered.

In the final chapter, I give room for Hammer to have the last words. The chapter is composed of excerpts from interviews Hammer and I had together during the last three years of her life. These interviews highlight some of the issues in her work as she looked back on it. Here, as elsewhere across the body of her work, what is most striking is her generosity in compiling an account of the intersections among her life and the history and culture she lived and shaped through her work. It stands as a last word in a book that hopes to be nothing of the sort. My greatest wish is that what follows might inspire others to further consider Hammer's complex, eclectic, focused, ambitious work as well as its position in occupying a key time in the history of the cinema as seen from its margins.

1970s

Barbara Hammer, Queer Pioneer

Soon after the raw experiments with film she undertook in the late 1960s, made without any formal training as a filmmaker, Hammer turned to moving images as her primary artistic outlet. After separating from her husband and traveling for some time, she returned to California, moving to the Bay Area and starting film school at San Francisco State University in 1973.[1] There, as she learned more about the craft, she began to make work candidly depicting lesbian bodies, including her own, and continued to experiment broadly with the tools and techniques of cinema. Of her many contributions to cinema, Hammer early on developed a cinematic language that draws on experimental film techniques while also representing lesbian women as empowered subjects. While several later films including *Nitrate Kisses* (1992) also play an important role in cementing her legacy, the 1970s films establish the trajectory of her career in their stylistic qualities and themes, which evolve along parallel tracks over five decades.

Several threads, including a focus on sensation, camera movement, and simultaneity, run through Hammer's work from the beginning, linking very early efforts to her last artworks. However, unlike in later decades, in the 1970s few of her works do not also put in the foreground female bodies, granting greater visibility to lesbians and women who had been hitherto unseen in the ways Hammer filmed them. In these films, Hammer put feminist/female activism and experience at the center. This chapter introduces Hammer's film work from the 1970s to provide a basis for understanding the building blocks of her work. It centers on several key issues that establish her career.

Specifically, first, the 1970s work distinguishes Hammer as a foremother of contemporary queer experimental cinema. Her 1970s films established Hammer's artistic vocation, and they are most frequently identified as foundational for Hammer's legacy to cinema history. Second, the films experiment with the formal dimensions of the film medium in a variety of ways. These films demonstrate that Hammer was in the process of discovering how to get the effects she wanted, skills that developed in tandem with

her content highlighting lesbian and feminist visibility. Third, the 1970s films show Hammer's early appreciation for the notion of sensation as essential to her aesthetic. As she recalled this period in a late interview, Hammer connected her coming out as lesbian with finding focus cinematically through a sense of touch: "So, this reinforced my own outline of the body and became the mode of my lesbian aesthetic, so that in my films I want the viewer to feel in their bodies what they see on the screen." Recounting reading about Carl Jung's four psychological functions around this time, Hammer remarked that the dominant mode for her way of approaching the world was through "sensation. That means that when I look at something in the world, I feel it in my body."[2] As Hammer understood it, this mode underscores both the content and the tactile experiments she tried in this medium. Finally, an unmistakable jouissance marks these films, which binds all of these elements together and distinguishes Hammer's work from some of her contemporaries. The element of joy derives from the films' focus on discovery and their pushing out of the bounds of conventional attitudes about women and filmmaking. The films she made during this period are giddy tributes to female experience elided in most films to that point; they are a clarion call to open the field to make way for something playful, earnest, new, and frankly queer. As a trailblazer of a certain kind of experimental, structural, poetic, and documentary cinema, Hammer embraced a broad vision of the artist's role and queer aesthetics throughout the 1970s.

The Early Years

Hammer first garnered attention for films in which she boldly represented underrepresented subjects and subjectivity. A closer look at an array of works from this time, including *I Was/I Am* (1973), *Menses* and *Dyketactics* (figure 4) (both 1974), *Superdyke* and *Psychosynthesis* (both 1975), *Moon Goddess* and *Women I Love* (both 1976), *Home* (1978), *Double Strength* (1978), and *Dream Age* (1979), illustrates Hammer's exploration of lesbian sexuality, identity, and social activism. Part of this exploration is highly personal. The films often put her own history into the mixture of images and ideas, and the people she films often include herself. However, the films also transcend her individual experience, opening out into an intimate but shared, communal experience. Hammer renders a whole subsection of female experience visible, combating the tendency for lesbian apparitionality—an elision of their cultural presence—described by Terry Castle.[3] Asserting her own presence, bringing friends and lovers with her into the legitimating light of recognition, Hammer develops her own grassroots, personal, experimental praxis.

Alongside her contribution of offering a wider range of representations of women, Hammer's work provides material for rethinking the twin issues of identity and

Figure 4. *Dyketactics* (Barbara Hammer, 1974)

identification. Behind the camera, Hammer's own identity marks her work as queer, female, and feminist, inflecting her work with specific concerns not taken into account in the same way for nonqueer, nonfemale, nonfeminist filmmakers. One of these concerns involves how identity bridges the space behind the camera with the image it not so much captures as creates of women in front of the camera. These also form a relay through the body of the filmmaker from the women she films to the women in the audience, who see something more of themselves than might be typical in cinema to that point. In tracing a line from identity to identification, Hammer's films lend nuance to a similar trajectory that has been discerned in feminist theory from the same period in the 1970s.

The emergence of feminist film theory coincided with the films that established Hammer's reputation. In the 1970s, feminist theory countered the repression of women in moving images. It did so first of all by insisting on the need for more breadth in the types of representations of women and calling for those representations to skew positive and multidimensional. So instead of films presenting hysterics, whores, femme fatales, harpies, or harridans, feminist theorists argued that films should aim for more fully developed, individual, specific, complex character traits for women on screen. Second, broadly speaking, feminist theory looked beyond appearances and addressed

itself to decoding structures of meaning contained, for example, in the relay of looks, the position of women within the frame, and the ways they were made to seem fetish, object, and/or emptied of agency.[4] The work of feminist theorists throughout the 1970s recognized and wrestled with how (especially female) spectators necessarily contended with ideologically compromised images of women. Feminists revealed the structural and systemic problem in which an assured place for women in film—whether in the director's chair or in front of the camera—did not exist. Aside from a nexus of scopophilic looks directed at them and not by them (their so-called *to-be-looked-at-ness*[5]), women were denied material or ideological space for their desire, creative energies, or individuality in cinema. In effect, feminist scholars excavated the poverty of screen images that offered little by way of recognizable self-images and showed that female, queer, nonbinary, and/or resistant spectators could relate to these images only through the psychic gymnastics of masquerade, transvestitism, or fluid gender postulation.[6]

These intellectual, feminist efforts went some distance in mitigating the effects that slighted women in their efforts at identification, if only by calling those effects out. But the identities behind the camera remained resolutely male, except in limited cases or outside the mainstream. As Patricia White has argued, the "minor" quality of lesbian representation, complemented by the cinematic forms and outlets to which lesbian artists have frequently gravitated (shorts, experimental or documentary work, work on video, or small gauge film), lies productively outside the dominant cinema industry. And indeed, Hammer seems to draw creative energy from it. As White suggests, these types of works

> deploy a certain "poverty"—in terms of means of production or aesthetic approach—in order to deflect audience demand for familiar stories, happy endings, repeatable pleasures, identity assurances. Although such practices do not and should not circumscribe the field of audiovisual work by and about lesbians, they enact the intersection of authorship and audience, form and subject matter, and desire and identification in crucial ways.[7]

The intersection White addresses is precisely the space in which Hammer works: in her films she constructs a network connecting self and others, filmmaker and audience, subjective intentions and the objective image. Alongside White's assertion that certain minor cinema embraces the "insignificant" and prefers an unresolving "potential" over some of the traditions of narrative including a tendency toward closure, Hammer repositions the purview of filmic identification toward open ends. The center is a fairly narrow domain, with edges; the margins stretch out illimitably, especially if one does not limit

oneself to the confines of the page/frame. Similarly, as I have suggested in relation to the work of Maya Deren, this embrace of an alternative aesthetic approach tends to affirm themes and methods not typical in mainstream cinema, like incompletion, repetition, and fragmentation.[8] Such alternative approaches look and act differently, especially because they put difference into the spotlight. They are, in fact, no less valuable (far from it!) than hegemonic forms. As Clara Bradbury-Rance suggests, investigating these approaches is well served by oblique angles of inquiry.[9] In addition to reckoning with the problematic of visibility/invisibility of lesbians that Hammer's work addresses, they do not assert their value in the same way as other films, and they court different audiences.

Hammer's work is thus implicated in the relay of identity and identification by its *substantiation* of queer, minor, and apparitional concerns. That is, while it operates at the limits of conventional cinema, it multiplies the points of intersection with outside points of reference and aims to make those limits visible, legible, and meaningful. It invites and celebrates what is usually off screen on screen and challenges the power of precedent. As White's essay and Sophie Mayer's writings on new feminist film explore, the method of such work hews to a style and content that vigorously celebrates diversity, marginality, and a poverty of means in contrast with the forms of dominant cinemas.[10] It renegotiates the terms of women's bodies on screen, forming a connection with the women's bodies in the audience, off screen. It valorizes a radical approach and a feminist mode of filmmaking.

Finally, these early films cement Hammer's legacy, but cement is not an ideal medium for someone whose primary mode of operation is the restless exploration of form and content. The reputation of these early films in fact prompts her to create work that does not look like them or engage the same bodies—indeed, some are entirely body-less—in ensuing years. In short, several of these films are the esteemed but sometimes confining foundation Hammer's later work not only builds on but also struggles to move past. All the same, embedded within these works are many of the same concerns Hammer will take up later that are not confined to their representation of queer bodies. That is, the dynamics of these early films exceed what has become their reputation, once one looks more closely at their relation to Hammer's later work. Thus, this chapter considers the 1970s work according to what it accomplishes as a baseline for Hammer's queer cinema poetics, how it engages specific audiences, and how it connects to Hammer's larger oeuvre as an unfolding phenomenon.

I Was/I Am (1973)

An example of Hammer's approach during this period may be witnessed from multiple angles in *I Was/I Am*, completed while she was a master's student in film at

San Francisco State University. During the time just before and during her work on that degree, she made several films—by her count, thirteen—that were not made specifically for a class but that allowed Hammer to avail herself of the department's equipment and other resources (including cooperative crewing with other students on films). Her second film on 16 mm (after *A Gay Day*, 1973), *I Was/I Am*, was one of the few during this time that she noted was actually developed for a class, although like others made from 1970 to 1975, it rebels in specific ways against the constraints of any assignment she may have been following. The film reflects how she aimed to fashion herself as a film artist in a tradition of feminist ideas and an experimental film lineage, and it demonstrates her development as a filmmaker. Unfolding in a disjointed but richly imagistic manner, *I Was/I Am* employs multiple exposures, discontinuous editing, and experiments with the tools of cinema available to Hammer.[11] It also introduces a documentary element, which will become central to her aesthetic and mode later on. Here, that element serves to underline the film's feminist interests.

I Was/I Am begins with an extreme close-up of a pumpkin cavity—the seeds and stringy, stretched pulp presented as an alien, abstract landscape. The camera moves over this object at close range while in a similarly disorienting voice-over, Hammer's voice echoes with tinny sound as she stretches out the following words: "If I pick out a book of poems, I read *all* the Elizabeths, Carols, Dianes, and Barbaras—skipping John, James, Dougs, and Philips." In the middle of this line asserting her allegiance to female creative productivity, she cuts from the pumpkin interior to the hem of a white toga-type dress, panning up the body of the woman (herself) wearing it, matching the shots on camera motion. That is, she moves the camera from the bottom of the frame to the top, then after a cut, continues the same motion but in a new setting. Instead of matching on a specific action that continues from one shot to another and following a tradition of continuity editing, Hammer stretches the boundaries of the standard technique so as to generate surprising experiences of connection in time and place—creating an odd continuity based in the camera technique rather than the content shown.[12] The movement continues upward until it reaches Hammer's face, at which point she avows, "I was."

The film pays homage to Maya Deren's work, particularly her first film, *Meshes of the Afternoon* (1943). Hammer's film makes direct reference to several moments and the style of the earlier film while also queering its imagery. Holding opposites together—from the film's main theme of the simultaneous presence of past ("I was") and present (by the end of the film, she asserts: "I am") to here and there, up and down, dream and waking—is one of the key ways Hammer pays tribute to Deren.

Just as Deren cuts across disparate times and spaces in *Meshes of the Afternoon* and other films—for instance, Deren's figure in *Meshes* treads in close-up on multiple landscapes, from sand to sidewalk to living room, showing five steps edited together as if the spaces were continuous—Hammer generates connection among parts that otherwise do not conventionally belong together. She makes her interest in this type of connection explicit. Quoting Deren (mostly) later in the film, Hammer elaborates a notion of continuity within a single being's multiplicity: "Maya Deren says: Woman is not committed to the natural chronology of her experience. On the contrary, she has access to all her experience simultaneously."[13] A difference in Hammer's appropriation of Deren's words is that she substitutes "woman" for Deren's original "man" (in the sense of "humankind"). It is an important update for Hammer in that it asserts the primacy of the female point of view on this matter of temporal and spatial connection.[14]

I Was/I Am pays further homage to Deren's *Meshes of the Afternoon* with several shot setups, props, and themes that match Deren's film. For example, she walks slowly up steps, moves in slow motion and backward as she crosses a field, and hangs a mirror around her neck similar to the one that circulates in the place of an enigmatic figure's face in *Meshes*. During the sequence most clearly indebted to Deren's film in terms of its imagery, she climbs the stairs to a bedroom, where she installs herself and begins restlessly to toss in a bed, apparently dreaming. Her dream, however, is decidedly focused on female bodies: this shot cuts rapidly to images of another woman who creeps into the room to kiss her, cut with a loosely composited image wherein Hammer projects the footage of herself crossing a field in slow motion onto a woman's naked midriff such that her vagina is illuminated in a square of projector light. The female body, Deren's film, and the dynamics of the medium merge as the language of Hammer's entry into cinema as an art form.

While at San Francisco State, Hammer wrote a paper describing the relationship she intended for her film to have with *Meshes*. In it, she points to several similarities between the films and elaborates on Deren's impact on her developing aesthetic sensibility. Of the comparisons she makes between the films, Hammer singles out the self-contained symbology of both films. The symbols in each "stand for themselves" without importing other symbolic resonances from outside the film's "poetic-dream-drama sense"—they "refer to nothing outside the film."[15] Like Deren, Hammer railed against interpretations of her films that took the symbols as Freudian or surrealist rather than as part of the logic of the film itself. Further, Hammer highlights her experiments with rhythm in editing as a result of Deren's example, and she expresses a similarity in their sense of simultaneity: "that everything can and does happen at the same time."[16]

However, while Hammer's film follows a path laid out by Deren's work, there are also important differences: Hammer acknowledges her cinematic precedents while also forging into new territory. On a small scale, for instance, unlike Deren, Hammer is making reference to other films as well as her own dream logic. She has an interest in her place within a larger history of making moving images. Also, Hammer is less interested in the tools of sequentiality that Deren's film espouses both in theme (multiplying versions of the self that leads to a crisis) and in editing. In Deren's film, a key drops from her fingers over several shots and the whole scenario repeats, while Hammer cuts (and jump cuts) to entirely unexpected new objects, angles, and scenes. Hammer distinguishes her work as being less invested in couching stylistic "tricks" with narrative meanings. In *Meshes of the Afternoon*, the tube/funnel that signifies a narrowing of vision is tied to the protagonist falling to sleep; Hammer employs new techniques for different ends, such as "getting into and out of the film," rather than hewing to character motivation.

Most of all, while *Meshes of the Afternoon* operates in a deadly earnest register, Hammer's film is playful, campy, or even funny in the midst of its seriousness. After being "shot" by a man wearing a silver helmet, Hammer writhes on the ground making grotesque faces while wolves howl on the soundtrack and children's feet and bicycles circle her on the ground. The mirror that pays tribute to Deren's film dangles from her neck over Hammer's naked body; without clothes to encumber her, she moves around the space manically brushing her teeth, wearing naught but a tool belt on which hang a revolver and her metonymic hammer (figure 5). She pretends to type while the typewriter twists and hangs from the ceiling behind her. The circulation of symbolic objects here (gun, pumpkin, typewriter, X-ray, hammer, motorcycle, mirror, key) is no less robust than it is in *Meshes of the Afternoon* (knife, bread, phone, phonograph, mirror, key), but they play as Grand Guignol rather than noirish nightmare. In fact, Hammer has it both ways: she lays claim to a serious place in the history of experimental art cinema but does not deny herself fun along the way.

Near the end of the film, Hammer turns to address herself in a mirror: "Listen, lady. It's tough! And it all happened at a Halloween party." She proceeds to tell the story of being shot with a BB gun in the forehead, an event that actually happened to her and that she documents here not only by telling the story but also by displaying the X-ray of her visit to the campus clinic, which provides clear photographic evidence of the BB. Sharing this story provides a motivation for her feminist outrage; in this case, that the doctor she saw at the clinic was going to leave the BB in her head because she was a woman and would surely therefore object to the cosmetic consequences of removing it. Her foray into the story serves as one of several examples of how Hammer

Figure 5. *I Was/I Am* (Barbara Hammer, 1973)

thought of the film as documenting something important from her experience at the moment of making it. Not only does the film illustrate the biased treatment she received from the doctor but it also shows Hammer's very raw living conditions during this time, a fact she frequently remarked on in interviews:

> I was living in the basement of two gay men and I had no toilet. I had no stove, refrigerator, anything. And so I used to pee in a coffee can and empty it in the yard. . . . So, they didn't say, "Come up and use the toilets anytime, come up and use the shower." So I was sponge-bathing and hot-plating and that's where I made *I Was/I Am*. And if you look at it, you'll see a typewriter—you'll see me nude, with a hammer in my belt, nude with a belt. And maybe I have Frye boots on. And then my typewriter is hanging from the ceiling, spinning around. And I am typing in the air. Because I'm working on my script. . . . And that's in my basement apartment. So, if you look you'll see—it didn't have even plywood on the walls, so you saw the 2 x 4s around.[17]

Hammer acknowledges the importance of the character of her work and living space for her whole career, including during the 1970s, and a film like *I Was/I Am* is testimony to that character shaping her work in look and practice.

Finally, another documentary element that combines the feminist and personal experience of the moment occurs in final shots of the film, when the man who earlier in the film shot her appears on a ledge in the hills, cockily pointing and saying, "She's got a million-dollar ass." His line prompts Hammer's character, hidden on a ledge above him, to leap down, pulling a plastic sheet over him. The next shot shows a body fully tied up in the sheet tumbling down the hill. That character was a man in Hammer's film class whom she charged with making sexist statements and films. He had directed her to film women in a way she perceived as offensive when she served as the cinematographer for one of his film projects for the class. He made her so angry she considered opening the back of the camera to expose his film. Instead, she decided to commemorate his bigoted character for posterity in her film. And there he remains to this day.

At the end, the film cuts to the wheel of Hammer's motorcycle. With another upward movement of the camera—the film's moving motif—it reveals Hammer seated behind the wheel. She takes a key out of her mouth (à la *Meshes of the Afternoon*) and shouts, "I am!" Bookended by the past and present, the film charts a journey from victimhood (Hammer writhing on the sidewalk) to empowerment (bagging the bigot). The title's collapse of "I Was/I Am" puts those two qualities into a position of simultaneity, so that Hammer is both at once. The last shots are black leader with "Agressa" scratched into several frames; she scratches the emulsion of the film to imprint her alter ego/pseudonym in the same way Stan Brakhage does at the end of his films.[18] Thus in *I Was/I Am*, she demands an equal place in experimental film histories while also calling attention to the medium of film, insisting on female power over male aggressors, and asserting a new, flexible film language unique to her vision.

Lesbian Bodies, Queer Experimental Pioneer

During her time at San Francisco State University, Hammer made several films in addition to *I Was/I Am*, most of them outside of the classroom. There she found a group of supportive collaborators as well as an audience for the work she accomplished. Two of the films that have received a lot of attention in her oeuvre, *Menses* and *Dyketactics*, were made in this context in 1974. Both emphasize the experiences of women, and both demonstrate the unique production processes and aims of a feminist, personal cinema as envisioned by Hammer during her years in film school.

In *Menses*, Hammer demystifies the "lace and daisies and muted whispers" that accompanied "so-called educational films shown to pre-pubescent girls in the closed-off walls of a hushed and secret auditorium."[19] By her account, the film was made quickly after gathering thirteen women together for a slumber party to share their stories and

feelings about menstruation. Hammer recounts that using a "non-hierarchical method of working . . . peculiar to feminism," each woman wrote a scenario for her part, so there would be "no separation between scriptwriter and actor," and the personal nature of each part would be "universally accessible to all women."[20] Filmed outside a Payless drug store and in Tilden Park in Berkeley, California, *Menses* features this collective of women conducting mock rituals related to menstruation, including a reference to the ritual of taking the Eucharist, substituting the wafer/body of Christ for a codeine tablet and the wine/blood of Christ for a goblet of fake menstrual blood. They bring a social taboo specific to women's bodies—something only mentioned in hushed school auditoriums—out into the open.

The sound and images of the film poke fun at this taboo. The film begins with a long shot of eight women in a park. They stand, naked and looking toward the camera, each with a single white egg between their legs. The film cuts in close to the "v" shape of one woman's vagina, and the camera pans over several of the women before compositing the images so that it becomes a mélange of women's vaginas and eggs between legs. A woman's voice asserts: "it's ecologically resourceful to menstruate," and another woman's voice (Hammer's), dreamily and with a lot of reverberation and overlap, begins to intone "Menses, menses, menses. . . ." The film cuts to a single woman's body from her waist down to her feet; she lets an egg drop from between her legs. There is a cut to a close-up of the egg, now with red liquid poured over it. Hammer cuts back to the eight women standing looking at the camera. They all let their eggs drop. She makes the symbolic aspects of menstruation literal, large, and communal: what is usually hidden is overt and baldly dramatized, and women—for whom menstruation demands attention on a regular, repeating basis—are foregrounded as the center and source of this fact of life.

Both serious and silly, *Menses* celebrates and denigrates menstruation. As to celebration: it brings an aspect of female experience to light, normalizing and demystifying it. As to denigration, as Hammer recalls, the initiating discussion of the topic of menstruation with her collaborators centered on the idea that it "was no fun. It was discomfort." She goes on to say that in the film, the portrayal of the topic is "exhibitionistic and free and wild," undoing the secrecy and shame of women's bodies that keep them out of the public eye.[21] The women cavort in the park or they leave the drug store balancing towers of feminine products in their arms or swinging tampons around. In both spaces, the camera frequently shows the women in collective groups but also offers shots of a single person executing an action. For instance, a short sequence shows one woman standing in the park, naked. She looks down, and the camera follows her look. Beneath her, there is a white cloth, and a red liquid drips onto it from her body.

(Hammer superimposes a close-up of an egg being flooded with a watery red liquid to suggest the action of blood flow.) The camera tracks in for a close view of red droplets falling on the white cloth between the woman's legs. Then the cloth is whipped away from the ground and the camera swings in a blur of motion to the woman walking away with the cloth wrapped around her shoulders. She whisks the cloth away from her naked body, defiant, holds it above her head, swings it around and turns, angrily flashing and shaking it around her and at the camera. Part of the group before this point, she is now a focus with a minidrama to play out on her own. The members of the community are also individuals with personal stories to tell. The final shot of the film shows the women gathered together again, leaving the drug store with a cart full of feminine hygiene products, arm in arm, smiling as they walk toward the camera. However they experience menstruation individually, that process also connects them as a community of women across times and places.

The film is also notable for Hammer's experimentation with the editing of these sequences. In particular, she uses superimposition, dissolves, and composite shots to elaborate the tensions inherent in the individual/collective on the level of the actors and actions, or the personal/universal on the level of the film's themes. At the end of the Eucharist sequence, we see one of the women drinking red liquid from the goblet; she lets it spill from her chin down her body. The camera tilts to follow the liquid to her lap, at which point a dissolve and graphic match shows the same part of the body in the same dimensions and position within the frame. Only now she is clothed, with a sanitary pad and belt over a short dress. The camera pulls back to show that we have switched to a new woman, who struggles with the belt. She stomps her feet at something on the ground, which prompts a cut to show the object of her action: a package of sanitary pads. In slow motion she crushes them with her brown, chunky shoes. There is a match on action as she kicks at the pads; in the next shot, they go flying from the motion of the kick into the next sequence back at the drug store, where a woman picks up a package of pads she has dropped. The relay of women engaged in similar actions across spaces and time shows the universal quality of menstruation while also articulating personal interactions related to it.

These editing techniques are also mobilized to show something similar to what we saw in I Was/I Am's collapse of lived time within one person. In one sequence of shots, she makes short, quick jump cuts of a woman washing herself with a sponge around her vagina and legs (framed in a medium shot from belly to knees); her action is doubled and repetitive to underscore the recursive structure of menses for a single person in her lifetime. Repetition also characterizes the two tracks of sound in the film: we hear a woman recounting how when she first started menstruating, she thought she

was "dying, dying, dying, dying . . ." Her story is punctuated with a voice repeating a series of words related to the theme: "menses, moon, month, moon, menses." Repeated words and patterns lend it a rhythm akin in form to the subject of the film.

Menses's treatment of its subject matter in its editing, repetitions, and as Hammer put it, "love of exaggeration" puts it in the territory of camp. Reading it in relation to the notion of camp highlights the playfulness in Hammer's aesthetic. Susan Sontag's "Notes on Camp" underlines the "playful, anti-serious" and "exaggerated" quality of an artwork in a camp mode; it is "generous. It wants to enjoy." Sontag also, however, designates camp as an aesthetic category that is therefore "disengaged, depoliticized—or at least apolitical," which does not sufficiently accommodate Hammer's intentions in making films that intentionally foreground female experience and raise awareness about that experience.[22] Even so, Hammer described this film as "quickly edited, playfully shot . . . and appreciated by a wide audience,"[23] and she thought of it as less autobiographical than her other work of this time as well as less political in intention. In its exaggerations, sense of community, and irreverence, it fits in well with Sontag's idea that camp "relishes, rather than judges." Further, as Pamela Robertson has argued in relation to feminist camp, it "blurs the line between the seemingly distinct categories of production and reception,"[24] such that both the film text and the audience reading it potentially initiate its camp effects. In *Menses*, Hammer similarly blurs such positions by working behind and in front of the camera and by collaborating with actors in the film who parallel her intended audience. In her balance of elements of seriousness and play, use of images of community and individuality, and overall content and experimental form, Hammer mobilizes a strategy for exploring female experience here that looks similar to the film that brought her the greatest renown, *Dyketactics*, made the same year. In that similarity, we see her development of a personal ethos and aesthetic.

Dyketactics (1974) aims to capture other aspects of women's experience. Driving out to the countryside with a group of women, Hammer filmed and was filmed by them partaking in an experience of nature and each other. The first part comprises a series of images of women outdoors, cavorting in the nude and engaging in rituals of community and sensuality (for example, one woman washes another woman's hair). The film announces its title in the first shot, as someone thickly brushes the word "DYKETACTICS" in white paint on a gray wall. Over the next minute and a half, the film runs through a series of superimpositions so that with the exception of the first shot, all of the first half of the film is composed of composite images of these women together. Making this series of composited images involved a great deal of imagination on Hammer's part. In addition to the sensuous content of the film, the specific tools of cinema—still relatively new to Hammer—are deftly mobilized in service of sensation,

particularly invoking rhythm and texture. Using four rolls of film (an A, B, C, and D roll), she used contact printing in the editing stage to merge two or more of her rolls' images, creating an undulating rhythm for what appears on screen (figures 6, 7).[25] The aim of her labors is to highlight elements of touch and sensation. Hammer described her process in a paper written for her master's degree in film at San Francisco State:

> I began to cut short pieces of action and put them together kinesthetically by images of touch. A woman combing hair, eating an apple, cleaning seeds from a cantaloupe, washing, touching feet to ground in dance, climbing, digging, stroking, bathing. Cut to touch. Cut to quick. See if it works. From 1200 feet of workprint the first two minutes of *Dyketactics* emerged. It was so fast, the images dense and overlaid, it was becoming a California film, a lesbian commercial.[26]

The dynamism of the images emerges in the intersection of multiple shots happening at once and blending into one another, with one dropping out and others switching in, to generate new combinations of images from four reels of film, which Hammer alternated by checkerboarding her four reels.[27] That is, Hammer took four rolls of film and edited each one with different images as well as occasionally black leader (so that this roll would not register an image at that moment), measured them out and aligned them, then had the lab process them all together, reducing the light as needed so each one could come through as semitransparent. There is an element both of the random (she could not know exactly how the final film would look) *and* of the exacting and meticulous in this process. Compositing the image in this way increases the number of images available to the spectator at any given moment in the film, and it allows Hammer a chance to generate a doubly mobile cinema such that for each frame, two, three, or four images are moving on their own and in relation to each other.

The imagery also focuses on positive sensations: women are naked and lie on the ground, they light candles while huddled together on their haunches, they walk across fields, they leap and cavort. Little lizards slowly climb over naked, sun-dappled backs. The women look as if they are recreating a Matisse painting, reaching their hands out in a semicircle. In one moment early in the film, Hammer lies on the ground, naked and sunbathing, then gets up and leaps. The film cuts to her rising again, now clad in jeans, alone, performing the same action. She matches the cut on her action of rising, and through overlapping editing and the repetitions of the movement, the film presents boundless energy constantly on the rise.

Figures 6, 7. *Dyketactics* (1974). Syncing A, B, C, and D rolls

Dyketactics is deliberate in its emphasis on touch; for Hammer, "every image in the film has a sense of touch about it . . . there are all kinds of skin aesthetics in the film."[28] She frequently commented on the fact that at the time she made it, she was interested in activating her audience through this sense. She noted:

> Reading Ashley Montagu's *Touching*—from 1971, and the only book I could find then on the sense of touch, which seems scandalous now—I learned that the area of the brain related to touch is much larger than that for sight or sound. I wanted the audience to be embraced, as if they felt their hands or bodies moving across the screen, connecting touch with the images. I want the audience to feel in their bodies what they see on the screen.[29]

In the first half of the film, a sense of touch is evoked not only in the specific images—for example, the scurry of a lizard on a naked back—but also in the structure of the film's overlapping images. As Laura Marks has argued, one way for a filmmaker to engage a "haptic cinema," one attentive to the sense of touch, is to "multiply points of visual contact all over the screen" and to foreground the surface of the image rather than its depths into which one might immerse oneself.[30] Hammer does both in *Dyketactics*. Superimposing multiple images and weaving the film strips into patterns of what is visible and what disappears, Hammer presses the surface of the image into conscious feeling. Within the first part of the film, the "touch" Hammer invoked may in the end have less to do with that sense being depicted than it does to a relationship between the film and its spectator, whose body becomes engaged with the film in a system of exchange, even "erotics."

The second part of the film moves indoors to show two woman having sex. The movement into the second part is marked by a fade to orange (and, briefly, black); the sequence of superimpositions and dissolves ceases and the sense of movement in the space between shots is replaced by dynamic cuts of direct action. For Hammer, by changing from a multiple to a single image series, the second part of the film "emphasiz[es] the reality of explicit sensuality of women loving," underlining the intimacy of two women (one of whom is played by Hammer herself) making love. Hammer notes that the impetus for the film came from "the new sensations and experiences of same-sex love" that she was in the process of discovering after coming out while her marriage dissolved.[31] The film details this sensation of striking out into new territory. Explicit depiction of lesbian sex is accomplished through a series of short shots. Two women, fully dressed, are together on the floor. One climbs on top of the other and the camera cuts to a closer view as they kiss. In brief but unhurried flashes,

they remove clothing, roll and twist together on the floor, touch and explore each other with hands and tongues, rub legs and arms together, kiss and stroke and brush skin. There are several close-ups of breasts, nipples, legs, arms, faces, and vaginas, and everything is bathed in the warm yellow sunlight coming down from the windows. Sensation comes to the foreground. In two minutes, the audience is privy to and implicated in this representation of tender intimacy acted by the two women.

The camera takes a sensuous part in the action as well, as Hammer asked that the cameraperson come very close and "stroke and adore us as if she were caressing us with the camera."[32] Almost none of the shots in this second half of the film is without camera movement (those that eschew camera movement place emphasis instead on the movement of the women touching more intimately and closer to the camera). Like Maya Deren's *Study in Choreography for Camera* (1945), the camera plays a role in the action performed (for Deren's film: choreography/dance; for Hammer's: intimate touch/sex). Touch is not just the key sense here, but a feminist tactic. Hammer subtracts the voyeuristic qualities of the film's image of women's bodies by making the cameraperson a participant, expanding the dimensions in which the sense of touch is cued. A relay from the people filmed to the person filming to the people watching the film extends the sensation across the boundaries of mise-en-scène, camera, screen, and audience. This quality of inclusion underlines other approaches adopted by women making experimental films. As Jennifer Barker has observed of another film featuring the filmmaker making love on screen, Carolee Schneemann's *Fuses* (1967), such a film "invites us not only to consider from a distance the film's feminist celebration of female desire but also, and more important, to partake in it." Citing Laura Marks's work, Barker reflects on the emphasis on touch as a feminist strategy, allowing access where it might otherwise be denied.[33] This strategy has an equality of participation that Hammer uses to re-balance power traditionally denied a woman on film as the "to-be-looked-at" object of sexual attention.[34]

With its overt lesbian lovemaking, *Dyketactics* garnered Hammer the distinction of pioneering such representation in experimental film. Undoubtedly, a key aim of Hammer's work was to bring aspects of women's experience that had been denied a place in the history of cinema into the light. Hammer's films in the ensuing years of the 1970s confirm this, *Multiple Orgasm* (1976) perhaps more than others. *Multiple Orgasm* superimposes two sets of images through most of its length: rocky mesas and bluffs alongside either an extreme close-up of a vagina being caressed or a close-up of the ecstatic face of a woman (Hammer). It puts the natural, rocky formations into counterpoint with the woman's anatomy and pleasure, combining moving shots with still and varying the transparency of either image so that one comes more to the

foreground or fades to the background.[35] At one moment, the camera moves through an open circle of sky seen through a rock formation so that the face of the woman has an empty background and appears clear without a superimposition to distract attention. The alternating attention to the surface and depth of the image, to its multiplicity or its singularity brings the spectator into and out of immersion with what is imaged as the film unfolds.

Hammer long indulged an impulse to bring unapologetic images of women's experiences—including women's sexual pleasure—to an audience. Her depictions of women's bodies seemed to some to be pornographic, and on several occasions she had to try to convince those who would censor her work that it was not.[36] Asserting a simultaneously more universal and personal impetus, Hammer claimed she was simply seeking "to satisfy the latent images of women's consciousness lost to culture and to express myself personally."[37] Meanwhile, as was the case for the whole of her career, radical inclusive representation was for Hammer's work simply a piece of a puzzle—perhaps a corner piece, but all the same—composed of multiple interests. Her work during the 1970s as a whole tended to bring marginalized and/or personal subjects to the screen.

A marginalized and personal subject became the center of Hammer's film *Jane Brakhage*, completed in 1974, shortly before she finished film school. As its name suggests, it concerns Jane Brakhage, then the wife of well-established experimental filmmaker Stan Brakhage. Hammer appreciated Stan Brakhage's work, going so far as to attribute seeing his *Dog Star Man* with her initiation into "seeing the world cinematically."[38] She met the Brakhages when they came to San Francisco for a screening arranged by filmmaker, poet, and professor James Broughton, whose class Hammer took. Hammer volunteered to pick them up at the airport and was immediately curious about and taken with Jane. The film offers a portrait of a woman whom Hammer admired and yet who had chosen a life similar to that which Hammer had abandoned: it both valorizes and subtly critiques Jane, but ultimately it keeps an aesthetic distance in order to accomplish a range of cinematic aims. While she aspired to the same work ethic and bravado as Stan Brakhage, for her film she instead quietly homed in on Jane Brakhage, on her personality and way of interacting with the world, allowing her a voice and to shape her own representation in a way Hammer perceived she had been denied in her husband's films that had featured her, particularly the films in which she gave birth to their children. Never short of ideas or energy, Hammer traveled to Colorado to meet with and film Jane, feeling she had found a fascinating subject. Although it required some extra justifications on Hammer's part to be accepted as such, it became her thesis film.[39]

One of the main sources of inspiration for Hammer was Jane's relationship to nature. Living among animals and the wilderness in the mountains in Colorado, Jane talked of the intelligence and vitality of the natural world. As Jennifer Peterson details in her incisive reading of the film, *Jane Brakhage* focuses on Jane's (and Hammer's) complex relationship to nature and expresses "posthuman feminist thinking," a crucial dimension both of this film and of Hammer's oeuvre overall.[40] With nonsynchronized sound, still images, and many-layered footage of Jane, Hammer pursues an eclectic approach to her topic that is echoed by Jane's own eclectic approach to her life and interests. For instance, Hammer's copy of Jane's "Bird Journal: Being a Hopeful Journal of Relations with Birds and Studies of Them," which includes sketches, quotes from poetry, and observations about her experiments with attracting and observing birds, finds its way into the film. Moreover, Hammer's emphasis on close views of Jane's hands touching branches and feeding birds or weaving continues her passion for finding ways to depict sensation as a key to a woman's experience and means for understanding the world (figure 8). In all of these ways, *Jane Brakhage* illustrates Hammer's continued interest in presenting the complexity and intelligence of women, an empathic treatment of her subjects, and different approaches in her work to documenting an elusive, complex subject. Indeed, one of the running themes of the film is the difficulty of naming,

Figure 8. Close-up and sensation in *Jane Brakhage* (1974)

which reflects the way such lived complexity eludes labels. When Hammer asks her whether she considers herself a housewife, Jane's answer bears a kinship with Hammer's approach to artistic matters: that it's "a great form" and she can "do what [she] want[s] with it." An urge to document complex people and ideas combines with her own experimental aesthetics as Hammer's work continues in the upcoming decades.

In the mid-1970s, Hammer was particularly prolific; her activity did not relent when she graduated. This period includes several films that flesh out Hammer's multiple interests in sensation, lesbian visibility and experience, and feminist activism, explored through the tools of experimental, poetic, and documentary modes of cinema. As she came to the end of her time in film school, in films like *Psychosynthesis* and *Superdyke* (both made in 1975), Hammer continued exploring similar themes but in radically different ways. While *Superdyke* primarily depicts joyous and communal lesbian experience—one kind of invisibility rendered visible—*Psychosynthesis* focuses on a different kind of experience and visibility: it makes visible what Hammer calls the four latent parts of her subpersonality. Taking herself as subject, Hammer plumbs her own depths to think through the stages of her life and the artistic calling to which she devoted herself.

Hammer encountered the idea of psychosynthesis through her interest in Carl Jung. Psychosynthesis is a psychological theory elaborated by Roberto Assagioli, which maintains that in order to thrive, one must contend with the multiple components of personality and experiences and strive toward the creation of a "harmonious integration," a unified Self.[41] Hammer's film announces its relationship to that aim from the very first: "*Psychosynthesis* is a film of Gestalt fantasy work, uniting my subpersonalities of baby, athlete, witch, and artist." All these personalities are pictured in the film, and aside from a baby cast to serve as Hammer, she plays them all in various guises (in fact, the film also includes baby pictures of Hammer, so she plays that part in a way as well). The personalities interact directly (for example, athlete picks up baby) or are superimposed over each other to create a visual connection that also reflects their simultaneity within the person of Hammer. The film, wrought by the "artist" part of the personality, serves as an expression of the simultaneous presence of multiple parts of the self and the effort to bring them together into that "harmonious integration."

The first image, which accompanies Hammer's announcement about Gestalt fantasy, blends three distinct images, each bearing a relation to the others: a woman driving a car, the reflections of the trees in the windshield as she travels, and a woman's bare breast on which are stuck the colorful magnet letters of the alphabet one might have found on a refrigerator in 1975, spelling out "Psychosynthesis." One person drives, but the other subpersonalities are also already in the car, synthesized in the multiple but unified image planes. Multiplicity is key not only to the theme but also to the technique of the film. As

in *Contribution to Light*, Hammer delights in the capacity for a single image to be multiple by emphasizing its angles, reflections, or shadows of things in or out of the frame. She also underlines the artist's ability to double the image through superimpositions. For the whole film, composite images are the rule; further, rather than the compositing of full, undistorted images that characterizes *Dyketactics*, many of the images in *Psychosynthesis* are doubled *and* bent down the middle of the screen (much like the folding Bolshoi Theater at the end of Dziga Vertov's *Man with the Movie Camera*). The double images perform a kaleidoscope of movement, expressive of the protagonist-artist's mobile psyche. While it only runs for six minutes total, the film is jam-packed with layers.

The soundtrack likewise offers a kaleidoscopic variety of voices, many of which are similarly distorted. The witch laughs, the baby cries, the sound of heartbeats and breath accompany the jogging athlete. Other voices are channeled through the protagonist, so that for instance her mother's voice (spoken by Hammer with a different intonation) is overlaid with the other inner voices: "Come down the steps, Barbie, like the movie star you're meant to be! Take drama lessons! Tap dance!" Carnival music accords with images of a merry-go-round that occasionally flash by, or it operates in counterpoint to other, less amusement-oriented images. A woman screams. The supersonic, very loud sound of aircraft emerges in tandem with images of Hammer stalking around bushes with a camera. Meanwhile, the artist puts it all together and contributes her own sonic demand by insisting on more "Energy! Energy! Energy!"

The film provides this energy in spades; with rapid cuts, multiple colors and superimpositions, and manipulations of the images and sounds, it is a veritable cacophony. She takes a conglomeration of things and processes them through creative form and technical experimentation, such that the artist part of her personality is in ultimate charge of the show. It is a vivid, kinetic aesthetic. In its images it runs the gamut from sacred to profane; there are stained glass windows depicting Saint Barbara with sword ablaze and images of a naked woman (Hammer) dressed in a white wig, sassy and cackling like a witch while masturbating with a rod. In between, there is a variety of representations of the other parts of the personality suggested by Hammer at the beginning. For example, the athlete runs (taken from a variety of angles) while Hammer meditatively intones: "and so, this year, I run the beat of my measure . . . down the clothesline track of my mind." Breathing deeply, she continues: "Four in, four out. Four in, four out. Counting my body into streams of energy currents." A clothesline appears, which then becomes two clotheslines, and then Hammer bends them in a double image, making abstract lines of connection.

There are multiple superimpositions of the same action of Hammer exiting a house, such that there is a blur of activity moving from inside to outside, from private to

public. These images use an array of camera and editing techniques. For instance, an extreme close-up of the bespectacled eyes of "the artist" is superimposed over Hammer walking out the door in long shot in the guise of a witch or in a blue track suit. These images might be superimposed over the baby crawling while the witch exits the door at the same position as the athlete had just done. The soundtrack runs in counterpoint to the image (so that we see the baby while hearing the witch, for example). While the images are an assault on the senses, Hammer deftly works to merge and ultimately unify these representations of different aspects of the self—through superimposition, match on action, graphic matches, and multiple soundtrack layers.

Superdyke, made later the same year, takes a different approach to self-expression. It features Hammer and several other women (and girls) funning around San Francisco while wearing lemon-yellow tank tops that read "Superdyke." They march around the streets and parks holding handmade shields that read "Amazon"; they ride a bus decorated with a banner reading "Lesbian Express"; they come to the rescue of a fallen friend; they laugh and hug and kiss and read lesbian literature; they jostle through the crowd and dance in the street; they ride motorcycles; they go to a museum displaying lesbian erotica and observe (and imitate) representations of women with whom they can identify; they go to Macy's and play with vibrators; they do archery in the park; they massage each other and are intimate and naked together. In the film, there are some of the same technical devices and inventive angles (for example, some clever upside-down shots), but the emphasis is on depicting this range of happenings featuring lesbians in and around town and out in nature. Interestingly, Hammer has commented on the fact that she was surprised by the attention the film received, considering it an "entertainment" rather than part of the efforts at film art that comprised much of her oeuvre.[42] All the same, it lays bare the commitment Hammer made to representation of lesbian bodies and activities. It also offers a positive, homosocial and localized engagement with the community of which Hammer was a part and that served as her primary audience at the time. To reach those audiences and provide them with a mirror for their lives, their lived experiences, and their embodied sensations were some of the strongest motivating forces behind Hammer's earliest work.

Radical Form for Radical Content

Expanding the emphasis on representation in *Superdyke*, *Women I Love* from 1976 demonstrates Hammer's developing aesthetic. *Women I Love* is composed of footage of several of Hammer's friends/lovers, which she edits together to create a prismatic, collective portrait. In organizing the work categorically (*here are women I love*), she puts the multiple subjects of the film on equal ground, shaped by her own perspective.

Perhaps drawing on her admiration for the idea that Stan Brakhage carried his camera wherever he went, Hammer frequently filmed even when she was not working on a specific project. About the raw material for *Women I Love*, she claimed: "Over the years I collected this footage, never intending to use it in a public film; thus the highly subjective, emotional, loving quality of the lesbian relationships portrayed."[43] While most of the film exhibits intimate moments with these women, Hammer also juxtaposes their representations with images of the natural world. In the film's pre-title introduction, Hammer films lettuces, cauliflower, and other plants in extreme close-up, which begin as de-familiarizingly close, closed buds. Hammer draws back and the images open out so that we see the plants in the context of their unique, enveloping configurations of leaves. Later in the film, Hammer presents the vegetation in stop-motion animation, giving life to these static objects. In all cases, the pattern reveals a movement from the center spanning outward, a trajectory decidedly nonlinear, one that pushes outward into an expanding space beyond the core and often out to the edge of the frame (figure 9). Throughout the film, shots featuring cut flowers, plants, gardening, and the out-of-doors commingle with the women Hammer loves.[44]

Not surprisingly, this correlating of women and flora—particularly because of the film's suggestive juxtapositions of the two (for example, a woman buries her face in a

Figure 9. Plants stretching out to frame edges in *Women I Love* (1976)

vagina; another woman buries her nose in a daffodil, a flower the film showed a moment earlier in a speculum)—led to the charge that Hammer held an essentialist view of women, most basically by associating women with nature and a universal feminine "essence" rather than depicting them as empowered agents of their own destinies. In *Jump Cut* in the early 1980s, Andrea Weiss further charged the film with naivete not only because of this content but also because it overrode formal elements; she admonished Hammer for "opt[ing] for what she would like to be an intuitive, feminine, and emotional approach to film, with an emphasis on subjective content rather than on structure and form" and for failing to reject the "notions of romantic love" that adhere to patriarchal norms.[45] In short, Weiss denigrated the film's representations of women, which cannot escape the traps, outlined by feminist film theory, that the apparatus of cinema metes out on women as subjects of films and as their spectators.

Women I Love is one of the primary examples detractors point to when they have charged Hammer with essentialism, something that Hammer grappled with from around this time forward. She worried that this characterization of her work in the 1970s prevented her entry into larger art circles.[46] However, she also pushed back against such critique from the beginning, noting in a 1977 journal, for instance, her aim to represent positive aspects of female representation and creativity, including her own: "as a woman I am particularly concerned with changing the phenomenon of 'who and what a woman is.' I want the borders to stretch as high as our imagination, to push the limits to allow all our energies, every conceivable form and manner of expression to be ours."[47] She presses against those borders in the film. For instance, *Women I Love* presents a panoply of women in episodic scenes rather than a single vision of femaleness. Hammer's film is not concerned with progression. Instead, it presents an array of women—younger and older, naked and clothed, delicate and hardy—suggesting through its categorical form a variegated collection, a bounty of lovable people of all measures. What is more, the film doesn't seem to suggest that this collection has limits.[48]

Nature as a touchstone also transcends its sometime association with the women. The two key sequences featuring plant life are first, the pulling out from the close views of the centers of the plants to the edges of the frame and second, the stop-motion shots just a bit later in the film. These are separated from and devoid of images of the women. While scenes with the women—particularly the sequence with Max Almy depicting ways of looking at daffodils (run through the dishwasher, placed in pockets or speculums, discovered and tested with the tongue in the garden, and so forth)—are implicated with natural elements, the main representatives of the vegetable world are juxtaposed against rather than conflated with the women. Moreover, as Peterson notes

for Hammer's work more broadly, one might do well to pause before dismissing the value of the natural in the current rethinking of "accelerating forms of ecological collapse in the Anthropocene."[49] Repositioning the work's disposition toward nature and its "potentialities for feminism" through its relationship to environmental thought, Peterson extends Greg Youmans's valuable research on Hammer's 1970s films, which challenges the way essentialism has been read within her work. Youmans argues the need for a reassessment of Hammer's relationship to essentialist thought in terms of its *performativity*—part of its method of presentation—which wills into being a world where images of women in states of nature do more than naively figure femaleness but instead imagine queer, utopic ways of being before those ways yet exist.[50] Hammer's playfulness, her constant reference to the making of the film (again we see her filming within the film), and the overriding sense that she is documenting joyous moments of communal discovery contribute to the layers of performativity that Youmans suggests nuance and temper the reading of Hammer's essentialist leanings.

The rift between a body-/nature-centric aesthetic and political stances in the 1970s happens especially in the wake of late 1960s politicized "radical feminism." Afterward, in the 1980s, the focus shifts to an emphasis on form and structure, which was the upshot of distrust of the structures of the cinematic apparatus that disproportionately denigrated women. Those like Weiss who played the role of, in Judith Mayne's words, "essentialism detectors" dismissed what amounted to a focus on bodies as naive at best and dangerous to a feminist agenda at worst.[51] Those filmmakers who held what were perceived to be anti-essentialist positions and put theory at the forefront of their filmic work tended to survive the 1970s and 1980s, which were so formative for setting a feminist agenda, while those like Hammer deemed to be part of the essentialist camp were dismissed. As Alexandra Juhasz has suggested, if a filmmaker did not proffer "images focused on how such a [female] body and sexuality [came] to be known through the representational systems of culture," it was dismissed or derided by the academy.[52]

The charge of essentialism was furthered by Hammer's production during the same period of several "goddess" films, including *Moon Goddess* (1976) and *The Great Goddess* (1977), for which she also drew on natural settings and imagery. In these films featuring women performing various rituals in nature, Hammer explored what she called a "spiritual connection to life and to breath and to the exterior world—and to people."[53] As Peterson notes, these connections between women, sexuality, and nature were broadly popular at the time "as part of the larger countercultural myth of nature in the 1960s and 1970s."[54] In *Moon Goddess*, a woman spins, walking bare breasted through rocky hills; the camera follows her across rocky terrain. Like other films of this period, we are offered glimpses of bodies and shadows on the ground,

suggesting figures rather than showing them outright. Although there is nudity, the images have little specifically to do with lesbian self-expression. In *The Great Goddess*, from the following year, Hammer shows all ages of naked women and young girls following a spiral outline burrowed into the sand on a beach toward its center. In the middle is a chair. A woman and child sit. They disappear. A single chime on the soundtrack announces the mystical qualities of the actions being performed. Like *Women I Love*, the goddess films navigate nature and women just at the moment when women as subjects and artists are under scrutiny for the type of feminism they represent. Her work highlighting these elements has been diminished by associating them with a taint of a new age, community-oriented, and yet ultimately self-expressive ethos. As Thomas Waugh puts it, Hammer's films "have a Berkeley spirituality to them, even at her most carnal moments. . . . Maybe it comes from her habit of linking eros to nature, whether it's the garden or the desert with all their iconographic associations in our culture; maybe it's the presence of a visible lesbian community throughout her films, the pervasiveness of sisterhood for all her obsessive egotistical sublime."[55]

While Hammer's work was seen as insufficiently form-conscious because it did not seem to critique the forms it adopted, whether cinematically, in terms of highlighting form over content, or socially, in terms of distancing itself sufficiently from the patriarchal dynamics of romantic relationships, it nevertheless did radicalize its form, just differently (and positively). In addition to presenting its details in simultaneous terms—its unifying title signifying the many variations of women Hammer loves in the present tense of the film[56]—*Women I Love* also delights in a range of possibilities for the film's form, refusing to commit (just as with these lovers and friends) to just one. For instance, in the movement from interior, strange buds to knowable, familiar plants effected by the camera (and then the inverse as fruits and vegetables are arranged into patterns in the later plant sequences), Hammer's film suggests that the camera can make the nature of such objects legible. These movements also run opposite to how identification and subjectivity are often represented in films with the camera's push in to a close-up on the face. Patrick Keating has credited such dolly-in movements with serving as "a powerful tool of emotional emphasis."[57] In *Women I Love*, however, they are used inversely and for precisely the opposite effect of holding emotional investment at bay. In this, the film's devices are akin to the use of discontinuous continuity editing in Maya Deren's films; they marshal the language of the cinema to tell another kind of story *through* form.

Parallel to this reimagining of the uses for cinema's tools, Youmans's taking up of the term *performative* for a film like *Women I Love* is apt; it underlines how such films mobilize "play acting" to access the "'realizing' aspects of gay and lesbian film

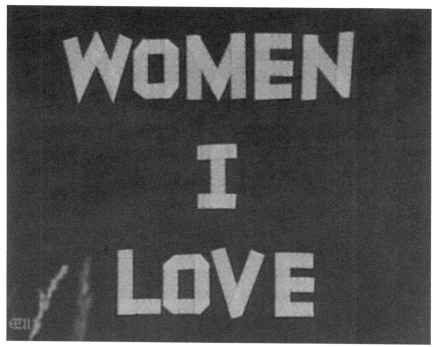

Figure 10. Names in celluloid: *Women I Love* (1976)

performance," which allow the players in such films to "[succeed] in realizing new selves."[58] Moreover, Hammer's movement away from a more conventional way of being less than a decade before this film suggests the need for such reimaginings through the film's associations. For instance, as in some of her later films, Hammer conflates herself with the film itself by rendering her name and the title of the film in white film leader; she and the product of her creativity are made of the fabric (or rather, the celluloid) of the film (figure 10). That the words are forged of film blurs the literal facts of (the) film and what they/it/she represent/s. She rewrites *herself* using the medium-specific language of her primary art form.

In the name of recuperating such images against a history that would erase all traces of queer women, intimacy on female terms, and sexuality that doesn't specifically court voyeurism, Hammer asserted the need to document and embrace a wider range of images of women than had to that point been the norm. In these aims, her work may include but is significantly more expansive than a label of essentialism would allow. Reflecting on the films she had made thus far by the end of the decade, Hammer noted: "Woman must write woman. Woman must film woman. Any censorship, any confusion of sexuality and pornography, any fear to treat the taboo topic, to not claim

our bodies ourselves, will further the silence of one half of the peoples of the world, will inhibit, and worse, prohibit our species' liberation."[59] Her work expands queer representation and sparks original forms for its expression.

Throughout the 1970s, Hammer considered how one might re-envision the role of the lesbian body that had first inspired her creativity as a filmmaker. Following *Women I Love*, Hammer's films *Home* and *Double Strength* (both 1978) do so by formally de-emphasizing sexual aspects of female bodies—but in antipodal ways. In *Home*, there are no bodies. The film focuses on recollections of Hammer's early life by her father and grandmother and presents footage of two houses where she grew up in the area around Los Angeles (as well as her school and the church where she got married). While at a couple of points we hear Hammer's voice confirming a detail with her father or see her shadow on a game of hopscotch or her reflection in a window—reflected or deferred images the likes of which have by this time become a motif of her work—we never see her or any lesbian bodies directly. Moreover, in giving over her life story to her father and grandmother, who limit their thoughts to a time only up to her marriage (by that time, over), the film gestures to the poignant absence (or early repression) of the personalities/identities we had seen Hammer explore in *Psychosynthesis* and other films from this period. That she made it with 16 mm infrared film so that the colors are deep, rich, and inverted—and that she at times separates the image just slightly into two closely doubled images—underlines the sense of this being a divided but parallel world that she occupied in her childhood and creatively reimagines as an adult and artist coming to terms with it.

In *Double Strength*, the female body is foregrounded but in a very different way from *Dyketactics* or *Women I Love*. Rather than focus on sexuality or sensuous experience per se, *Double Strength* depicts nude women to showcase their strength, flexibility, and capacity for movement. In the film, Hammer joins her teacher, mentor, and lover Terry Sendgraff in exercises Sendgraff had developed as part of the movement form she called "motivity," a "combination of dance, gymnastics, and motional improvisation . . . performed with special sensitivity to the environment" that includes a suspended swing-type apparatus.[60] Krystyna Mazur further clarifies that "in *motivity*, the body is explored as the source of knowledge unavailable to the mind," noting that "not unlike Sendgraff, who practices *motivity* to discover the presence of her own body and its desires, something that was always there but hidden, Hammer's camera brings to view what is there but we could not see without it."[61] Thus *Double Strength* represents a further effort toward making visible the invisible in Hammer's films. The motivity work featured in *Double Strength* also serves as a counterpart to the cinema's mobile foundations: both call on the vitality of movement as a key expressive mode

for meaning. Using trapezes and filming from a multiplicity of angles, Hammer and Sendgraff collaborate, and their theme centers on combining, doubling, and shadowing the energy of female bodies working in tandem and in motion.

Like *Home*'s use of a nonstandard film stock that intensifies its images, its colors saturated but strange, *Double Strength* also experiments with aspects of the medium of film. The film begins with a montage of still photographs: black-and-white close-ups of Hammer's and Sendgraff's faces alternating from one to the other. Their facial expressions and the editing suggest a conversation, with one reacting to something the other has just said or done (for example, Hammer puckers her lips, Sendgraff raises her eyebrows). Around the same time, Hammer made the short film *Haircut* (1978), which also uses still images in quick succession to create eddies within the duration of the time it takes for Hammer to have her hair cut. A bit like Chris Marker's *La Jetée* (1962), but with the gaps significantly closed in time from shot to shot, both of these 1978 Hammer films *play* on the tension between stillness and motion partly to underline that tension in the ontology of moving images.[62] The snapshots come to life through the editing; their otherwise still nature underlines the contrast in the women's movement-practice shortly to come. The shots are held together with just the suggestion of movement rather than its actuality—providing a doubled version of movement in tension with stillness.

To transition from this series of still shots, Hammer draws a red heart over the image of her own face directly onto the filmstrip, further reminding the viewer of the cinema's material foundations. As Mark Toscano, archivist of Hammer's film materials at the Academy of Motion Picture Arts and Sciences, points out, even when Hammer's engagement with the material qualities of her medium is not foregrounded, "her rich engagement with its intrinsic, expressive capabilities nevertheless contributes a complex vein of meaning and effect in her work." Toscano connects the haptic, sensuous qualities of the film medium as Hammer explores them with the bodies of the women she depicts. He writes: "The film medium in her work is like a living body, and her films feel vividly like those of an artist working with the physicality of that body, treating it with attention, tenderness, tactile curiosity, respect, and definitely with sensual pleasure."[63] Painting the red heart on the film strip, Hammer does all of this while also setting one of the themes of the film, that of charting the rise and fall of a romantic relationship. Hammer has described the trajectory of the film as showing the shifts in a relationship, from beginning to breakup, and these first sequences support that intention by formally interrupting the flow of their movements together. After this, a flirtatious and symbiotic collection of movements between the two women is set into motion. However, later, returning to the still photomontage

format, Hammer will suggest the breakdown of bodily communication between the women before finally implying the end of the relationship through a similar, stilled montage. Although there is no explicit sexual content in the film, as there was in both *Dyketactics* and *Women I Love*, these photomontage interruptions shape the way the movement sequences depict the relationship of the women's bodies to each other and point to the film's romantic subtheme.

Immediately after the initial sequence, still images give way to movement, and the scene shifts to a studio/gym space. The camera turns to two trapezes laid out on the wood floor, slowly panning along the rope until it discovers a ladder on which Hammer (with camera) surveys the room. Through the ladder, she observes Sendgraff, who takes another trapeze hanging from the ceiling and dangles from it. She allows its movement to turn her as she simply holds on. Yet it is not a wholly passive movement; the trapeze's movement happens in reaction to her weight hanging from it—and the tension in her muscles and even the gentle movement of her head looking up and down provoke her slow spin. A nod of the camera down to her feet reveals just how much interactivity there is in the action. She has her legs tucked under her, and as she lengthens them, the spin accelerates, then varies in speed as she stretches her legs or tucks them again, until she reaches her toes to the floor to stand.

The camera cuts in to an extreme close-up of Sendgraff's eyes, then zooms out to reveal her full, now nude body from above. Hammer's bare legs are visible as she films Sendgraff below her. Sendgraff hangs on to the trapeze and to Hammer's feet. What follows is an interlude of graceful, strong movements, a pas de deux coordinating the women's movements with the physics of movement deriving from both the apparatus of the trapeze and the camera's functions. The camera captures both women in various states of movement and from a range of perspectives: from below, above, while swinging, while static, side to side, spinning, or up and down, but ever in motion. The film ruminates on the way movement and stillness are counterweights to each other in the play both of cinema and the acrobatic routine the two women have choreographed together. They display spontaneity, play, planning, and feminine physical power. Hammer noted that the nude sequences were inspired by the fact that no costume could sufficiently highlight their musculature; again, the film provides representation of an aspect of women not usually so plainly on display.[64]

The next phase of the film eliminates the trapezes and focuses on gymnastic movements in the studio before moving out into nature, where Sendgraff hangs from and climbs through trees. A still photograph photomontage that interrupts this moving footage shows the women's faces as more serious, even angry. But immediately after, Hammer segues into a remarkable sequence in which she doubles Sendgraff's body as

she turns, nude, along a wall in the studio. One of the doubled images is color, one black-and-white (processed, like *Dyketactics*, by measuring out and aligning the two sets of footage when the rolls were developed). Throughout, it is difficult to tell the women apart when their faces are not shown in close-up; either they shadow each other, or one woman shadows herself (figure 11). Complementary yet contradictory aspects of their bodies stand out. The women appear very similar, and their nudity has the effect of decreasing their difference. With similar haircuts and builds, and often depicted from afar and behind and in black-and-white photography, they could be doubles of each other, as the title and method underscores. However, near the end of the film, Sendgraff's more mobile body (depicted in color, moving film) is superimposed over Hammer's close-up face (black-and-white, still photograph) in mid-expression to mark their difference. They are individuated though also partners in a single enterprise. In this sequence's variations, Hammer highlights the powers of movement inherent in the medium. The choices with the camera enhance the growing differences between the women in the motif of a declining romantic relationship. The overall impression is a study in movement highlighting the power of women's bodies and doubled by the power of the camera to enhance, alter, or transform their motion both in counterpoint and together.

Figure 11. Double images in *Double Strength* (1978)

The first full decade of Hammer's development as a filmmaker came to a close with her production of *Dream Age* (1979), which looked back on the decade and explored her transformed, artistic self, the lesbian community that nourished her identity, and the creative techniques unique to the film medium that were used to explore these ideas. Having just turned forty, Hammer decided to make a film that addressed her progress in self-actualization and self-expression through her art form. Depicting a seventy-year-old lesbian feminist (who has seen the world and found it has not made as much progress as she wanted) encountering her forty-year-old self, *Dream Age* like *Psychosynthesis* presents multiple versions of the self. Not only are the self's forty-year-old version and the seventy-year-old version brought into temporal and spatial proximity in the film, but also different parts of the personality are presented together by the film. This time these subpersonalities appear, according to Hammer, as "the guardian angel who has all she needs, the seductress who leads her astray, [and] the wise woman of secrets whom she meets underground."[65] There is a sense of lesbian community—that those who have come before her will help guide her—as well as an individualism that suggests that Hammer, as a pioneer of queer experimental cinema, must also do that work of guidance for herself.

Hammer's contribution to making women visible through film, both as the one who wielded the camera and as a purveyor of female images in the 1970s, is considerable and historic. By the 1980s, Hammer's work began to shift in response to changes in her artistic and intellectual ambitions and outlets, her geographical location, and her desire to expand her work's reach to wider audiences (all of which were intertwined). The breadth of her interests and ingenuity of her creative approaches resulted in an expansion of her artistic purview. Her search for ways to channel her roving creative interests led in the 1980s to work with radically different kinds of themes as well as forms, for instance, in performance pieces. The shift may be characterized as one from the electric, embodied representation of lesbian experience to, on the one hand, the larger art world to which she had yet to be invited and, on the other, the larger real world, in which she traveled and accumulated new kinds of experiences she would express through cinematic means. Even with these expansions, however, the foundations of her work and the fact of her pushing out of the boundaries that might contain her, remained constant.

1980s

Vocation and Expansion

Her first films, photographs, and artworks from the late 1960s through the 1970s demonstrate Barbara Hammer's commitment to lesbian subjects and advocacy. In these years, her ethos as an artist developed by representing lesbian identity and social activism. Although she did not limit her work to the medium of film, Hammer established herself by the end of the 1970s as a serious experimental film artist with a following (particularly by women). If the work limited to that single decade constituted her only contributions to film art, it would still mark a historic achievement, the critical upshot of which would understandably situate her as a pioneering lesbian filmmaker. Of course, that is how her contribution is often situated anyway. However, the 1980s demonstrate a seismic shift in her work and ambitions parallel to that taking place in the wider realm of feminist art production in the 1980s. Looking at her work in this new decade demands a recalibration of the Hammer legacy along additional lines of influence and production. At this same time, Hammer also began to expand her reach in other ways, by teaching classes, doing performance pieces, and beginning to catalog her work (figure 12).[1] In the 1980s, Hammer seizes on new strategies, including adopting structural film techniques, and she courts new audiences, especially those associated with the broader realm of experimental film art. This decade begins to widen the swath of her interests, methods, and audiences that together put pressure on pervasive notions about feminist experimental cinema then and now.

An early film from the 1980s, *Audience* (1982–83), stands on the threshold of the shift in Hammer's work; it provides a glimpse of her 1970s mindset but also offers hints as to her future focus.[2] In it, Hammer documents those who attended retrospective screenings of her films that took place in a range of locations: San Francisco, Toronto, Montreal, and London. It shows Hammer interacting with her audience before, during, and after screenings. As people line up to get tickets for the program of 1970s films in San Francisco, she happily finds old friends, flirts with people, asks questions about what they expect from the films, and talks with them about experimental and lesbian cinema. Mostly the attendees are women, but Hammer takes time to draw

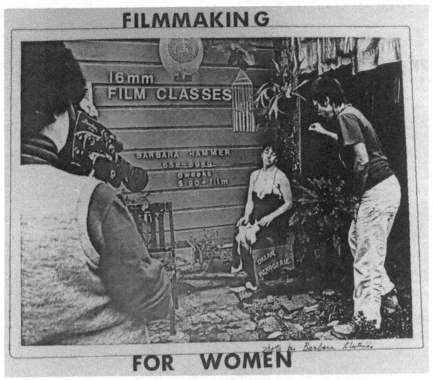

Figure 12. Hammer's advertisement for Filmmaking for Women, circa 1980

aside several men, including a gentleman coming to the cinema for the show, wherein she wonders aloud whether he really knows what he is getting himself into. He gamely asserts that he comes to see whatever this venue is showing—he is a cinephile of great capacities, and just the sort Hammer increasingly will seek to connect with through her work.

The rest of the film shows Hammer introducing the screenings or skipping forward in time to postscreening discussion groups or to Hammer interviewing individuals who are milling around after each program. These moments are highly interactive; at one point she gives one woman the microphone and insists that she conduct the interview instead (figure 13). The films themselves are the alluded to but unseen source for the commentaries that follow. Through both the prescreening and postscreening footage, a portrait of different cultures emerges, with the San Francisco group rambunctious and randy, the Montreal group erudite and a bit critical, and the London audience somewhat aloof in the face of Hammer's dynamism but thoughtful about the films. *Audience* provides visible evidence of a specific cultural moment pressed into articulation by a woman determined to make it speak. As a later *Light Industry* review

of the film puts it, "*Audience* serves as an invaluable historical archive, providing quick but complex portraits of lesbian scenes in different cities and countries."[3] But what is most striking about the film is the synergy between Hammer and her audience. Her openness to their responses makes plain Hammer's desire to understand and shape the way her films are received, while the testimony of women who have been moved by her work also demonstrates her impact on 1970s feminist and lesbian art production.

The film attests to a time and set of places at a small but meaningful remove from the 1970s. Since making those films, the time that passed afforded space for Hammer to reflect on her flurry of activity in these first forays into filmmaking. Moreover, the film evinces an increasing interest on Hammer's part in the metadynamics of filmmaking that would move her in the direction of paying greater attention to the medium itself. While the films from the 1970s did not eschew such attentions, in the 1980s, they became a key focus of her work, which *Audience* demonstrates since it explores the act of filmmaking as much as it offers a film in its own right. A filmic segue from a mode in which her own body served as one of the key touchstones of her films to one where it became increasingly absent in favor of other people, objects, and especially places, *Audience* simultaneously calls attention to Hammer's body in a new way (as an artistic persona), to the film as a film, and to the fact of this film as a testament to its time and the multiple locations where nuances of reception are discernible. J. D. Rhodes observes that in addition to providing a document of the differences among lesbians, women, and audiences, *Audience* offers a site for communal aesthetic judgment: "The practice of judging and being immersed in other peoples' judgments operates here as the constitutive ground of artistic (and social) practice," which will come increasingly to define Hammer's ethos.[4] Importantly, the differences expressed in the after-screening interviews provide real, cinematic evidence of Hammer's eagerness to engage a vital and eclectic audience. She both reflects on and generates that audience in the film, through the film.

As such, while Hammer positions the viewer of *Audience* to think of the making of the earlier films (where she is frequently a primary subject), she also goes behind the camera and makes it conspicuous that she is working both sides of the lens. At one point, she circles the women she interviews, coming around to the other side to provide a view of her rather embarrassed sound person (figure 14). Highlighting the processes involved in making this film, the audience is invited into new relationships with the work. That invitation includes the audiences within the film *and* the potential/expanded audience she has begun to court. As Rhodes puts it, the film "documents its own coming into being, and its own initial reception."[5] Above all, in *Audience* Hammer hoped to find as well as to engage an *active* audience.[6] Around this time, she wrote

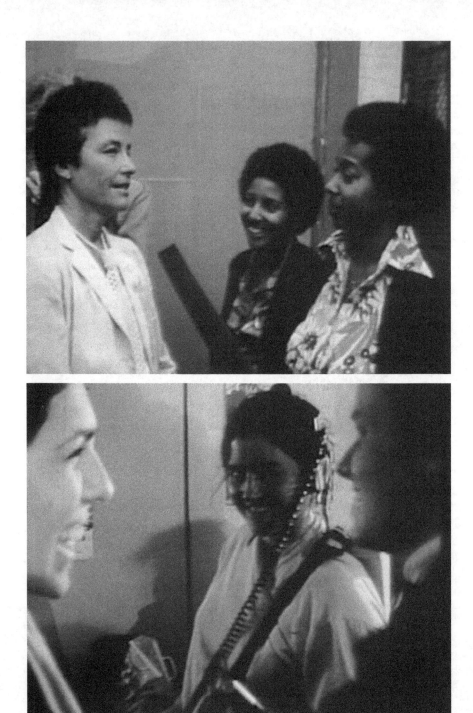

Figures 13, 14. Stills from *Audience* (Barbara Hammer, 1981)

variations of an essay attesting to her interest in the full and, importantly, embodied interaction of spectators with her work.[7] In a letter to Claudia Gorbman, Hammer emphasized that the reactions she sought had to do with the audience members' physical responses in addition to their individual ways of thinking about the films:

> I want my audience to become "alive," to feel the blood moving, the air moving in and out, to be quickened and alerted through my films, not to be drowsy and led through a director's dreams, not to be "taken over by the screen story," someone else's view. The point for me is to encourage my audience to be active, to make their own decisions. I am happy with the results: mixed reactions to my films.[8]

Around the same time, Hammer riffed on the same idea in "For an Active Cinema," a short piece she contributed to *Fuse Magazine* in 1981: "Active cinema is a cinema where the audience is engaged physically, involved with a sense of their bodies as they watch the screen. . . . [It] respects the physical and mental intelligence of its viewers by increasing rather than subduing self-awareness."[9] One of the methods behind generating this respect is to "repeatedly point to itself as cinema."[10] Her films around this time did not just depict lesbian and feminist experience, they underlined its depiction cinematically, demanding multiple levels of engagement from those who viewed them. Rhodes underlines this activation of self-awareness and critical faculties as one of the key components of *Audience*. Hammer found through the process of making the film a basis for thinking about how to listen and respond to the audience's reactions. She folded those reactions into the creative act of filmmaking in this metaintentional film but also increasingly thought of her audience in relation to her development of new projects in the 1980s.

In *Audience*, Hammer is having fun finding out what people think of her work. She takes delight in the process of assessing her accomplishments up to that moment and attempts to see what else might come of it as a result. Her apparent pleasure in the potential discomfiture of the male cinemagoer mentioned above, along with her simultaneous respect for his presence at the screening, reflects the position she occupied on the threshold of the 1980s. His broad-minded cinephilia is something she hoped to tap into for a wider range of potential audience members. Women-only screenings continued for Hammer into these years due to invitations by specific groups; however, Hammer also made efforts at this time to include men in her film's subjects and audiences. Moreover, in her work's greater foregrounding of the dynamics of the filmmaking process, she aimed to connect to the larger experimental film scene. She recounted

on several occasions that the first time she screened her films "outside the supportive lesbian community" was on the cusp of the new decade, in 1979, at the invitation of Terry Cannon at Film Forum in Los Angeles, who enlisted her to screen her work in a program of experimental films rather than as specifically lesbian films.[11]

Hammer's turn to the experimental film scene at the end of the 1970s coincided with a moment when an aggregate of people making or thinking about experimental cinematic work likewise expanded their participation in that field. As Erika Balsom points out, the same moment has been described by some critics as a period of decline for American experimental cinema. Picking up on some of the implications of this assessment, she wonders: "Was it a coincidence, that the so-called 'end of the avant-garde' arrived just as women were asserting a central place within it?" Balsom raises this question to investigate the critical reception of work by another rising figure of this moment, Peggy Ahwesh, who, like Hammer and other contributors to the first wave of feminist art production in the 1970s, turned her creative practice "to whatever technologies, whatever aesthetics, seem most fitting, working with diverse techniques across multiple formats."[12] Tracing the "paradigm shift" that led to the emergence of a different and more inclusive model for experimental production in the 1980s, William Wees has pointed out that many of the filmmakers and critics of the time sought directly to contest the "giant" or "genius" model of experimental filmmaking that had in preceding decades remained primarily the province of men. In his account of the complexity of contributions by women in this period, Wees notes that filmmakers like Hammer "[devised] new, or [revised] earlier formal strategies to suit the issues they wanted to explore."[13] Moreover, many of the filmmakers and critics involved in the shift (including Hammer) had interests that dovetailed with the arrival of sustained studies of feminist film theory, which called for alternate filmmaking models that would forego the traps of narrative.[14] This range of influences and approaches from a variety of contributors drove the move to a more eclectic set of experimental practices—across oeuvres and within the same oeuvres—in the experimental film milieu of the 1980s.

The search for any outlet that might serve or drive an idea strongly characterizes Hammer's work in the 1980s as she consciously balanced form and content in new ways. Like other women making experimental film and media works at this time, Hammer forged in the direction of form to gain traction in the wider art world. She did so by combining her interest in issues related to female experience and identity with a wide-ranging, playful mode of foregrounding her experimentation with the medium of cinema. The many "most fitting" techniques Hammer mobilized in the 1980s—the use of the optical printer's capacity for superimposition

and layered images, the generation of computer images and sound, the manipulation of time through especially fast motion and time lapse photography, and the coloring of the film strip—all point to her heightened sense of the medium's possibilities for expression. While one of the prominent reasons cited by scholars and filmmakers for structuralist film's emphasis on the medium for meaning hinges on its rejection of narrative's soporific immersive qualities—its tendency to replace reality with a seductive illusion—and while Hammer, as we have seen, sought to activate her audience for some of these same reasons, her films from the 1980s did not cleave to structuralist tendencies in quite the same way.[15] In their inflection if not quite all out embrace of structural and materialist concerns, Hammer's films connected specifically feminist content with the larger experimental film milieu that would facilitate broader acceptance of her work. Hammer's work called for the marriage of formal strategies of the 1980s avant-garde with feminist content, which bent each (form/content) to the other's needs without obscuring either.

Attention to filmic techniques was not new for Hammer, but her increased emphasis on highlighting those techniques marked a shift with important ramifications for her oeuvre overall. While in the previous decade of filmmaking she approached work with a lesbian focus—exposing lesbian bodies, points of view, sexuality, and "herstory"— and while there was an undeniable interest in the medium and formal concerns within these films in the whole continuum of Hammer's work from beginning to end, in the 1970s, their content took precedence. These films allowed screen time to constituents denied that space by conventional cinema and showed Hammer exploring a network of interests related to sexual identity and politics. However, by the mid-1980s, Hammer began to suspect that she was putting her work at a disadvantage by being so focused on that content. For an artist working on the ground, the notion of feminist creative activity holds certain dangers. Work that privileges the female body and issues of identity may well be taken up by those for whom feminist social, cultural, political, intersectional, and/or aesthetic interests matter, which potentially guarantees a certain audience. However, it also might limit how the filmmaker can generate that content without alienating that audience. In a passage she cut from a draft of a paper she wrote in 1984, Hammer distilled this dilemma:

> Today I find my early work and reputation as a lesbian filmmaker wants to trap me. I am invited by young women to college campuses to represent what I was. The films they want to see are *Dyketactics, Superdyke,* and . . . *Multiple Orgasm.* When I highlight the program with the recent films underwater and above ground concerned with floating movement and physical walking of

the camera, their attention strays and I feel I disappoint them. I have only been making 16 mm films for eleven years and I think there will still be more changes. If I feel one mode of expression is limiting because it represents but one of my multiple concerns, can I be embraced by a public that can also accept growth, change? . . . The lesbian feminist activist is also a film artist.[16]

Despite her worries about their limitations, labels did not hinder Hammer's development of new forms; they may even have accelerated her search for new outlets. Near the end of the decade, in 1988, Hammer organized a conference session at the Second Annual New York Lesbian and Gay Experimental Film Festival titled "Radical Content, Radical Form" and invited artists including Jim Hubbard and Su Friedrich to convene to talk about these issues with the aim of remedying what she described as a "lack of gay and lesbian theory of film."[17] Her comments during the panel advocated equal weight for content and form in producing gay and lesbian cinema. Like another of her copanelists, Abigail Child, Hammer saw the two as inextricable. Child put it thus:

Radical form *is* radical content.
 Radical content radicalizes form.
 Form and content shape each other. Content just "seems" to represent us better. We look *at* content. We look *from* form.[18]

The question of the role played by content for representing queer and female concerns was not an insignificant one. Marginalized on screen and behind the camera, content more obviously addresses the disparities of representation, but representation can also be further marginalizing, as Hammer suggests in her worries about becoming known only in terms of that content. Such content threatens to subsume the formal concerns belonging to an art form, so that for a serious artist, one who wants to reach an audience interested in art, content might prove double-edged. Like Child suggested and Hammer corroborated in her own remarks, content radicalizes form, rendering a new position from which to understand and view the world. In the panel, Hammer insisted that "meaning is derived from the weaving back and forth, in and out, through and through of these two concerns [form and content]."[19] A focus on content alone was not enough.

Hammer's pursuit of new outlets for her ideas came about because the personal, feminist, queer, and aesthetic positions she adopted were and are complex moving targets—they remain both resilient and mercurial in connection to understanding

her work. Around this time, Hammer also became more noticeably interested in feminist theory, as several films, including *Sync Touch* with its Lacanian dialogue, demonstrate. Theory served as a point of reference but also as a bridge between, in one decade, the depiction of and emphasis on the female body, and in the next, an emphasis on abstract, intellectual, avant-garde forms. Hammer's work allows us to see why a more capacious notion of feminist activity—because it is not just a historical phenomenon, but a lived, evolving experience—is necessary for understanding more recent feminist work. We must expand the category to consider the particular ways in which a committed feminist ethos has often sought out a renewed set of forms, themes, and technologies/media/methods to express itself.

Without abandoning her commitment to lesbian representation, Hammer began to channel it into new modes of filmmaking. She described her process and its relation to radical form and content with characteristic brio:

> To see the rules and be able to break, rearrange, underline, score and ignore them. To be controlled, uncontrolled, outrageous, ordered, to be simple, to be baroque, to combine the uncombined. To practice holding on and letting go in the same double breath. To be aware. To practice the mindful pursuit of the unpredictable. To be off the wall but centered in the bed. To be sexual, intimate, lusty, trusting, committed to a same sex partner. Outrageous. Perverted. Splendid.[20]

The awareness and colliding of opposites, welcoming of experience, and embrace of uncharted territory informed Hammer's 1980s approach. Grounded in the personal and flexible in practice, her work applied itself to the radicality of formalist experiment. She sought techniques that would best serve the expressive needs of a queer, feminist cinema: "To experiment with the format of the film . . . the projection apparatus . . . the emulsion . . . positive and negative space"; "to run sound backwards"; or "to suggest through abstraction." She had been working toward this multiplicity of formal experiments from the beginning. But by the early 1980s, Hammer began increasingly to explore the ways in which she might use (or, as Greg Youmans has put it, "appropriate"[21]) subjects from new sources while also querying the material foundations of the cinema that treated them. Whether repeating a series of single frames so as to still the illusion of movement in *Pools* (1981), step printing in *Pond and Waterfall* (1982) to simulate slow motion with an added rhythm of brief staccato as the camera moves through underwater spaces, or using stop-motion animation in *Doll House* (1984), Hammer experimented with and focused increasingly on the cinema's possibilities.

Associated with Peter Gidal's and P. Adams Sitney's conceptions of structural film, materialist film practices flourished especially in the 1960s. Emphasizing the material foundations of cinema over and above issues of immersive (and especially narrative) content, structuralist/materialist film per Gidal underlines "its own making" and depends on "the mental activation of the viewer," who is not immersed in the film but produces the meaning of the film by identifying its form as its content. Sitney echoes these defining features, noting that structural film "insists on its shape, and what content it has is minimal and subsidiary to its outline."[22] He identifies four techniques frequently employed by structuralist filmmakers—a fixed camera position, flicker effects, loop printing, and re-photography of a shot or scene—with the caveat that these are neither the only techniques available and employed nor that he means they are used consistently or all at once by any given filmmaker. While Sitney focused on structural film as the province of work by Tony Conrad, Michael Snow, Hollis Frampton, Ernie Gehr, Ken Jacobs, and others (Joyce Wieland is the only individual female filmmaker mentioned by either writer), the influence of the ideas driving his formulation became more widespread over time, and their effects have lingered, sometimes with surprising resonance, in feminist practices.

A couple of decades later, Hammer adopted some of the strategies of structuralist film, partly in her bid for greater legibility and legitimacy in the art world. The conspicuous intersection between these strategies and feminist issues in her work reveals that Hammer did not however abandon her aim to address a subjective, embodied, queer perspective. Although she (in her own words) "strategically and purposefully decided . . . to take women's bodies out of [her] films,"[23] and particularly her own body, the films trace the movements and process of a specific individual creative effort that points back to that body all the more powerfully because of its absence. Throughout the 1980s, Hammer sifts anew through the expressive possibilities of experimental film, often putting several modes of expression into play at once. These are busy films, brimming with energy and packed with experimental layers.

Sitney remarked that structural film's aim was "to orchestrate duration" and "permit the wandering attention that triggered ontological awareness." At the same time, he argued, such films were meant to "guide that awareness to a goal."[24] Hammer's work does not absolutely conform to this notion inasmuch as any goal is less the point than an openness to new horizons of experience. This aspect points to the critical role Hammer's feminist and theoretical impulses offer for her unique experimental form of filmmaking; she seeks alternate angles for accessing meaning. Hammer's experience, perspective, and mission fundamentally differ from that expressed through the hegemonic, patriarchal forms that she perceived as dictating art production over the long

course of Western history. Her method instead tends to center on empathy and play. As for empathy (a touchstone throughout the whole of her career), at the threshold of the 1980s, she noted that by expressing something intimately subjective, she finds a point of connection with the women in her audience who have not been addressed in that way at the cinema:

> I think what women find in my films is a mutuality of feeling. Women often come up to me after a film performance and say that they've had the same feelings or that my images have touched an experience close to them. It's then that I feel an intimate moment—a highly personal truth—has made a full circle, that I have communicated.[25]

As for the notion of play, though its source differs, Hammer's feminist film praxis tallies with an element in Walter Benjamin's work on play as outlined by Miriam Hansen: the idea of tapping into a "bodily presence of mind" that offers another "mode of attention" for "reading" the world. For Benjamin, this approach to the world is dependent less on the visual sense than on channeling a multiplicity of possible outcomes projected by any given moment into a singular fulfillment through making a choice.[26] Hammer, of course, tended not to limit herself to just one. Harnessing the possible into the actual—expressed through the language of cinema and enacted through raucous, generative, transgressive play—constitutes the method of films like *Sync Touch* and *Doll House*. Moreover, as Hammer contemplates the role of form in her art, she notes that she would not "[throw] out the formalist bathwater" just to make a point.[27] To enable cooperation between form and content in order to fashion a truly radical cinema, she needed to shift toward formal concerns while keeping feminist content in play.

Hammer's key moving image works of the 1980s are concerned with a panoply of issues: place, play, form, time, sensuous experience, and perspective, but all these issues become relevant as enacted through heightened attention to the medium of film itself. However, as Mark Toscano observed:

> Hammer is hardly a mere fetishist of film. Her interaction with all media technologies has always been marked by an unafraid curiosity and eagerness to explore new modes of audiovisual expression. This has been an intrinsic and crucial part of her ambitious and pioneering efforts to define a lesbian cinema; in her view, this cinema must be driven by an adventurousness and inquisitiveness that is always seeking to discover new forms of expression, free from prescribed and pre-existing technological and social boundaries.[28]

The shift in her work in the 1980s points more to an expansive (and still expanding) framework for her interests than to a departure from the interests of the 1970s.

Coincidentally, Hammer's shift to this material was at times not as warmly received as her earlier portrayals of the female body. She had built a reputation on the former and had enjoyed success with that material, and even in the 1980s, a certain expectation of her work dogged her formal experiments. Film scholar Scott MacDonald's response to the work in a letter written to Hammer on November 30, 1984, is suggestive in his perception of a difference between the success of Hammer's earlier films and of failure of the new ones:

> I have to confess that I wasn't taken with the films. Of them the one I found most watchable was *Bent Time* (I found it a formalist piece which is easy to relate to).
>
> I had real problems with *New York Loft*, *Stone Circles*, and *Doll House*. I didn't find much in them and found them hard to keep my attention on. They seem somehow flimsy, lacking in the intensity I respond to in, say, *Women I Love* and *Double Strength* or even *Available Space* and also less sensuous to look at. Ah well.[29]

MacDonald's statements of preference for certain films over others are not unreasonable and correspond to his taste; moreover, certainly some films may be more successful—at some technique, in overall conception, or something else—than others. However, his feedback to Hammer begs the question of whether her work from the 1980s, such as *Stone Circles*, should depend for their success on a set of motives consistent within a different group of films or even motives belonging to a different set of artists. The intensity and sensuous look of works such as *Double Strength* derive from their address of the spectator through the body. It was a move beyond this address that precisely concerned Hammer at this time. (As she wrote to Claudia Gorbman, the topic that interested her most was "the change of location from body of flesh to bodies of earth and water."[30])

Undoubtedly, MacDonald does not mean to confine Hammer's work to a narrow roster of expectations, and his appreciation of *Bent Time*—he approves of its "maintenance of a particular gesture, in this case the tracking forward through all those places, spaces, times"[31]—shows that he is not averse to a range of approaches in her work. All the same, he raises two issues that trouble feminist film artists attempting to push out of the framework of representation and certain corresponding expectations of their work. The first is the suggestion that her excellence in representing underrepresented people, experiences, situations, ideas—in short, all of the things for which her work is

often praised—should be her unique province (with the implication that out of it she ought not to stray). And the second is that efforts in other directions are hamstrung by their loss of first the sensuous luster of women's bodies and second their authority over such corporeal terrains. Both issues come to the fore as Hammer experiments in new directions that foreground form.

In fact, in Hammer's assaying of the wider terrain of experimental film production, she found productive consequences both in the short and long term. From 1983 to 1985, she received a major grant—her first—to complete *Bent Time* (called *Curved Time* at the time of her application); she entered competitions in festivals and found new audiences in academic settings and galleries; and she had a piece (*Optic Nerve*) honored by selection for the Whitney Biennial. Her work began to enjoy the attention of institutions, critics, film festival judges, and others beyond her stalwart set of admirers and those attending her women-only screenings during much of the 1970s. While she did not cease to validate and celebrate the experiences and perspectives of women, the multiplicity of types of experimentation she tried in the 1980s became a permanent hallmark of her work, which followed her into new territory after that decade.

The trajectory of Hammer's activity from the 1970s into the 1980s is foundational for understanding how she grapples with key interests. This period prompts scrutiny as to how a number of feminist avant-garde filmmakers have felt compelled to reinvent themselves in order to get their work funded, seen, and ideally, appreciated, beyond the parameters of what looks like a strictly female focus. This question first presented itself to my research when a retrospective of Carolee Schneemann's work opened in late 2016, and the *New York Times* covered it by beginning with the following assertion: "Sure, the artist Carolee Schneemann may be best known for pulling a scroll out of her vagina." Howsoever that line might affect anyone's impression of what the work's value might be, the review continues by underlining precisely the issue of feminist production of art in the aftermath of provocations of the 1970s:

> But that piece, "Interior Scroll," in which she read aloud from the scroll the remarks of one of her critics, dates back to 1975. More recently, she has been working on motorized sculptures, often with video projections.
>
> "I'm very anxious for the culture to pay attention to the work that's not 40 years old," said Ms. Schneemann, 76. "Culturally, my use of the body has dominated the larger body of work. I hope now this will be redressed."[32]

The *New York Times* review has it both ways: it advocates for redressing the emphasis on Schneemann's older work by covering the exhibition and offering her space to ask

for this revaluation of her whole oeuvre while simultaneously participating in the act of emphasizing that older work, both by its flippant opening that pulls focus onto that body-oeuvre and by its inclusion of images mainly of that older work for illustration of the retrospective. A similar issue worries the inheritance of feminist art and theory from the 1970s more generally, and Barbara Hammer's work is a central case study for the implications as the artists who were working during that period continued to work, innovate, and age (both Hammer and Schneemann made work for another forty years after the works for which they became known and before they died, ten days apart, in March 2019).

Hammer articulates the contours of the shift from the 1970s as relocating from the body to its environments: "The move from locating the film image in the body to the landscape is a move for me from intense interior-looking and identity-naming to a broad geography-claiming." Within this claiming, she focuses on "the nature, the materiality of film itself."[33] Many of the films from the 1980s focus on space and subtract the body within it while highlighting the camera's encounter with that space. Still, the camera is not out for a walk or a plunge into water on its own: it is intimately connected to the body of the filmmaker, and as such creates a cinema that still is very much tied to aspects of the lesbian perspective Hammer claimed she was making visible to her audience. In *Stone Circles*, Hammer's knees match the standing stones she films while lying on her back amid them; later, she piles stones on her face as she lies on the ground. She plunges into the water in *Pools*, and the suggestion of her body immersed in the water the whole time becomes finally concretized in the last image—silhouettes of women swimming. Moreover, as Chuck Kleinhans aptly noted:

> Hammer's understanding of the body itself changed and deepened in the 1980s. The body's social nature came to be represented no longer as a circle of women cavorting in Northern California, but a body imbedded in contradiction and complication through the impact of government censorship and right-wing repression, of AIDS hysteria in the media, of disease and dying, of aging, and of environmental decay.[34]

These elements find expression through the way Hammer addresses and represents women's bodies in the new decade—both corporeally and through totally abstract representations, as it suits each film.

In addition, several of the 1980s films are made with place as central to its meaning (a tendency she picks up again in her last decade of film production). Among these are films like *Our Trip* (1980), *Parisian Blinds* (1984), and *Tourist* (1984), which are

structured around travel. Such films illuminate the movement outward from private experience toward the landscapes being experienced. A subset of her prolific output, the films made during this decade highlight her articulation of a more expansive idea of what is fitting for the queer screen. As one of her later artist's statements plainly asserted, "In the eighties I found my earlier films with themes of lesbian representation had not been recognized as fine art. I began a series of more formal work in optically printed films on themes of fragility of light, life and film itself. . . . This strategy worked, and my work was included in several Whitney Biennials and MoMA Cineprobes."[35] Her strategy gained purchase gradually. After the films of the 1970s, a film like *Sync Touch* (1981) announces Hammer's partial pivot away from films that emphasize bodies to films that emphasize the medium of film and that turn to a multiplicity of forms for expression of complex ideas appealing to different audiences. In addition to courting these new audiences, Hammer forged into new technological territory as well, for instance, experimenting with computer graphics and collage in *No No Nooky T.V.* (1987).

In the 1980s, Hammer also extends experiments she had begun in the late 1970s with repurposing and mobilizing (literally) her film work into various performance pieces, so that earlier films like *Moon Goddess* (1976) and *Available Space* (1979), for example, are put into galleries or other public spaces using mobile projectors that use walls, large balloons, and other surfaces as screens.[36] These pieces activate her audiences (and her practice) in new ways. Other work, like a performance piece titled *Would You Like to Meet Your Neighbor: A New York Subway Tape* (1985), innovate differently. In that piece, she films people on the New York City subway while wearing a mask and a costume with a map of the subway on her body. As a film and document of a performance piece, it reads as an intersection between Hammer's lived experience and her work, a crossroads she contemplates with frequency. Diversity of expression is the norm in this decade. Looking at a sampling of the more than thirty films she made during the 1980s, we see Hammer's commitment to an expansion out of the frame she had initially set for her work. Indeed, we must not lose sight of the fact that it is through her ranging exploration of approaches that we may see Hammer's commitment to expanding the queer screen. Hers is an art practice that defies simple categorization or a single channel for her many works.

Travel and Place: *Our Trip* (1980), *Pools* (1981), and *Bent Time* (1984)

Hammer's travels throughout this period provided the material for several films. Her hunger for travel began when she was in college; by her account, she agreed to marry

her husband only when he promised to take her "around the world on a motorcycle." They traveled by land and water—hitchhiking, driving a Lambretta motor scooter, and boating through Italy, Greece, Turkey, Syria, Iraq, Iran, Afghanistan, India, Vietnam, Japan, and Hong Kong.[37] After coming out in the early 1970s, with her first girlfriend she embarked on another motorcycle journey through Africa.[38] Specific trips are the point of focus for a number of her films in this period. In *Machu Picchu* and *Our Trip* (both 1980), *Pools* (1981), *Stone Circles* (1983), and *Bent Time*, *Parisian Blinds*, and *Tourist* (all 1984), Hammer travels with her camera, exposing her practice to new influences. Through these travels, she begins to address a broader range of themes and medium-specific concerns as well, by the manner in which she documents her way around the world. Movement—cinema's ontological touchstone—is literalized and made allegorical in travel, such that the voyage is both the point and the point of departure for new things. A closer look at a few of these films shows that the trip and the kinds of cinematic adventures it motivates are equally important.

In *Our Trip*, Hammer transforms photographs taken during her trip to the Andes with Corky Wick into a rumination on the nature of documenting such travels. She turns a playful eye to the gap between the photographs' role as documents and as raw material for this film's expressive language. Drawing attention to the elements of film at least as much as to the journey the film depicts, Hammer playfully emphasizes experimental techniques and their power to tell a different kind of story. The opening shot announces this emphasis with a single word: FILM (figure 15). This image of the word ingeniously packs in everything needed for the journey ahead in the way it signifies on several registers at once. First, it is one of the very few words that appears in the film at all. It has an almost vocative function; it serves as a kind of title-card introduction to what will follow (indeed, a film does follow). It also calls attention to the difference in written/spoken language and film language; it is written, but *on and also actually in film.* That is, the image is not only a written word. It is made by puncturing the film in dots, then placing it before a light, which shines through the defaced celluloid to make the word discernible. This "Film" is part and parcel of the film's medium and language. Also, the necessity of projected light in order to read/ see a film, which tends to go unremarked on as part of the exhibition of the film, here is threaded into the production of the work. It is a compulsory component for reading the image. This first image gives way to a superimposed second FILM, which gains a circle looped around the word made by stop-motion animation (and the same hole punching through the film). This second FILM shows the two layers of film at work in creating depth as well as, again, highlighting the fact that we are looking at a film that looks at film. Finally, these layers anticipate the film's revelation of the key differences

among the trip, the photographs shown of the trip, and the film being made and now watched: then and now, document and reality, still and moving.

The still/moving difference also finds expression on several other levels. Moving images, of course, are also still images *derived* from movement in the world (traveling being a key category of movement) and rendered into twenty-four (or so) still images per second that are then put into motion on a film strip pulled by the sprocket holes through the projector to provide an illusion of movement again. Hammer's photographic artifacts of her travels further *depict* varying states of arrested movement and moving stillnesses (a hike, feelings like rising anger, stopping to pose before the camera) to further highlight the way film works with these dichotomous ideas and brings them into provocative, fluid, stop-start relations. The second image (puncture holes around the word "FILM") gives way through a dissolve to the tearing back of the circle of film from where it has been perforated, revealing the light board behind it. Hammer then writes "FILM" again with marker on the light source, only now the word is not composed of the material of film, but nevertheless highlights the material base on which it is written (figure 16). Shortly after this, Hammer cuts to images of several strips of film on the light board, her hand touching them in perusal of a good choice for a transition to the next shots, which feature the trip itself (figure 17). A soundtrack of a traditional Peruvian guitar (another trace of the trip) begins and the rest of the film unfolds in rhythm with this music.

For the remainder of the film—which is just a little over three minutes—Hammer chronicles her journey with Wick as they hike through the Andes. Photographs of Wick, preoccupied with aspects of the journey or posing for the camera, are intercut with photographs of Hammer in the same conditions. They hike, sleep, smile, yell, and flip off the camera as they await a plane that does not come. These are presented as still images, but Hammer animates them by moving them around in the frame or by panning the camera across them to inspect all the photographic information captured even outside of the shot's point of interest. In this way, she extends the trip a bit, as one might well do, by seeing the sights again, including things one may have missed along the way as a result of concentration on other things.

Moreover, Hammer does not leave the photographs to speak for themselves but adds color and lines to them—for instance, by drawing on the film strip or on glass over the shots. She also evanescently narrates the trip, displaying dictionary entries or writing a word or two of her own to identify locations or feelings recalled when seeing the photographs. In this way, she creatively intervenes in the way the images are shared, enlivening and shaping the meanings of her travelogue. Though the film is titled "our trip" and the key focus is on two women traveling together, seeing the sights, taking a break from

Figures 15, 16, 17. Opening shots in *Our Trip* (Barbara Hammer, 1980)

quotidian concerns, and so forth, it does not linger much on the details of that trip, preferring to leap associatively from one notion of the meaning of travel to another. For instance, a tour of the dictionary comes after Hammer colors in and dubs an image of one of them hiking "the lavender INCA trail." Her own writing of "Inca" on the photograph leads to a look in the pages of the dictionary for "Inca," for which entry the rather blurry, very close-up words "Indian" and "Peru" are most legible. "Incapable" and "incandescence" ("hot body . . ."), proximate entries in the dictionary, follow in short order, a shot per second or so, just enough time to register. Then the camera leaves the "I" section and moves to "trail," which she underlines with brown marker, highlighting the idea. But it is not just an underline; it turns into the beginning of an image of an unwinding trail on the page, similar to the way she fills in the path on the black-and-white photographs with different colors, showing us the way. The tour we take is by route of Hammer's stream of consciousness, which deftly ferries us across a current of thought in which we discover aspects of her journey because they approximate the way the mind works as it encounters new things: making connections with the familiar and taking delight in the kismet of connections that come from random encounters with unfamiliar places and people. Other words are added to the images by Hammer herself to describe what we see or what the trip's participants are feeling (for example, "ANGER," "SEETHING") or attending to (for example, "FOOD"). So while some of the information is presented to us or elaborated by the apparent connections Hammer makes as she goes among the elements of her trip, others are explanatory and directive, trying to pin meanings down. It's an organic and hands-on approach, and it blends the content of the journey with a number of experimental film techniques that are mobilized to access something akin to a journey in moving images in itself.

Hammer submitted *Our Trip* for consideration in the 1981 Athens International Film Festival, and the judges' comment slips give a cursory sense of how her work was being received in that moment. Overall, the reports are dismissive. One judge's report confesses to being "confused about the film's intentions" and describes the film as interested in "a dialectical structure between aspiration and technique," without clarifying how those qualities might compose a dialectic structure or attending to any of the details of the film. Other judges issue perhaps the more damning evaluation: "content and form do not wed," or "technique overwhelmed content." In other words, the judges condemn the film for lacking the very balance Hammer was at that moment striving consciously to strike. *Our Trip* is indeed deeply self-conscious about its technique, as the above description should illustrate; it highlights the features of the medium that enable the telling of personal stories about the way one moves about in the world as well as about inner journeys, thought, and embodied experiences.

Hammer reaches out to forge the language for expressing these ideas, and she uses the film to explore her own memories and thoughts. It is, like many of the films of the 1980s, a busily playful and dynamic film, with individual shots layering effects and meanings within a very short space. Like the films of the 1970s, it foregrounds lesbian experience and her own body, but now the surrounding environment—onto which she maps thoughts, feelings, and the creative impulse to shape daily encounters into something artistic, lasting, and meaningful in a larger way—moves to the center of the frame, so that the channeling of experience becomes part of the artistic trip.

The next year, for *Pools* (1981), Hammer similarly represented an embodied experience while deliberatively reclaiming and recrafting a relationship to unique, existing spaces. This film shows the development of her commitment to technique and the medium of film within the spirit of experimentation and discovery. *Pools* begins with the sound of water and a thumping noise, as if recording depth. After the title, Hammer offers glimpses of water, from under it. A reflection of the pool floor from the bottom of the water's surface is shown as the camera surveys the underwater vista and bobs through the surface to look around the place above the water. The location is the William Randolph Hearst estate's famous Neptune Pool in San Simeon, California, and Hammer did what it took to get permission to make the film, mainly, she claimed, so that she could swim in this beautiful, privileged, and totally private space.[39]

At first her camera observes the statuary and the quavering waves of light reflecting in the varying shades of blue-green water. Ghostly underwater light allows us to see the ladder, and what begins rather dark turns to brighter shades as the film progresses. At times the image is clear, and the blue, red, and gold mosaics of the walls or the marble statues come into sharp focus. In the mosaics, there are stars dancing and trumpeting merpeople; the statues are graceful and elegant figures of classical beauty, wealth, and status. Hammer's camera pauses on several of these, allowing the eye to take in their shapes and representations. Stairs and ladders leading into and out of the water suggest vertical mobility and the plunge that the body and the camera are able to take. Between the classical art of the constructed statuary and the moving, watery light, several dichotomies—the divergent elements of this world (water, earth), natural and constructed spaces, and the dynamics of cinema vacillating between stillness and motion—are again represented. As often as the image is sharp, it is blurred and abstract. Reflections of light above and below the surface stretch into wavering lines, and shadows of objects in the light's path attenuate the view. Light and water are reduced to a common denominator of waves.

The camera plunges in and out of the water, exploring the sensations of underwater sound and movement. The sound of flowing water, the splash as the camera emerges

from or submerges in the water, the thumping depth-sounding noise, and other sound effects sustain a rhythm. The soundscape connects the spaces Hammer's camera observes. It marks above- and underwater movement and the submersive experience of, importantly, an *embodied* perspective of being in water. Once the film has explored the aqueous environment and its fluid relationship to the world outside of water, Hammer takes artistic license with the recording of these sites, coloring directly onto the film or draining it of color entirely, turning the filmstrip sideways, and slowing down or speeding up the frame rate, frequently stilling motion in the footage in order to add her own movement of painting directly onto the frame in watercolors. In this way, in addition to exploring the medium of cinema, this film (like *Our Trip* and several others) connects to her earlier art experience, to her training as a painter before laying claim to film as her primary medium.

While most of the footage in *Pools* is devoid of any human presence, within these investigations of the physics of light and time and an environment, Hammer does not eschew bodies entirely—nor radical feminist politics. At the end of the film, Hammer designates a space "in honor of Julia Morgan," the architect of the Hearst Estate and its pool, the titular subject of the film. As Ron Gregg has suggested, this film marks a "[turn] to exploring lesbianism in history and biography" in Hammer's nod to "the unmarried, pioneering architect Julia Morgan."[40] Doing so, Hammer recasts the filmic exploration in terms of homage to a powerful female artist who *also* colored in the spaces traversed by the Hearst family. She begins consciously to build a lineage of foremothers and to recuperate lesbian "herstory" for artists whose work across media allows them to occupy (and build) spaces differently than they might usually have been otherwise.[41]

For *Bent Time* (1984), creative exploration of space, geography, and the study of environments is all-encompassing. The film accelerates as it cuts across times/seasons and places, some of them familiar and dotted with landmarks like the Statue of Liberty, others perhaps more personal like a grassy lane where one might take a solitary walk. Hammer described the film as having "moved outdoors, into the urban landscape, the body politic, and claimed those places and images. There is an ambitious energy, roving and uncontainable that won't stay in the closet, at home, or at nation. There is a delight in the abstract, an attempt in the abstract to find a new way of seeing."[42]

The first shot is characterized by stasis and an extremely subtle movement—for twenty-three seconds, a thin streak of light cast on a sandy stone spiral moves slightly, eventually cutting through a crack in the stone near the bottom of the frame. The rock is stasis epitomized. This representation of the extreme slow motion of geographical time provides a foundation for the scherzo of human activity that Hammer then builds to in the film. She channels the kinetic energy of moving in fast motion through

landscapes—much indebted to Marie Menken's film *Go Go Go!* (1962)—and provides another example of drawing from her travels for her subject. Here Hammer's film traces another, but more momentous, life journey—her own migration east from San Francisco to New York, where she hoped to embark on a more serious art career and where she would reside thereafter. From stone monuments and ruins, Hammer fast forwards in time lapse to skim the surfaces of the earth in their many variations, winding up passing over the country to New York City. There, the camera moves toward Manhattan from the water, toward where the Brooklyn Bridge spans the gap between lower Manhattan and Brooklyn Heights. Crossing distances in an instant is a key device in the cinematic toolbox; the claiming of the connection between those spaces is unique in this case to Hammer's personal relocation and span of distances between her previous experience and her new life moving forward.

The film explores the city, but it also strays out to the countryside, and to paths trodden by horses—another touchstone for Hammer's personal journey. The film connects the natural spaces with city places and brings our attention to the experience of those places in a new way. Keeping the camera in constant fast motion, Hammer brings things and places into relationship: here by layering or collaging images. The film's nonstop imagery imparts too much too quickly, such that glimpses become meaningful only when viewed in the context of the whole. This method offers a disembodied alternative for meditations on the body that includes the mind's roving eye. In the end, Hammer returns to the first image, a slow movement of light on stone; it stills the film's relentless motion and returns the spectator to the place where just projected light makes meaning possible.

When she made *Bent Time* in 1983–84, Hammer received her first major grant, from the Jerome Foundation, to help her finish the film. That fact buoyed her, by her own account, as she entered realms she felt had been denied her up to that point. It validated her practice beyond the interests of a lesbian audience that embraced her work. *Our Trip*, *Pools*, and *Bent Time* signal a geographical move to other spaces and occupations of queer art—moving out further into the world and doing nontraditional forms of women's work. Hammer contributes her own creative labor as a layer in this work and begins to assert herself within the wider realm of film art. Her film *Sync Touch*, also from the early 1980s, corroborates the importance of that assertion with its investigation of feminist ways of speaking.

Intimacy and *Sync Touch* (1981)

In a 1979 interview, Hammer wondered, "How can I break through the conventional patterns of perception to capture my sense of intimacy, put that feeling evoked in me

into images, and externalize the internal feeling that is truth in its deepest sense?"[43] This question sticks with Hammer for the duration of her working life.[44] Though *Sync Touch* (1981) looks very different from *Bent Time*, both films are examples of a cinematic answer she conceived for addressing the idea of externalizing internal feeling and making clear her "sense of intimacy." Feeling is established as the central subject of *Sync Touch* in an array of ways. Roughly divided into three beats, it devotes its first third to abstractions connoting tactility. Accompanied by a percussive beat and edited metrically, the rhythm of the first sequence asserts an importance equal to its thematic meanings. Hammer presents still images that she then manipulates, putting bright and thick swaths of paint on them, moving them manually in front of the camera to give them a different kind of motion than that usually found in cinema, presenting them in negative, and showing them leap into motion to belie their status as still images. Sometimes she moves the film strip from the top of the frame to the bottom to mimic the movement through the projector—which simply draws attention to how film *usually* works, but which is not being done *here*. How does it work here? She films what she has already filmed, generating new images out of the raw material specifically of cinema, leading to a mise en abime of imagery.

An exploration of cinematic and actual tactility shapes this imagery. This first section presents multiple images of hands: a spread of two hands in a single black-and-white image with the background dark and one hand left in photographic white while the other hand is painted red; after a moment the white hand is splotched with bold colors of paint (red, purple, blue, gold); these hands are printed on noncolor film but become brightly colored all the same; after a moment, we see that the image of the black-and-white photograph being colored is refilmed on color film stock inasmuch as we see a hand appear over it in color; the very next image is the same hand, now with the nails colored with paint, just like the image it hovers over (figure 18). Speaking of hands: speaking *with* hands is also part of this section. Hammer takes little paper cutouts of hands showing the form for each letter in sign language; she moves them around in chains of possible words and fragments. Eventually, a set of hands appears in close-up; the cutout hands are rearranged and move as if of their own will around the large hands until those large hands are rubbed together and cause the paper to magically disappear. The film enacts variations on cinematic prestidigitation, where a sleight of hand (and stop-motion animation) conjures powerful illusions. In addition to these multilayered hand images, there are several other images of two or more hands, the centers of tactile in- and output (as the second section of the film will tell us). The sequence continues with images of two hands reaching out to each other. Hammer paints over these images with her hands as the film rolls, invoking the sensation of

Figure 18. Touching hands and the tactile image in *Sync Touch* (1981)

feeling and touch. Then she cuts to hands that have come together to touch. She cuts back to the hands reaching, then to the hands touching. The simulation of the act of touching is accomplished through the cut—an ironic way of bringing together proximate but separate objects as if they are touching, enacted through common cinematic techniques. The hands resemble those of Adam and God on the ceiling of the Sistine Chapel—a spark of creation generated through touch. In highlighting and manipulating the material basis of film images throughout this sequence, Hammer joins medium and sensation, conjuring an answer to the question of how to "break through the conventional patterns of perception to capture [her] sense of intimacy."

Close-ups of film strips appear several times through this first third of the film, and crayons are used to smudge paint or watercolors across the film frames. At a certain moment, the smudges take the shape of fingerprints, showing the trace of a touch. In a cut-up collage of a girl and Hammer herself (both still images from Hammer's documentation of her performance piece titled *Camerawoman*[45]), figures interact and merge again by means of the cinema's tools. She points to the tactile possibilities of cinema that she had explored in such a different way through *Dyketactics*. As if to remind us of that difference, in the middle section of the film, footage appears of two female

bodies touching each other sensuously. Just before that part begins, there is a long narration by a woman whom we see synchronously speaking in Brobdingnagian, extreme close-up, such that her mouth and other parts of her face are rendered abstract and almost grotesque, similar to Willard Maas's *Geography of the Body* (1943). The woman in this segment tells us about tactile impulses, and alerts us to the prominence and biological foundations of touch: "Biologically . . . the cortical representation of the lips and of the hand, especially the index finger and thumb, are much larger than other areas of the body." Through all of this section, the camera is strange; it occasionally seems to stutter in the projection gate or blur without cause. The step motion advances with juddering slowness. Hands touch breasts while around the bodies colorful shapes arise; images of a hand massaging a clitoris suddenly float up as a series of still images on a film strip; lines are drawn around two lovers. These effects aim to remind the viewer of the connection between the ideas of tactility and the means for conveying that idea through the sensuous medium of film, however imperfectly.

The final section drives home the connections among touch, language, and film through what it says and how it says it. Hammer and Roswitha Mueller, a feminist theorist, speak in French (subtitles are provided, underlining language on the register of translation).[46] In the shot that begins this section, they face each other and the camera comes in closer. In short phrases, Hammer repeats what Mueller says (figure 19). Occasionally Mueller corrects her pronunciation. Together, they say: "Feminist language is complete. It reunites mind and body, intellect and reason, to physical sensation and emotion." The camera is quite close to them, and at first we see only their faces. It moves out just a bit to show that they have their arms around each other as they intimately intone what follows: "I think French is intellectual and rational and good for theory. It isn't good for emotional or sensual expression." Next, the camera cuts to a shot with their faces smooshed close together, so that we see only one eye for each woman, and they have turned to face the camera. They continue: "We are in a culture where expression of the heart and the senses are repressed." Finally, the camera cuts to the same opening shot, with them facing each other again, only now they whisper: "The heart of film is the rapport between touch and sight." When they utter in French "spectacle" (translated in English as "sight"), they turn to the camera and break the fourth wall to address the spectator of the spectacle directly, returning sight with sight.

In their body language, their intimacy of proximity and of hushed voices, they bend French—the language they have deemed "good for theory" but not "for emotional or sensual expression"—to their will. Their argument that cinema serves as a connection site for touch and sight derives not from all of cinema but from Hammer's particular

Figure 19. *Sync Touch* (1981) and translations of senses, ideas, words, images

articulation of it, observable in the scene in question and what has preceded it. The cinema via Hammer links vision with feeling—it synchronizes touch with sight. Mobilizing theory (and a film theorist), Hammer demonstrates her interest in the way film can enact a particular thought about how such complex operations might work and visualize it as well as translate it from and into feeling.

The Arrival of *Optic Nerve* (1985)

A big step toward recognition in the larger art world came for Hammer in 1987, when *Optic Nerve* (1985) was selected for the Whitney Biennial. John Hanhardt, curator of the film and video entries, chose *Optic Nerve* for inclusion in the exhibition.[47] In his accompanying text for the Biennial catalog, he described it as a "compelling meditation" that provided "a powerful personal reflection on family and aging."[48] Although Hammer had by this point begun to win awards and grants for her work, the Biennial marked a point of arrival for her in her move from the West to the East Coast.[49] It was an indisputable achievement that was legitimating to Hammer's sense of her work, and it shaped the way she would promote that work and advocate for it thereafter.

Optic Nerve's point of fixation is Hammer's grandmother, Anna Kusz, who had recently gone into a nursing home. Hammer was close with her grandmother—she is

one of the primary subjects of at least three of her films, and she influenced Hammer's decision to be an artist—and she described her film as an effort to work through some of the feelings she had in helping her to go through this difficult transition.[50] She was deeply upset by her grandmother's treatment in the home, writing to her uncle, Will, the year before making the film and pleading with him to move her out: "She wants out of the nursing home. The sights you see there give you nightmares and I was deeply distressed during my stay in California. . . . She told me she wouldn't eat because she is not happy. I wouldn't eat there either."[51] Just as in *Sync Touch*, *Optic Nerve* begins with the image of film strips, announcing the medium itself as one of the main subjects as well as the material for the film. Hammer told me the film aimed to balance her feeling about her grandmother with structural techniques, creating something that structural film had not yet accomplished. She claimed that, for her, the film both relates to her grandmother and is also not just a use of but a response to norms in structural film:

> So, when I moved to New York in the mid-'80s, I think about '83, the art world was dominated by minimalism, by structural filmmaking . . . built on what the camera could do, or the equipment around the camera, or the way perception is built. But I thought . . . they left heart and emotion out of film. And I wanted to use the qualities of filmmaking that they had brought to the fore—the apparati and the methods of filmmaking, with an emotional reason to make the film, besides an academic study, which I think, ultimately, structuralism is.
>
> So, I used my grandmother, who had lost one eye. You don't see that, but she only had one eye that could see, so that gave me a flat screen. Because we need two eyes for depth perception. And I used my optical printer because that also, in rephotography, brings a flatness to the screen, much as my grandmother was perceiving. . . . I used her demise in a nursing home, because I had to put her in that home which was difficult. I didn't have a way to take care of her. And to show that, I used emotional techniques that were really camera techniques, that one might use in structural film.[52]

The images Hammer provides walk this line between emotion and medium abstraction. As Rizvana Bradley puts it, "*Optic Nerve* demonstrates Hammer's proficiency with fusing the materiality of the medium with the physiology of her subject. . . . The line between materiality and image is radically blurred as the body *in* and *of* the work fuse and strain against both time and technology."[53] A good example is the first image of her grandmother, which is shown on a film strip (including sprocket holes)

with the serial presentation of its adjacent images above and below as Hammer moves the film strip vertically within her frame, as if through a projector. All of these serial images, even in (or perhaps because of) their multiplicity, are difficult to make sense of; eventually, we discern that we are looking at a wrinkled neck as Hammer's grandmother's mouth comes into view (it calls to mind the same defamiliarizing extreme close-ups of the face in *Sync Touch*'s middle segment). Almost the moment the image becomes clear, Hammer begins to manipulate it and make it strange again, for instance by infusing the frames with green and red tints that flash as the strip continues to roll, now at double speed. The next shot collages an image of her grandmother's face dominated by a single eye, signifying the flat image and her grandmother's vision impairment. In the next moment, she puts color footage of her grandmother, running simultaneously right-side-up and upside-down toward the center of the frame in a doubled, inverted image. Hammer explores the moment—and the apparent weight of the feeling her experience generates—from every angle.

Whether the image is abstract or legibly representational, such as with the occasional glimpses of other residents in the home as Hammer pushes her grandmother in a wheelchair through the building, Hammer cut the film to draw attention to the recursive nature of her experience of this encounter. Her visit with her grandmother in the film is marked by hesitations. Their progress forward as Hammer pushes her wheelchair is stymied by repetitions of the same moment, by step printing, and by exploration of individual frames (similar to Ken Jacobs's *Tom, Tom, the Piper's Son* [1969]). Movement forward slows or stops at multiple points in the sixteen-minute film. Despite the fact that one of the only recurring phrases of the film is "straight ahead!", Hammer seems equally set on looking back as going forward. Hanhardt picks up on the way memory and time are layered in the film when he admires the way "the sense of sight becomes a constantly evolving process of re-seeing images retrieved from the past and fused into the eternal present of the projected image."[54] The film brings into focus a collection of small details and objects—a lamp, a table, a hand. They take on significance through Hammer's extremely close attention to them through cinematic postfilming manipulations, particularly in her use of the optical printer and coloring processes.

The use of an optical printer was high on the list of techniques that charmed Hammer and influenced her work in the 1980s. As John Powers has shown, the optical printer "influenced . . . the avant-garde's long-standing investment in perceptual transformation" in the hands of creative technicians like Hammer.[55] He links Hammer's interest in sensuous tactility in particular to her use of the JK optical printer, which was compact and portable. In his interview with Hammer, she remarked that it

"encouraged creative intimacy. . . . I worked intuitively and kept journals of detailed technical notes. I would have an idea, make it happen, and follow whatever idea came next. This process was extremely satisfying and exemplified my creative process. I loved this printer."[56] Indeed, Hammer purchased her own in 1983, and it was one of her most prized possessions.[57] The effects it accessed were already part of her wheelhouse, as she had innovated makeshift solutions for making double images for a decade without one, as in her quadruple printing of the four reels of film in *Dyketactics*. The use of the printer in *Optic Nerve* readily allowed Hammer to explore existing images in detail and then to layer them with other images, linking them materially and visually, and with greater certainty about the look of the outcome. Moreover, the title of the film connected the printer's optics with those of the eye and its connection to feeling—a key aesthetic motivation for her work at this moment. (The optic nerve transfers visual information to the brain, where it may be processed, felt, and understood.)

While *Sync Touch* emphasized the connection between vision and touch as a theme and argument about her film practice in general, *Optic Nerve* mobilizes this connection in order to explore a specific feeling: the emotional terrain traversed while caring for a loved one in decline. Hammer repeats moments—such as her grandmother moving her hand away from her as Hammer reaches for it—to underline that feeling. Underlining happens through the technique, but however much the film seems to highlight techniques, it is not the technique that is the point but the means for making the point. As ever, she aims to strike a balance between the emotional content of the film and the techniques for accessing and sharing that content. Hammer noted that in repeating the shots multiple times, they gradually dissolve and become less clear through rephotography: "So, this shows repeated action, and not only becomes a ritual and allows you to do something that you have a real resistance to the first time, but it also carries, for me, the emotional impact—or imparts the emotional trauma, of doing something . . . that I had no other way out but to do."[58] The filmic technique (rephotography, repetition) has a psychic equivalent in terms of her dealing with her aging grandmother.

The film thus opens onto issues of aging and medicalized bodies that Chuck Kleinhans recognized as a shift in Hammer's work of the 1980s. The jouissance of her 1970s films and their claiming of a space at once cinematic and public for women's bodies and experience is here applied to a very different context. Hammer roves around in images of her grandmother both from the past—while her grandmother is spry, mobile, and smiling—and in the present tense of the film, in the nursing home. Her camera stops on the eye of her grandmother or to observe the way she walks away from her—as if hoping to fix the image in her mind and on the film. Hammer connects

her grandmother's experience to her own by including herself and foregrounding the dynamics of her artistic intervention in the moment, and in this way makes a strong intergenerational statement about her place in a continuum of strong women. Later, she will further explore her grandmother's past in the documentary mode that comes to characterize her films in the next decade. But here, *Optic Nerve* allows Hammer to find a first entry into the art world, where curators and grant-making entities increasingly begin to take notice. Especially in its use of experimental time loops and its emotionally vivid subject and theme, notably connected to but visually distant from the body of the filmmaker, the film finds a productive shift in method and look that will expand some of her playing field while still allowing Hammer to investigate the topics that engrossed her creative imagination.

Technological Experiments and *No No Nooky T.V.* (1987)

Hammer noted that her curiosity about new technologies—really anything that allowed her to experiment with the generation of different kinds and qualities of images or sounds—drove several projects or ideas for new work. This is the case in a 1987 work on video she began when she had access to a Commodore AMIGA computer program, which allowed her to create visual illustrations through commands, drawing on a new source of play for originating images. The AMIGA had only been introduced in the consumer market in 1985. A jump forward in designer applications and technological capacity, it featured a veritable rainbow of over four thousand colors and, with its advanced processing speed, could run several applications at once.[59] Experimenting with its capabilities, Hammer introduces a flurry of images, text, patterns, and sounds throughout *No No Nooky T.V.* Not unlike others of her films in this period, it seems to offer too much information to take in at once: the screen changes one element while another remains, colors mutate or shift, images overlap, words fly in and out of the frame, and parts are collaged together in mutating configurations.

Much of the film is focused on the craft of generating and animating designs and images. While it makes reference to TV both as an object and a theme, it stands in contrast to television's penchant for simultaneously capturing and broadcasting live images and its disinterest in directing the viewer's attention toward the tools of creation that Hammer employs here. Rather than live-ness, the act of creation is central. Creation myth is skewered in the first moments of the film. Over a black background, the voice of the computer is heard, as if in the moment before (were it another kind of creator) it would command, "Let there be light." The voice instead announces: "I have a male voice. I was created by men in their own image. So I have a man's voice. They

would not think to give woman a voice. However . . . by appropriating me women will have a voice. So there." In the gaps between statements, one can faintly hear the clacking of the keyboard as what is typewritten becomes word. The film manifests this trajectory of coming into being; commands become words uttered or text appearing from where no text was, which become images, which become flesh as the body of the filmmaker appears in the frame within which another kind of filmmaker might have immersed the spectator.

After these words have emerged from darkness, they become deeds. Starting with the program's text and drawing functions, Hammer draws (seemingly by hand) a primitive outline of the midriff of a nude woman's body in red over a green background with blue typed words—"ELECTRONIC BODY"—as wallpaper. While its basic computer design makes it look somewhat simplistic, the full range of specific details depicted in the film for the following (typical) second or two derives from many choices and actions. A second body is drawn, partly overlapping with the first. Above the breasts, lips are drawn over the two bodies, integrating their lines with the lines of lips. The lips are filled in, then the lines of the lips are made bold in green, connecting them to the background. The words "EROTIC TEXT" are typed over the lips, with EROTIC above the line and TEXT below (figure 20). The image snaps

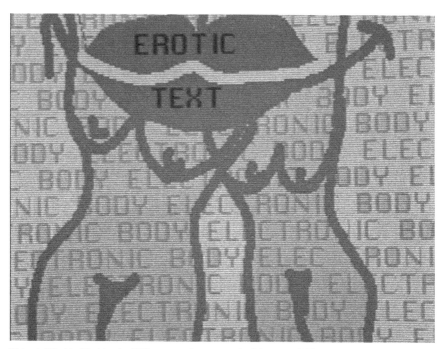

Figure 20. *No No Nooky T.V.*'s computer-generated images (1987)

to a slightly closer view. The whole time, the background flashes from blue to green, but at this point it disappears and is replaced by a wholly blue background with a few green dots. The image of bodies now appears like a collage cutout. A quick flash to black, and the image snaps again to a closer view. The word "LOVE" appears on the bottom of the lips. All of these visual layers take place in about eleven seconds, accompanied by bleepy computerized music, which continues as Hammer further plays with the options available to her in the program. She thus foregrounds her command of the apparent male domain embedded in the computer protocol of this female friend (named as such: "amiga," a point Hammer brings out later in the film when she seduces the AMIGA and calls herself and the computer the "TWO AMIGAS"). She appropriates that protocol for her own flirtatious plans with the screen—a metaphor if there ever was one for Hammer's larger project of reworking the tools of cinema for highly personal, experiential, creatively expansive intentions and discoveries.

Some of the film is abstract—boxes fill in with different colors, dots and lines are drawn or appear at seeming random—and some of it is explicit and/or otherwise representational. Overall, the film recounts a sexual encounter that plays out over the phone line, using the same means for connection as the computer (a sound like the first internet connections through the phone line recurs through the film). In text, she asks: "does she like me? WANT ME? . . . She called. . . . Didn't know if she wanted art or love. . . . You can have both. And more. Much more & more." While we are immersed in the computer screen—for most of the time, the frame of the film is the frame of the monitor—the explicit encounter (for example, "getting ready to fuck you," "spray me," "vagina fireworks," "I'm going to say some dirty words") is presented either through the appropriated male voice or through suggestive drawings and in typed or handwritten text on the computer screen. Thematically, the film ruminates on how "desire is a construct." Only, when the computer utters those words, "construct" is pronounced by the male voice with the emphasis on "struct," nuancing the more static concept of "a construct" with the suggestion of its verb form "to construct," highlighting the act of making of the artwork in front of the audience. After providing only an immersive view of the computer screen (without any part of its frame showing), Hammer shifts to several images that lay bare the fact that we are looking at a screen that contains another (and sometimes two other) screen(s). This happens in several ways: as she turns her seduction to the AMIGA itself, she applies massage cream to the screen, reminding us of its surface. We are shown a hand silhouetted in front of that screen, drawing attention to the space outside of it; Hammer appears, rubbing a vibrator around her face as she stands before the monitor;

there is a side view of two monitors with projections on the side surfaces while the screens display other figures and words; a matte provides images from earlier Hammer films including *Yellow Hammer*. Similar to this profusion of types of images (different origins, different ontologies), the sound also derives from multiple realms: the computer-generated voice, the voice in the reader's head as words appear on the screen, sound effects such as the phone's busy signal, voice-over from other sources (for example, a woman narrating a time when her lover talked dirty to her). The effect is a cacophony of images and sounds that all serve to underline an obsessive, sexual, explicit *creation*, effected with a deep irony regarding the tools used to express the desire that fueled the encounter.

Like other films Hammer made in the 1980s, including *T.V. Tart* and *Bedtime Stories I, II, III* (both made the following year in 1988), the unique dynamics of *No No Nooky T.V.* seem to have been initiated by her exposure to and delight in experimenting with the possibilities of a new technology. It afforded her new possibilities that ignite a playfulness in each of its subbeats over the trajectory of its seminarrative arc. Its joy in discovery is expressed through juxtapositions of the different languages it employs—the language of the computer, the text, the sounds, her own earlier work. These drive it to its (literal, or as she suggests in the film, "cliteral") climax. While in its focus on a cyber-realm it looks different from several of the other films from this period, especially the ones that focus on experiencing travel in real places, it belongs very much to a decade characterized by further exploration of the medium and efforts to expand her audience. It repositions some of the lesbian content of earlier films in a co-opted space that "would not think to give a woman a voice." It is easy to imagine that in this moment of expanding into the realm of the art world, Hammer might have thought of such a gesture as emblematic of her ambitions more generally.

Still Point (1989)

As the 1980s came to a close and Hammer was gaining wider recognition, she worked on a couple of films that merge the playfulness of *No No Nooky T.V.* with a thematic seriousness that would incite a shift to a documentary mode in the following decade. In *Endangered* (1988), she shows herself working at her optical printer and shares the results of that work by reflecting on the medium of film as well as on the animal kingdom and natural world, both of which are presented in juxtaposition with the technology at play. Images of her printer, snowfall, film strip perforations, and abstract blurs of objects are layered over each other. The edges of the image become themselves a frame for another image, so that a border frame of snow surrounds an object; images

become part of the act of cinematic framing and not just representations of things. Tigers, lions, and blue-footed boobies appear, touched by cinematic techniques—the tigers are divided into a split frame almost like a Halloween costume with one person playing the front and another the rear of the animal; the blue-footed boobies have ripples of damaged film around them; lions are framed with the image-as-frame as described above, and also with the film emulsion scratched around them (figure 21). In its foregrounding of the medium of film as a conduit for thinking through endangerment of the animal world represented in images, Hammer took steps toward expressing an outward-looking social consciousness that would increasingly become a source for exploration in future projects.

Similarly, in *Still Point* (1989), a medium-specific experiment supports a series of ruminations on homelessness, coupling with a life partner, the American "dream," and (again) travel. It represents an apotheosis of intersections among different creative approaches expressed through its multiple screens, use of filters, slow motion, black-and-white versus color film, and movement running up, down, outward, and inward—all of which call attention to the process for making each image. Its title's source, taken from lines of T. S. Eliot's *Four Quartets*, points to the film's interest in holding the tensions of these movements together in an aesthetic instant:

Figure 21. *Endangered* (Barbara Hammer, 1988)

At the still point of the turning world. Neither flesh nor fleshless;
Neither from nor towards; at the still point, there the dance is,
But neither arrest nor movement. And do not call it fixity,
Where past and future are gathered. Neither movement from nor towards,
Neither ascent nor decline. Except for the point, the still point,
There would be no dance, and there is only the dance.[60]

Hammer's first master's degree was in English, and (not unlike one of the filmmakers she most emulated, Maya Deren) she gravitated toward T. S. Eliot and *Four Quartet*'s articulation of ideas about balancing stillness and motion, multiplicity and singularity, "transiency and rootedness"—ideas expressed throughout *Still Point*.[61]

The film is divided into two or four frames for most of its duration. The opening shot, a grid of American flags, shows each of four images with different filters, the flags fluttering at an almost imperceptible different speed and with some images inverted. Instead of focusing on four different things, Hammer often puts the exact same thing under scrutiny in slightly different iterations, underlining perspectives rather than things. The connections between the things depicted happen in the simultaneity of their presentation in multiple frames—sometimes in configurations of four but also with three or two images within the same shot. The editing and layering of raw or manipulated images then also creates new combinations. For instance, within the shot, the camera pans over the flags, which give way to their context, a merry-go-round (figure 22). The merry-go-round flashes to a single image of a man in close-up and black-and-white: a documentary image of a serious person with human needs whom one might encounter on the streets, which is a foil to the flash and color of the children's amusement (figure 23). This connection is supported as the camera cuts between other people similarly presented, against a soundtrack of Hammer talking about people in doorways and shelters, combined with a man's voice noting that something unnamed was "open only when the temperature fell below forty degrees."

Talk of the weather is picked up on again later as Hammer and Florrie Burke reflect on their recent choice to become life partners. Shots of them on a nature trail are juxtaposed with talk of the weather on the radio and whether the weekend would be good for being outdoors. This, beside the repetition of the idea and image of homelessness, creates a strong, socially conscious contrast between the women at play and the people surviving on the streets. Hammer uses her own complicity in the failed social contract that allows people to fall through the cracks when she and Burke talk on the soundtrack about "domestic boredom" and "sharing the wealth" in their partnership. As they playfully share an apple down to the seeds, a man rummages in a garbage can.

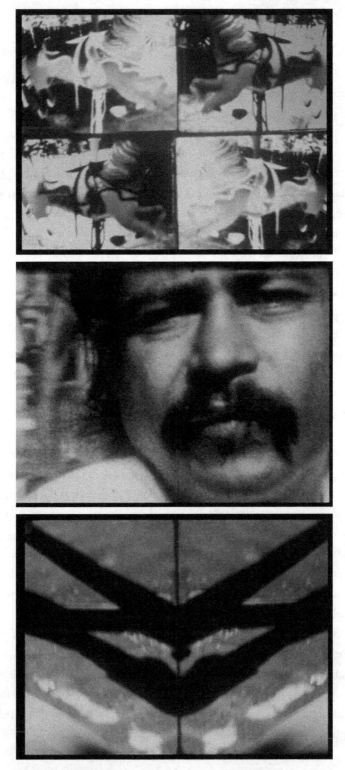

Figures 22, 23, 24. *Still Point* (Barbara Hammer, 1989)

Hammer contrasts color footage of herself and Burke as well as flags and merry-go-rounds (visions of American dreams and leisure) against black-and-white images of people panhandling and sorting through garbage on city streets. A dilapidated house is presented against the empty, inviting hiking path. The connections are not explained or explored as documentary issues, but they are presented in this way as an artist's response to an awareness of those issues. And through its images and the cinematic devices used to present them, the film's overarching themes become clear: they grapple with privilege in the face of visible and pervasive poverty.

Through its multiple images, use of color, and abstractions, *Still Point* extends some of the same aesthetic exploration of Hammer's other films. People casting long shadows on the pavement become lines and designs in the urban landscape, then chevrons, as Hammer bends the lines across a frame split vertically down the middle (figure 24). Some of the images are in negative, others are treated with filters or flipped; the hunger for seeing what kinds of images are possible is discernible as much as ever. But the societal critique implicit in the ways the images are contrasted has extended outside of the realm of identity issues that characterized the films of the 1970s. This emphasis galvanizes and redirects interests that are perceptible but underplayed in films like *Menses*, where she presents individual responses to a single issue (menstruation) as a collective event. An interest and curiosity in broader social issues finds purchase increasingly in the following decade.

Janus-facing the 1980s

Points of intersection in the 1980s films abound. They absent the female form that populated the films from the 1970s, they focus on places (a famous pool, tourist spots in England and New York, snowy or grassy or aqueous landscapes), they embrace new ways of looking at the world, and more. The 1980s films represent both innovations in Hammer's style and an updated creative response to her aesthetic, social, and political passions of the 1970s. They are a collective act of questioning of where she has been and where she is going, sometimes literally picturing both directions and considering the flexibility of time, memory, and lived experience through cinema.

In the end, the turn to make form more central, to render it equal with the radical content of Hammer's 1970s films, underlines the need for rethinking the purview of feminist film/art and theory. Feminist art activity was mercurial during this period as it looked for outlets that would accommodate its moves and allow it to shrug off or repurpose its past to move toward its future. For Hammer, it involved a restless search for the oblique angle by which a feminist practice might confront staid traditions. This approach paved the way for further moves—off the map as it had been charted thus far.

That is, without eschewing lesbian content, Hammer's work in the 1980s took a turn toward a broader horizon of experimentation that emphasizes form and a perceptive, embodied, feminist, lived experience. What prompted this shift for Hammer was her sense that showing lesbians was not sufficient for a feminist cinema. To court a different audience and to establish a foundation for thinking through a feminist cinematic ethos required a turn to further formal experiments predicated on a basis of theory that she expressed creatively in her films and in writing, presentations, and interviews. She explicitly and ecstatically engaged with formal experimentation, and in so doing, like many of the female filmmakers of the 1970s who moved into the 1980s and beyond, strived through her new work to assert herself in the larger art world. Her work in the 1980s looked to other aesthetic strategies—to an unbounded screen that commingled art, feminist language, medium-specific exploration of film's expressive capacities, and life.

1990s

Rewriting Herstory

The 1980s found Hammer busy at work especially with exploring the form of film and expanding her films' access to a wider audience; in the 1990s, she continued these initiatives while also turning to new sources for inspiration. She attempted new forms and broadened the scope of the content on which her films focused. Most obviously, much of the work in this decade was fashioned in longer formats and with a documentary emphasis, somewhat downplaying but not abandoning experimental aesthetics. Still, the overarching aims of the 1990s films remained consistent with the earlier work: these aims included making queer experience visible, considering empathic subjectivity, arguing for the fluidity of sexuality, and restoring the history (and the "herstory") of this fluidity, which she argued had long been elided, erased, or misrepresented. Harkening to the powerful combination of experimental and documentary forms in film history, Hammer's work in the 1990s addressed itself to the lack of representatives for queer experience and felt around for models for and language that speaks to that experience. Unlike the eclectic, prolific style of working in the 1980s—which yielded so many more works than there is space to address here—in the 1990s, Hammer consolidated her energy into a smaller set of longer works. The four major films of this period, *Nitrate Kisses* (1992), *Out in South Africa* (1994), *Tender Fictions* (1995), and *The Female Closet* (1998) share these qualities and assert the shift in a documentary direction for Hammer's creative energy.

While *Nitrate Kisses* marked the first feature-length work in Hammer's oeuvre, before it and at the very outset of the new decade, we see several of the same tendencies of the longer films in microcosm within a trilogy of short films—*Sanctus* (1990), *Dr. Watson's X-Rays* (1990), and *Vital Signs* (1991). Within each of these films, Hammer angles for a way of getting at complex themes, and each is marked by its particular relationship with evidence. Whereas the films of the 1980s had moved away from a focus on the body, in these earliest films from the 1990s the body becomes central again, albeit in ways quite different from the 1970s. Turning on their head certain notions about how the female body offers a spectacle *to be looked at*, as well as

issues relating to conventional identification and the interiority of subjects in cinema, Hammer spectacularizes the interior terrain of bodies in these three films. Across the works, she explores the possibilities and limits of the medicalized body as well as of the cinematic tools for presenting it. Running at an angle to documentary, the films seek alternative paths to court elusive ideas.

Not Bare Bones / Between Things

The trio of films, *Sanctus*, *Dr. Watson's X-Rays* (both 1990), and *Vital Signs* (1991), were made within a short span of time and intersect at several points. Most obviously, they prominently feature images of skeletons, whether shown through X-rays, in cutout paper images, or as props. These images serve as concrete touchstones for elusive and abstract ideas about mortality, creativity, identity, and beauty. The films also collectively expand Hammer's interest in Jungian self-consciousness, ego, and ways of understanding the world. Although they are shorter and in some moments more fragmented, collaged, and playfully edited than the documentary feature films shortly to follow, together they foreshadow the approaches, imagery, and issues Hammer would develop in the decade's major projects soon to follow.

Having toured the archives at the George Eastman House (now the George Eastman Museum[1]) in Rochester, New York, Hammer came into possession of found footage of several examples of cinefluorography (X-ray moving images) taken in the 1950s by James Sibley Watson, Sydney Weinberg, and their colleagues. A polymath with the means, connections, and skills to pursue a number of interests, Watson was a one-time literary editor, maker of ethnographic film, and eventually a doctor with more than a passing interest in photography and moving images. With Melville Webber, he cocreated the experimental films *The Fall of the House of Usher* (1928) and *Lot in Sodom* (1933), considered part of the first American avant-garde cinema. The latter film would come to play a significant role in Hammer's *Nitrate Kisses* (1992). Describing his role in making the earlier avant-garde films, Watson noted that while Webber contributed the scenario, scene painting, costumes, makeup, and ideas, he (Watson) was responsible for the lighting, filming, developing, printing, splicing, and projecting; in other words, Webber was the "idea man" and Watson the experimenter at every level of the filmmaking.[2] Having at that time only recently discovered a passion for film, even in the first blush of owning a camera Watson exhibited a propensity for technological experimentation. When touring Paramount Studios in Astoria, he waylaid a production on set by questioning D. W. Griffith's cameraman Eddie Kronjager about lighting and other techniques; when making their first film, he tried out methods to create superimpositions (later he would innovate his own makeshift optical printer, another point of connection Hammer appreciated).[3]

In 1930, around the same time as they made these experimental films, Watson and Webber also produced a film commissioned by Bausch and Lomb Optical Co. in which they treated a documentary subject in a manner that anticipates their X-ray films. The staff at *Movie Makers* journal, reviewing a selection of the best amateur films of the year, selected this film, *The Eyes of Science*, describing it as following what was beginning to emerge as a pattern of accomplishing camera effects with technological brio:

> Multiple exposures, lap dissolves, color and microcinematography, as well as a number of surprising photographic effects, give this film a technical interest much above the average. Of these, some of the exceptional examples are the photography of light rays passing through prisms and lenses; a recording of the phenomenon of Newton's Rings in color; a scene showing a subject, together with its image on ground glass of a camera; strains in a structure revealed by polarized light and many other remarkable shots. In short, the combination of cinematic art and skill with which this film is composed places it well in the front rank of all existing industrials regardless of the source of their production.[4]

Hammer learned about this film and its radical forms of experimentation and aestheticism wedded with science, as well as the cinefluorography footage, on a visit to the Eastman House in 1990. Her recognition of a kindred spirit in Watson led to several nods in his direction in her films from this decade.

The footage Hammer brought home from Rochester was the result of Watson's labor as part of a team of radiologists at the University of Rochester Medical Center. These men took hours of cinefluorographic footage from the 1940s through the 1960s for what seem to be purposes both medical and aesthetic. While the fragments of the footage in Hammer's *Sanctus* represent a mere fraction of the thousands of exams the doctors devoted to cinefluorography (most of which were considered confidential medical records and which were slated to be recycled for the silver comprising an element of their film materials), they remain an illustrative subsection of the original films' twin aims. Although their primary purpose was to make transparent the workings of the human body, they equally make plain a visual and technological curiosity similar to that which must have driven Watson's role in the experimental works of the 1920s. The films Hammer uses lean in this latter direction. Several of these moving X-ray images transcend their purely scientific aims of demonstrating an aspect of the internal body that may prove useful to those studying medicine. Among films that

showcase the movement of liquid through the upper digestive system or that show the neck bones as they flex forward and backward, allowing doctors access to the interior mechanisms of the bodies they were treating, Watson and his team also include several X-ray subjects performing a variety of tasks (for example, holding a camera) that are unlikely to have had significant scientific value but that must have been of interest to the inquisitive team of cinefluorographers. Even a couple of moments that document the doctors themselves as skeletons or that show their stethoscopes in action observing a patient's breathing or heartbeat seem to be about more than just seeing how things move on the inside while they use a stethoscope on the outside of the body; the inclusion of their own intervention offers a (dangerous) self-view as a nonpatient doing their daily routines. The blur of Watson's aims evident in the films corresponds to aspects of Hammer's approach at this moment as well. In her reworking of the films, she acknowledges their affinity with her own fixations, including, as Miriam Posner has suggested, their mutual uncovering of "the truth about bodies."[5]

Sanctus uses Watson and Weinberg's footage to construct a meditation on what lies beneath the surface of the skin. The film penetrates this mystery literally, in the form of the X-rays that pass through the surfaces of living people, and figuratively, in probing the elusive qualities that would seem to spark people toward various forms of activity despite (and in the full knowledge of) the inevitability of mortality. The sampling of footage that came into Hammer's possession may have been a unique subset of the full collection of films made by Watson and Weinberg, as archivist Morgan Wesson reports in Hammer's *Dr. Watson's X-Rays*; all the same, Hammer gravitated toward examples from the footage that showcase animated bodies in excess of a medical purpose, such as images of skeletons shaving or playing a trumpet.[6] She also playfully transforms more quotidian examinations into something near magical. Barium liquid is swallowed, then reverses and ascends the gullet again. Skeletons double and raise and lower arms simultaneously, split into multiple frames, or radiate with Hammer's addition of bright colors like green, yellow, or orange. She underlines the strange beauty of the footage—for instance, dwelling in fascination on the oddities of cinefluorography's representative process as when a leg swings forward, rendering the flesh briefly visible as a ghostly presence around it—*and* she generates her own strange beauty by bringing the full force of her experimental toolbox to bear on the footage.

Two distinct realms—the X-ray films and Hammer's own cinematic practice—comprise *Sanctus*. The X-ray films offer contemplation of the body per se, the nature of images of bodies, and a peppering of reminders about the memento mori that is the body, especially perhaps the skull (alas, poor Yorick). In effect, *Sanctus* sits at the fulcrum between the kinesis of moving images and the stasis of the memento mori.

Figure 25. Pretty skeletons in *Sanctus* (Barbara Hammer, 1990)

It looks at and through objects that do and yet do not quite yield their interiority. Wilhelm Roentgen's first X-rays offered a similar paradox: his images of his wife's hand show her skeletal fingers with a wedding ring. The hard jewel is entirely opaque and obstinate—no interiority at all—while the hand yields its secret bones readily. But both signify something in the image, and almost in inverse: the wedding band tells us something about the relationship of the photographer to the subject while the subject is laid bare without revealing anything further at all. In Hammer's film, similar estranging effects derive from seeing the movement of bodies unencumbered by clothing and muscle—often doing things that skeletons just don't need to do, like apply makeup (figure 25)—and sometimes with ghostly traces of breasts, legs, and other parts that are difficult to identify or name.

Animating skeletons in moving pictures has long been an attraction and has had many precedents in mainstream cinema, from the rhythmic early sound short *Skeleton Dance* (Walt Disney, 1929) to Ray Harryhausen's skeleton fight in *Jason and the Argonauts* (Don Chaffey, 1963) to Gore Verbinski's troop of underwater marching half skeletons in *Pirates of the Caribbean: The Curse of the Black Pearl* (2003). Each of these adopts its own creative cinematic approach (cel animation, stop-motion models, CGI)

to bring collections of bones to life from a state of implied or explicit narrative inanimation: death. Cinema has been a fertile site for thinking about animate and inanimate states of matter—beings in thrall to time's vicissitudes and inevitable havoc on bodies. Hammer's use of Watson's footage in *Sanctus* offers something more off-putting than these playful or genre-specific uses of skeletons; she proffers glimpses of living (documentary) skeletons in motion and directly confronts the connotations of mortality that are merely suggested in other examples. Moreover, she connects the process of bodily decay captured by medical imaging technology with cinematic technology's decay, adding or highlighting blurs and blotches resembling water or heat damage and shrinkage of the film. These cinematic blemishes bloom out of the X-rayed body. *Sanctus* effects a collapse between filmic images of the body and the body of the filmic images to highlight the precarious material foundations of both mediums of motion.

Watching the vulnerable material bodies of film and persons inevitably raises questions of identification and empathy. The film reminds us of the mortality that haunts every human action. It seems an animated body would bespeak life, but *Sanctus* literally shows us that behind every motion, every vital sign of our lively aliveness, a skeleton lurks within us, ready to be all that will remain of our physical presence after we die. We are invited to see intimations of our own death in *Sanctus*, to identify with an image that could well be ourselves. And yet all traces of differences—sexual orientation, race, physical identity, and so on—are erased by cinefluorography. Hammer's work has always complicated issues of identification, by putting herself on both sides of the camera, for instance, and in *Sanctus* these issues are heightened by the ready observation of bodies' hidden depths but erasure of surface and individuality. Any view of the self from the outside has the potential to disturb. As Jean Epstein observed, comparing the cinema with his descent down a staircase lined with reflecting mirrors: "I had never seen myself this way and I regarded myself with horror. . . . These spectating mirrors forced me to see myself with their indifference, their truth."[7] One of the key sources of the anxiety of seeing oneself from the outside is that rather than looking out from the body, a subjective position, one gains access to what one looks like, an objective position. In short, the body becomes an object, and going one small skeletal step further, the ultimate version of the body as an object is the body as corpse, an association underlined here by the constant presence of bones.

Scientific processes and cinematic ones have a long history of mutual technological development and expression, as Oliver Gaycken has shown. Early scientific films, he argues, "function as contrivances of the concept of curiosity itself . . . they are curious experiments that invigorate the senses and activate the sense of wonder."[8] Similarly, in Hammer's film, the science of the medicine practiced by the doctors making the films

and of the cinematic treatment of its subjects are cause for wonder. At a minimum, these views of the body would not be accessible without the cinematic and X-ray (quite closely related[9]) technology. Hammer further enhances their wonders by adding her own cinematic processes to their merger. Hammer creatively imbricates the two levels of filmic representation included throughout *Sanctus*. Meanwhile, the animating spirit becomes more visible because the flesh of the body itself is absented—a spirit made manifest by the suggestion of invisible forces that make it move. As Jon Gartenberg suggests, Hammer's manipulations have the effect of "transforming this raw material into a celebration of the body as temple."[10] The soundtrack, dominated by found clips of performances of the "Sanctus" section of a choral mass created by Neil Rolnick, also underscores the sacred theme of the passage of bodies through life into death.

Thematically, *Sanctus* is both enthralled by and reproachful of the found footage it employs. As Tanya Sheehan has observed in her study of photography's uses in medical contexts, the clinical gaze of the cameraperson allows a command of bodies. Photographic medicine confers the necessary "knowledge and authority" to allow the doctors the ability to probe and penetrate the bodies under their care.[11] Hammer's film subtly criticizes that command even while it delights in the views provided because of it. Evidence for reproach comes even in the first frames, which feature the "China Girl" (not an X-ray) image used by film processing labs to calibrate color for a film. Ara Osterweil connects Hammer's inclusion of this image to feminist aims: she "weaves the fate of these anonymous subjects together, suggesting an ominous narrative for the women whose bodies and faces have been instrumentalized for the sake of 'clarity' in the medical and cinematographic apparatus."[12] In their anonymity and medicalized representations, these women have had all signs of difference and individuality erased. One of the next images in the first seconds of the film shows a figure in X-ray hoisting a camera up and adjusting its parts; the gendered act of filming and of being filmed—keeping the China Girl image still but giving life even to the skeletons of men—is presented with subtle irony.

Like Osterweil, many viewers of *Sanctus* have taken the film's aims as expressly feminist, or, like Matthew Burbidge's assessment in *Frieze*, as an indictment of the antifeminist approach of the medical profession toward women:

> Hammer treats the footage of this erstwhile publisher, philanthropist and pillar of the community with heated disdain, cropping and burning it, giving the women back a kind of subjecthood even as they perform for the camera, washing their hands, drinking milk, putting on make-up. These skeletons even have a threatening aspect.[13]

Undoubtedly, *Sanctus* deals in feminist idioms and reconfigures the ways images of women might fascinate a spectator. Hammer saw a continuity in these works and the schema of her oeuvre. Describing a shot in *Dyketactics*, when the camera asserts its position in the midst of a couple making love, she notes:

> And that's my favorite shot in the film, because it's trying to get inside the body—which then I can do, many years later in 1990, with *Sanctus* and with other films.
>
> So, there's a thread. Even though one looks at changes of style and direction in artwork, I think in my work you can find threads that go all the way through. Mortality and interiority and bringing the interior to the exterior. Or, when we go into the more intellectual films of essay-documentary, like *Nitrate Kisses*, you're making the invisible visible.[14]

The declared project of Hammer's films to make lesbian experience visible broadens in this period to encompass a curiosity about other invisible phenomena. It puts one in mind of early experiments with cinema in the 1910s and '20s, for instance, Germaine Dulac's film *Germination d'un haricot* (1928) showing the germination of a bean plant, marshaling the camera's power to show a visible experience that the naked eye nevertheless cannot perceive without the tools of cinema. It is telling that Dulac then repurposed this film as one fragment for an experimental film of her own, *Thèmes et variations* (also 1928), which also playfully brings together science and art for a cinematic expression.[15] Hammer embarks on similar acts of discovery as she disports with the X-ray footage to uniquely combine it with her creative vision. Moreover, connecting *Sanctus* to *Nitrate Kisses* in their mutual focus on making visible the invisible bodies of the underrepresented underlines the feminist bent in Hammer's work across the decades, howsoever different that work might look from film to film. Here, amid its strange dynamics of identification, female *to-be-looked-at-ness* is mitigated by the presentation of bodies as skeletons. That is, indications of femininity by association with body organs are rendered moot here as organs do not register as such. Even certain apparently gendered activities, like applying lipstick, are flattened for lack of the signifiers of the body—for whom should we assume is putting on lipstick? Most nonforensic specialist viewers would be hard-pressed to say whether a skeleton was definitively any gender.

In addition to their feminist aims, several of *Sanctus*'s elements also emphasize more universal implications. The interiority of bodies on display becomes radiant and legible with the miracle of radiation. About two-thirds of the way through the film,

however, a critique of the double edge of that miracle, which has been implicit in every moment to that point, becomes more explicit. Parts of words appear on scraps of paper: "radiolo . . . ," "diagnos . . ." followed by full words: "clinic," "cancer," "tumor." The process of cinefluorography required a minimum duration of filming that was damaging to the bodies under X-ray as well as to the bodies of the doctors behind the cameras—especially when they were also in the X-rays, but even when they were just in the vicinity of the radiation. The process of making these arrestingly beautiful images that peer beyond the boundary of flesh also charge that flesh with radioactivity. In a sense, *Sanctus* points up the fraught merger between technology and organic material and even between cinema and bodies—a relationship on which Hammer's art practice is predicated.

Hammer's fascination with the footage she acquired in Rochester did not stop with the completion of *Sanctus*. Her next film, *Dr. Watson's X-Rays*, makes very different use of the same material as *Sanctus*. It represents an early attempt at employing documentary tactics that Hammer developed for her sequence of feature-length documentaries in the following years. Watson's footage itself is included only very briefly in the film, rather than comprising its full content as in *Sanctus*. Instead, Hammer interviews several people who knew Watson or who had an interest in the footage, including archivists at the George Eastman House, fellow doctors, a film historian, and Watson's widow. She takes us on a tour of the facility, making the spectator privy to some of the objects Watson used to make the films. She shows us his magnifying glasses and posits that he would have clipped them onto his regular glasses the better to observe film frames; she looks at the optical printer Watson had specially made by an acquaintance he met on a train; she collects some of the original positive and negative prints of the films from an archivist; she looks at photographs of the man himself. Intermittently, she turns to the footage that is the subject but not the content of her film. She projects the films; she watches footage on a flatbed monitor; or she just presents some of the flickering footage in full frame.

While the film focuses on the objects and people associated with Watson's footage rather than the footage proper, some of the same interests expressed in *Sanctus* are in evidence here. Hammer again explores the question of the simultaneous damage and allure of X-ray images, the interest in Watson's eclectic visual aesthetics, and the desire to penetrate interior mysteries of the body (now complemented by the desire to penetrate into the mysteries of Watson's venture in cinefluorography), only now these issues are mobilized toward and presented through documentary conditions.

In terms of Bill Nichols's categorization of documentary modes, Hammer's work here and through the decade is both interactive (she pops into the frame from time

to time to participate in the line of questioning she has initiated) and, especially, re-flexive: "the most self-aware mode . . . [the reflexive mode] uses many of the same devices as other documentaries but sets them on edge so that the viewer's attention is drawn to the device as well as the effect."[16] Both modes shape the film and will come to characterize her foray into documentary forms more generally. Here, for instance, the film starts with Hammer's interview with Morgan Wesson, a technology archi-vist at the George Eastman House. Wesson offers perspective on the general interest of Watson's films held by the archive, telling her about his creation of a catalog for the films, showing her the optical printer, and discussing the provenance and nature of the films. Employing a mostly straightforward interview technique, Hammer asks questions, comments on the things they look at together, and occasionally encourages Wesson's commentary by proffering a laugh, a "yes," "mm-hmm," or "oh, yeah." As she concludes his section of the film, however, she walks backward with the camera, away from him, so that in a moment he is hollering down the corridor the rest of his com-ment about how difficult it is to confine Watson to a single description. She can't seem to help herself. At least briefly, her documentary strategy digresses in this way. It hints at a direction that will be less descriptive and observatory than playfully partici-patory and self-aware, particularly for the long-form documentaries including *Nitrate Kisses* and *Tender Fictions*, which she made not long after this film.

The structure of the film follows a simple trajectory: from Wesson she moves to James Card, the founding film curator of the Eastman House, who tells a variety of stories about his encounter with Watson's work as well as his curation of the films for the archive. After Card, she interviews film historian Lisa Cartwright, a couple of X-ray technicians, another archivist, Raymond Gramiak (one of Watson's colleagues/fellow filmmakers), and Nancy Watson Dean (Watson's widow). In transitions be-tween these interviews, she allows some of the cinefluorography to speak for itself; for example, she shows the footage of a model demonstrating the X-ray technology first in regular photography (smiling and showing a seashell to the camera) and then with the X-ray of the same scene for comparison. Photographs of Watson as well as the objects in the archive are static moments that punctuate the interview sequences. Hammer traces for the spectator the progress of her discoveries in the archive and side inquiries she makes along the way. The interview with Cartwright yields some history of cinefluorography in general as well as highlights of the deleterious effects of scatter radiation on the doctors. Gramiak confirms that a segment of their work emerged out of sheer curiosity: "what would it look like if . . ." And Nancy Watson Dean recollects that Watson did not think his eventual cancer diagnosis had anything to do with his X-ray work. She also recalls his sense that the films were as ephemeral as their subjects.

When Hammer asks her what he wanted done with the films after his death, her reply underlines that notion: "I hate to tell you how he felt about them—it's just so shocking. He said, 'My dear, that's all in the past. Throw it away.'" Hammer ends the film with this assertion, allowing his dismissive attitude to close the inquiry and fading to black before showing Watson's life span (1894–1982) in white lettering for the last image, allowing his death to be the final word on the matter.

A great deal of Hammer's work before *Dr. Watson's X-Rays* mobilized elements of documentary for expressive power. Films like *Sisters!* and *Superdyke* provided snapshots of a cultural and historical moment; *Double Strength* documented a romance and breakup as well as a performance method (motivity); *Our Trip* took us along on Hammer's travels; and *Snow Job: The Media Hysteria of AIDS* (1986), perhaps the most recognizable as belonging to the genre of documentary, offered documents of media coverage of the AIDS crisis even if it chose atypical strategies for presenting them. Her command of documentary techniques in *Dr. Watson's X-Rays*, as in *Snow Job: The Media Hysteria of AIDS*, is perhaps less refined than her command of the tools of experimental cinema; cuts are clunky, sound recording is uneven, and the whole process has something of the air of being on the fly. So while it signals a significant thematic and generic shift for the following decade, *Dr. Watson's X-Rays* likewise demonstrates the continuity of Hammer's interests—for example, in mortal bodies, the visibility of the invisible, experimental and documentary film history, and ephemerality— across her oeuvre.

The third film that fits into this triad of related works at the threshold of the 1990s decade is *Vital Signs*, which further elaborates the variety of ways she applied herself to and experimented with an idea. *Vital Signs* alternates footage from Alain Resnais's *Hiroshima, mon amour* (1959) with texts from Michel Foucault's *Birth of a Clinic*, footage of Hammer dancing with a skeleton, sound edited from Camille Saint-Saëns's tone poem *Danse Macabre* (Op. 40), and images (and sound) from a hospital. Dedicated to John Wilbert Hammer (her father), Curt McDowell (fellow experimental filmmaker working in San Francisco; he briefly appears in Hammer's 1982 *Audience*), and Vito Russo (author of the groundbreaking book *The Celluloid Closet*), all of whom had recently died, *Vital Signs* considers mortality from yet another set of intersecting angles.

Starting with the opening chords of the *Danse Macabre*, Hammer is seen waltzing and looking lovingly into the eye sockets of a skeleton adorned with a veil. A second image of the dance is optically printed with greater transparency beside it so that it ghosts the first dancers. Only a few seconds pass before the song and the dance are cut against a man being wheeled down a hospital corridor. Another cut returns us to the waltz, but at first without the music, and soon adding the sounds of hospital machinery—a constant

bleeping—before returning to the music of the *Danse Macabre*. Dancing and medical treatment overlap at the level of the soundtrack. Hammer stops and starts, stops and starts the dance with the editing, creating a hesitant movement around the space. Just before the title appears on a black screen, she dips the skeleton in a closer shot. From the black screen, Hammer's voice asserts, "Something fell off the ventilator, and it's starting to make those sounds." A skeleton and Hammer appear in a medium close two-shot, echoing her films from the 1970s in which she highlighted the intimate relationship of two women through such framing (figure 26). Indeed, Hammer looks lovingly in the direction of the skeleton as if half in love with death. Like the films from the 1980s in which many layers speak at once, these frames use a split screen format; Hammer's image is multicolored while the skeleton is black and white and sometimes layered with text. The image wipes from the side or the top several times, each time slightly shifting one aspect of the image; the whole thing turns red, part of the image is blurred, part of the image is doubled, and so forth. Within these alterations of the Hammer + skeleton image, the bleeping sound of machinery continues quietly in the background. At one point, the image shifts to a moment in *Hiroshima, mon amour* in which a woman in a hospital bed holding a book turns to look toward the spectator. After a cut back to the Hammer + skeleton interlude, the woman in *Hiroshima, mon amour* looks back

Figure 26. Skeleton love in *Vital Signs* (Barbara Hammer, 1991)

to her reading. The speed of the shifts, the content of each image, the superimpositions of images and sounds, and the tangents of the multiple allusions combine to generate a mosaic of meanings, all tied to mortality.

From the start, the expectation of romantic coupledom suggested by the intimate waltz is undercut by several things. Most obviously, Hammer dances with a skeleton who cannot but fail to join her in a living romance. Hammer runs her tongue along the skeletal arms, but they do not embrace her to reciprocate her advances; Hammer eats spaghetti, but the skeleton has none; Hammer casts loving looks, but the skeleton scarcely acknowledges her! On the level of sound, Hammer also stops the music just as it becomes familiar, thwarting its harmonious closure. On the level of the image, she creates a second, ghostly dance that echoes the first one. Finally, all the images surrounding the potential couple point to disease and death. For instance, the section of *Hiroshima, mon amour* to which Hammer cuts is taken from the beginning, when Elle (Emmanuelle Riva) recounts to Lui (Eji Okada) the immediate aftereffects of the bomb dropped on Hiroshima at the end of the war. Resnais's film includes the woman's own history as she slowly recounts it over the course of the film. It sees her coming to unsteady terms with her past, connected to the film's recounting of Hiroshima's history. By invoking this moment from the film, Hammer addresses the difficulty of dealing with loss and death through personal and larger histories.

The dedication to her father, McDowell, and Russo also links the personal and the historical moment. While *Vital Signs* most overtly concerns her father's death (footage and sound from hospital corridors where he was a patient recur through the film) as well as her thoughts on mortality generally, the other dedications open the film to history that may be personal but lies outside of her immediate family. McDowell's experimental work connects to her own art and advocacy for queer visibility, while Russo's activism and authorship bring to light queer readings of mainstream films. Clips that include Foucault's *Birth of a Clinic* underline Hammer's commitment to expanding her knowledge of theory[17] and integrating that theory into her thematic obsessions. The passages she cites (showing pages in a book) relate to the ideas already expressed in *Sanctus*. For example, she shows a page, then crosses things out until all that remains are the words "the moment that sickness . . . turned into spectacle." This and the "clinical gaze" (another phrase she highlights) show that after *Sanctus*, Hammer continued to reflect on the ideas surrounding the way the decline of the body holds our fascination and our look. However, in addition to the intertexts inspired by McDowell, Russo, and Foucault, these men also have another thing in common: all died of complications due to AIDS. Hammer raises the matter very delicately and obliquely, only once introducing the word *epidemic* in some of the brief snatches of

text we see in the film and through the coincidence of their AIDS-related deaths, which signal Hammer's intimation of the issue.

In 1991, the CDC reported that as many as one million Americans had been infected with HIV and over 150,000 people had died of AIDS. While Hammer's work does not focus on the crisis directly in *Vital Signs*, just five years before making this film, Hammer made a film that fully centered on the issue, *Snow Job: The Media Hysteria of AIDS* (1986). She began working on it after first hearing about AIDS while living in Chicago in 1985. She was teaching at Columbia College and asked her students to compile media coverage of the disease, which scandalized her in its stigmatization of the gay community. She compiled news programs, call-in shows on the radio, and media headlines and put them alongside a song about homophobia and footage of Brent Nicholson Earle during his American Run for the End of AIDS (for which he ran some 9,000 miles over a period of twenty months to raise awareness and funds to help prevent the spread of AIDS). In her overt address to issues surrounding the AIDS epidemic, Hammer underlined the political motivations and cultural hegemony that promoted hysteria and homophobia around AIDS. She considered this film a necessary diversion from her more usual "personal approach" into something that addressed an urgent social issue: "a film where the political implications are central to the project."[18]

In *Vital Signs*, although it serves as a motivating subtext, AIDS and the losses it effected are more implicit than explicit; the issue has become one of the latent energies of the film without eschewing that more "personal approach." The political activism that inspired several of her 1970s films had mostly become subsumed by other concerns in her 1980s work; however, it reemerged in various sites including *Snow Job* before becoming central again to the 1990s documentary projects. What *Vital Signs* presents in the place of a political statement aligns with Hammer's broader thematic and stylistic precedents; it makes the invisible cost of lives to the epidemic visible, but in a manner akin to the ghosting technique in her depiction of the skeleton dance. That is, it traces the issue but leaves blatant representation out of the picture. In a grant application project proposal for an installation piece she submitted the year before *Vital Signs*, Hammer elaborated some of the dynamics she envisioned for addressing these issues through a kaleidoscope of modes. Titling the proposed installation "X-Ray," she envisioned it as a "slide, video, film and performance piece that examines the nature of aging and dying through the images of the physiology of the inner body (x-rays and skeletal structures)," which would also include "vignettes from . . . the deaths of friends and family."[19] *Vital Signs* evokes a wide ambit of emotional, intellectual, social, and political reference points. A skeleton serves as the emblem of an awareness of

missing something that was there all along (just beneath the surface representation). The absence of direct reference to AIDS, although it informs the whole project, functions similarly to Hammer's citation of a subtitle in *Hiroshima, mon amour*: "How could I not see it?" The films that she makes during the rest of the 1990s would answer that question by embracing and pushing to the center people and images that had long been pushed out of sight's way.

By threading these parts together, Hammer makes the film a poetic reverie on mortality within art, theory, society, history, and personal lives. *Vital Signs* has strong ties to outside referents but also her own work; it glances back toward *Optic Nerve*— also set in a caregiving environment with a loved one on the decline—as well as her 1970s work with making images of queer relationships joyous and visible and her 1980s work using a veritable blur of colors, texts, and allusions. It also anticipates the work that follows by offering variations on a theme (as we have seen, along with *Sanctus* and *Dr. Watson's X-Rays*, fixated on medicine, images of skeletal bodies, beauty amid tragedy, and death). After this trilogy of films that address similar ideas from different angles, Hammer began to emphasize documentary aims, turning toward a more direct confrontation with queer history and visibility to make what she and others have called her "history trilogy": *Nitrate Kisses*, *Tender Fictions*, and *History Lessons*, all concerned with granting visibility to lesbians in history.[20] As Ann Cvetkovich has observed, central to the history trilogy "is a desire to create a fuller sense of lesbian lives by insisting that intimate relationships are crucial to the public record and should not be cordoned off from the work."[21]

Nitrate Kisses (1992)

Hammer's *Nitrate Kisses* is often touted as her masterwork. When pressed to assert which of her films she would save in a shipwreck, Hammer put *Nitrate Kisses* at the top of her list.[22] Figuring centrally in her oeuvre, it has enjoyed the success of openings at film festivals, awards, and recognition in critical scholarship.[23] As her first feature-length film, it stretches into the longer format by dividing into four smaller parts, each one with a dual focus on a specific couple and a discourse that complements issues raised by that couple. She acknowledged that she made it in smaller parts because that was more akin to her "usual way of working." That is, as she noted: "if you break down those sections . . . they all run into about a twenty-minute section."[24] This segmentation accords with Hammer's initial conception of the film as an experimental work (rather than as a feature-length documentary), with footage accumulated over time and from a range of sources, including her travels to Europe and the Watson footage from the George Eastman House. For each segment, footage of a couple engaging in

sex alternates with images and sounds related to the complementary material. Each features multiple forms of imaging, speaking, music, and other representations of history and memory. *Nitrate Kisses* embraces this multiplicity of forms and makes them speak to the issue of "how history is made," as Hammer described the film's main theme.[25]

Nitrate Kisses was developed initially by Hammer when she was teaching in Chicago. She applied for and received a $20,000 grant—her most substantial grant yet—from the National Endowment for the Arts (NEA) in 1990 to "support the production of an experimental film."[26] It emboldened her to make a further request for $60,000 from the recently founded Independent Television Service, whose charge was "to expand the diversity and innovativeness of programming available to public broadcasting" and to "encourag[e] the development of programming that involves creative risks and that addresses the needs of unserved and underserved audiences."[27] Hammer proposed a project titled *Sodom's Lot*, for which she would use Watson's footage and focus on the disappearance of queer history. She felt it would be a perfect fit for these monies established by the Corporation for Public Broadcasting through legislation passed by the United States Congress.[28] When she had completed the application, she was slated to begin a tour in Europe, where she took more footage for the film on Super 8 and recorded sound for a part of the film. In fact, she did not end up getting that larger grant. However, she owned that just completing the application had set the wheels of the project in motion: "In my first grant application to ITVS . . . I wrote expansively, researched a large project of 'searching for lost lesbian and gay culture,' and proposed a budget to match the project's scope. In my usual manner, I couldn't wait to see if I were funded, but began to shoot almost as soon as I had conceptualized the ideas."[29] At the point at which the project was already well underway, she decided to continue it by balancing the plans she had worked out in advance with kismet, as she traveled and collected more pieces for the film.

As such, the film illustrates Hammer's organic working method. The motivations for her starting work on the film centered on a few factors including the impetus of her grant application (collecting her thoughts about the shape of the project), but also a desire specifically to show older lesbians on the one hand and on the other to use the striking footage of *Lot in Sodom* to which she had gained access after establishing her connection to the George Eastman House the year before. Once she started the film, however, other factors also came into play as she began to research and travel. In interviews, she noted that, on tour with her earlier films in Europe, she met new people and had experiences that would find their way into the film: "In Hamburg, Berlin and Paris I borrowed Super 8 cameras, hunted out the only source of Black

and White Super 8 films, cajoled transportation from my hosts, and began to film. By then I had found I didn't enjoy 'touristic' travel and was much happier pursuing research even when I was on a screening tour. The days were intense, but I like them that way."[30] She took footage of ruined spaces, interviewed people, and drove out to concentration camps, for instance, where she conceived of the third section of the film about the erasure of quotidian lesbian life in and out of the camps.[31] The research she conducted—including documentation of daily lesbian experience that might otherwise be lost to history—also shaped the film in the form of several direct textual quotations as well as in an assemblage of footage found or taken as she worked.

The film's four-fragments shape puts four couples into mutual juxtaposition as uncollected pieces of queer history in the past as it continues into the present. Rather than present four images simultaneously, as she did in *Still Point*, *Nitrate Kisses* presents the four fragments side by side and counts on the audience to connect the parts. Hammer amplified juxtapositions in *Nitrate Kisses* so that it was "maybe the ultimate form of requiring a viewer's participation in the construction of meaning in the film, ultimately, at the end," requiring multiple viewings to gather the full impact of the artwork.[32] The notion of the film as a collection of fragments accords with Hammer's interest in Walter Benjamin's writing, which is cited in the film and serves as a touchstone for its dynamics.[33] The four parts aim to offer a range of examples of what Hammer felt was censored even within the queer community; she proposed that the film would "take responsibility for my own community's response to censorship, our own censorship."[34] The first part features the history of author Willa Cather alongside an older lesbian couple (figure 27); the second part juxtaposes footage from *Lot in Sodom* (the original centerpiece of the project) with an interracial gay couple; the third part intercuts documents, people, and texts related to concentration camps during the Nazi regime with a young lesbian couple; and the final part puts an eclectic collection of references to lesbian history together with an S&M lesbian couple.

Within each part, Hammer provides layers of signifiers to restore lesbian history. For instance, in the first section, as she allows the voices of the people she is interviewing about Willa Cather to discuss Cather's penchant for dressing as a man, Hammer shows photographs of Cather being put back together from torn scraps—the reassemblage of her history. The segment shifts to a group of older lesbians recollecting their coming of age at a time of secrecy and discrimination; they tell stories about growing up lesbian and reflect on shifting tides of acceptance and definition (for example, the falling away of "butch" or "femme" labels) for lesbians. Images of movie stars in the queer firmament (for example, Katharine Hepburn, Marlene Dietrich, and Judy Garland) as well as covers of lesbian novels are added to the mixture of individual ruminations on

Figure 27. *Nitrate Kisses* (Barbara Hammer, 1992)

lived history. Like the photograph of Cather, when put all together, the film configures a whole image of lesbian history out of sundry and strewn fragments.

Each of the parts builds in relation to the others. From the first part's reflections about butch/femme binaries comes further thematic development in subsequent sections. Rather than serving as isolated example, it builds into a theme—in this case, of recognizing the complexity and fluidity of sexual identification and experience. That theme is complemented and extended in the second segment in a discussion about the polarization of homo-/hetero- designations (with the alternative of bi- also not expansive enough) and how they ought to be more complex to accommodate the way people live their lives. This theme also registers across the diversity of couples and their accompanying discourses in each segment.

What connects the sections of the film is the clear overall aim of presenting lost history so that it might be recovered, as well as the stylistic features of the film. On the level of style, *Nitrate Kisses* replicates a layered approach in each section so that with each shift of perspective the audience has a collection of texts and subtexts to sort through. It also looks and sounds uniform across the sections; the often beautifully lit, slightly grainy black-and-white photography makes the film cohere aesthetically. When the camera cuts in for close-ups of faces and other parts of (mostly)

naked bodies, its uniformity of approach grants them the fluidity o

register that is also raised as a positive attribute on the thematic regi:

echoes the initiating aesthetic of Watson's outtakes from *Lot in Sodo*

that the past depictions of queer erotica correspond to the present ten

making history a continuum of experiences that includes more than

coupling.

Hammer punctuates the brief gaps within each section with a range of texts, images, and sounds that complement and complicate the sexual themes. Texts include citations from Benjamin, declarations of her own, or phrases her interviewee has just uttered, made textual on a black screen. The soundtrack favors interviewee voice-overs rather than sync sound because Hammer claimed she wanted to emphasize a collected history rather than a story told from one perspective.[35] And the music—for instance, the blues or German songs with queer themes—underlines this historical aim and echoes motifs developed on the visual level. The songs make apparent a queer history that has shadowed straight cultural history all along; meanwhile, older movies are also presented with configurations of female couples and cross-dressing women, suggesting on both the sound and visual level that something queer has long been afoot even in mainstream entertainments.[36]

Before these multilayered dialogues and discursions unfold, the film opens with an epigraph by Adrienne Rich that announces the film's key concern:

> Whatever is unnamed, undepicted in images,
> whatever is omitted from biography,
> censored in collections of letters,
> whatever is misnamed as something else,
> made difficult-to-come-by, whatever
> is buried in the memory by the collapse of
> meaning under an inadequate or lying
> language—this will become, not merely
> unspoken, but unspeakable.[37]

Hammer's film dives into the buried memories of history and harnesses the language of cinema to recuperate queer experience—what Ron Gregg has described as Hammer's impulse toward queer visibility on the historical level[38]—and to marvel in its diversity, beauty, and precise manifestations. Taking up B. Ruby Rich's charge to name and speak a language for just this purpose, Hammer's film brings queer experience to cinematic light.[39]

.e film overall employs several of the experimental strategies seen in earlier films. Moreover, its bending and blending of conventional documentary techniques aligns it with aims of queer documentaries as outlined by Chris Holmlund and Cynthia Fuchs. For instance, it underlines "questions of communication and translation, reconsidering how speaking and naming, silence and suggestion, are expressed and experienced."[40] The project of finding alternatives to well-trafficked ways of speaking about queer experience provides the foundation for Hammer's film. It acknowledges the multiplicity of strategies that blur in the practice of making the film, such that "distinctions among documentary, fiction, and avant-garde films and videos are . . . untenable."[41] Hammer interviews her subjects and films real people in real places doing real things. But she also employs actors following her (loose) directions for showing underrepresented modes of love-making. And she lays bare the devices of her filmmaking: she cuts to images of herself in reflections, filming, or she inserts images or text in counterpoint to the interview she is in the process of conducting. She experiments, fictionalizes, *and* documents, providing a dynamic, fluid approach to the material she presents.

The texts that make their way into the film perform several functions. In some cases, they provide points of artistic intersection, so that "who is the angel of history? . . . and where does she reside?" brings her film into contact with Walter Benjamin's text and its own set of literary, artistic, and philosophical allusions, such as Paul Klee's painting *Angelus Novus*. But it also updates the reference and casts it in the territory of lesbian history—Hammer asks where *she* resides. At other times, the text is a corollary to a spoken sequence, as when in the third section of the film, the category of "asocial" is discussed in relation to group designations for those sent to the Neuengamme concentration camp in northern Germany; marked by a black triangle, this is the category into which lesbians were put. Across a black screen appear the words "Asocial is a woman," and shortly after, the woman recounting the lives of lesbians in the camps states the same, elaborating on the tragedy of being marked by that triangle in this time. As an example of the erasure of lesbian experience, this one is violent and extreme. Other uses of text serve a didactic function. In the fourth section of the film, in which such text is used with the greatest frequency, Hammer makes the messages of the film overt, cutting several times to a black screen with a single line from spoken testimony from lesbians about their erasure in history. This section, which includes images of the places Gertrude Stein and Alice B. Toklas lived in Paris (a harbinger of Hammer's interest in artists' environments, which becomes increasingly important in the following decade), footage of the fourth couple, and images of Hammer filming while reflected in mirrors, is punctuated by texts related to the film's mission:

Sexual activities are contextual and relational.

Sexual activities do not have a fixed or absolute meaning beyond time or place.

Sexual identity and sexual desire are fluid and changing.

No specific identity and sexual desire can be historically denied.

With such blatant declarations, there is no longer any mistaking the message about the legitimacy of all kinds of differences and identities (based on sexual preferences, race, age, and such) as the film moves toward closure. Text throughout the film serves this wide range of functions, from the suggestive and allusive to the definitive and recuperative.

The juxtapositions among the sonic, visual, and textual elements of the film are often witty or serve multiple purposes. As Lawrence Chua has noted, one key moment of counterpoint between text and image happens in the second section, in which a pointed comparison occurs as the Hays Code scrolls up the screen: "The text of the Hayes [*sic*] code (the 1930 censorship regulation for Hollywood movies, prohibiting, among other things, depictions of miscegenation) scrolls over a black penis rubbing against a white ass. The text becomes a fence: it can be read through or around, but it obstructs our more urgent [*sic*] voyeurism."[42] Critique occurs through juxtapositions based on how Hammer intertwines the multiple registers of the film. For the end credits of the film, Hammer intercuts a voice-over by two actors reciting (in the accent of a hick) parts of a speech given by Senator Jesse Helms (R-NC) denigrating "self-proclaimed artists . . . who insist upon mocking the American people and shocking the sensibilities of the American people and who shield themselves behind the sponsorship of the National Endowment for the Arts." Right after the word "sponsorship," Hammer includes an acknowledgment of the Frameline Completion Fund's assistance in supporting *Nitrate Kisses*. This moment is followed by a woman's voice laughing in the blues song on the soundtrack and footage from one of the old movies with cross-dressing women in which the players pull a tablecloth out from under an elegant dining room table setting. Hammer underlines the happy fact that some progressive funding entities still allowed monies to be disbursed to artists working with what Helms saw as incendiary material not supported by "the American people." In Helms's memoir, he evades the question of censoring work by insisting that it was simply a question of spending money on something people did not want to see.[43] But which people? Of course, Hammer's entire mission is to make visible the aspects of queer experience, including sex, that had long been repressed by dominant and moneyed public and private interests. Alongside these visual and sonic cues, Hammer's

use of anarchic female laughter—accompanied by footage that points to a history of cinema where such images have been presented as innuendoes rather than as explicit content—sidles up to a set of meanings rather than addressing them head-on.[44] Such an approach is not simply polemical, though it is pointed in its critique of the history of queer representations. It is also generative and creative, demanding interaction with and transcendence of the codes of the past (the Hays code being only one such code). As one viewer remarked of the scrolling Hays code amid interracial gay sex: for a queer audience, "It's our very own *Star Wars*."[45]

The critique of censorship fuels *Nitrate Kisses*. The film is an overtly contentious response to censorship—a censorship that was part of the political discourse of the film's moment.[46] That *Nitrate Kisses* became the target of censorship itself coincides with how clearly (and how queerly) it confronted the issue. Hammer kept files on instances when her work was censored; she gave the matter a good deal of thought. As we have seen, when she courted a larger audience through the 1980s, the sexual content of her films became much more subdued or vanished entirely. However, in the 1990s, her work began again more openly to question staid artistic conventions, including its censorious avoidance of depictions of sex, and a film like *Nitrate Kisses* calls attention to and reproaches that censorship in part by how it flies in the face of sexual shyness. As an artwork that enjoyed relative critical success, it affirms this strategy. It fared however less well in other instances; while it received the NEA grant for its development in 1990, later the NEA disavowed the film and asked that Hammer not include its name on the film. In 1997, on learning that Canyon Cinema was distributing *Nitrate Kisses*, the NEA rescinded a grant it had awarded them.[47]

As the first in the trilogy of films that explore the recuperation of lesbian history, *Nitrate Kisses* participates in Hammer's larger mission of the 1990s to add lesbian voices to the collective recounting of history. During this time period, Hammer also initiated a website called the Lesbian Cyberspace Biography, an interactive site designed to allow visitors "to participate in the rewriting of Lesbian/Gay/Bisexual/Trans-gendered history." Users could see firsthand accounts of queer experience and contribute their own, generating communal content that could serve as an alternative account of history. With its mélange of documentary and experimental strategies working together, *Nitrate Kisses* introduces another major shift in Hammer's focus across her oeuvre. If the 1970s were primarily personal in expression and the 1980s were primarily formal experiments, the 1990s melds these approaches in the service of a larger, community project that continues to experiment but with the addition of a strong documentary component. She continued the theme of bringing these invisible histories to light with two feature films soon to follow, *Tender Fictions* (1995) and *History Lessons* (2000).[48]

In these films and the other works made through the 1990s, including *Out in South Africa* (1994), *The Female Closet* (1998), and a handful of shorter, experimental works, Hammer honed her documentary artistry and advanced the cause of preserving lesbian history in a variety of contexts.

Out in South Africa (1994)

As a working artist scrambling for sufficient funds to continue working, Hammer took a page from the book of some of her artistic foremothers and combined travel invitations and workshops with new projects, affording herself some of the resources she needed for making films. Her next film developed out of exactly this sort of situation. Invited to show a retrospective of her films as a guest of the first Out in South Africa Film Festival in 1994, Hammer arranged to teach a workshop on filmmaking during her visit. That workshop became a central subject for *Out in South Africa*, Hammer's next project. At the beginning of the film, she recounts the situation: after she is called and invited to the festival, she tells the organizers, "Yes, I can come. But I want to give something back besides the films. I want to teach video in the townships." It is in connection with the workshop that Hammer made this feature-length documentary based mainly on the workshop participants' experiences being gay or lesbian in South Africa.[49] Her empathy for the stories she records and her desire to empower her subjects with the tools for making their own films are amply evident in the film and form its thematic core and overall ethos. Her time in South Africa gave her opportunity to experiment with a new form—interestingly, one that results in possibly the least experimental film in her whole oeuvre—a mixed-mode documentary characterized mainly by an expository aim of conveying information about the queer lives affected by the eradication of apartheid in South Africa.

The tools Hammer proposes to teach her students and the ones she employs in the film she herself made are typical of this mode. She interviews people or captures conversations as they unfold, she adds explanatory voice-over narration to contextualize what the viewer sees, and she includes brief text with the image to identify places or people (the latter often simply by their first names to protect their identities). Any argument the film might adopt comes at an angle and concerns the need for more rapid and deeper change on the level of people's attitudes and education about queer identity and experience. Although racial identity is less overtly addressed, the messy aftermath of apartheid is the context for the ability to talk about these attitudes, and it inflects everything in the film. The issue of naming comes up again, as it did for Hammer in her own early encounter with lesbian identity, and she makes it clear that having an outlet and community that might help people better understand who they

are is a crucial part of normalizing queer experience in a culture all too accustomed to its suppression.

The heart of the film is the interview subjects recounting their experience, and Hammer attempts to balance letting them speak for themselves with offering her own views on what that experience means. As a foreigner, Hammer affords the material an outsider's perspective (later, it is to be expected, the students will make their own work from their own points of view based on the tools they learn in the workshop). The film allows expression for these subjects at a point when they are only just beginning to name and understand their identities and context. One of her subjects, Bebe, relates how a sympathetic teacher helped him to understand that he was gay; another, Zandile, talks about how neighborhood boys want to rape her because she is a lesbian and a virgin. Hammer asks people who have had both male and female partners whether they are bisexual, but the film suggests they don't know what that would mean; they see themselves as gay but married and in a heterosexual relationship. At one point, Hammer interviews a man who talks about using a condom with his wife if she doesn't take her pill, but never using a condom with his male partners. He says they are living happily and he does not know whether his wife knows he is gay. Soon after, Hammer recounts his story to another interlocutor, asking if there is AIDS in Soweto and linking his story to the possibility of spreading the disease because of ignorance about it. His hidden identity and trouble with bringing identity issues out into the open allows that ignorance to flourish, she seems to suggest. Later, in the Guguletu workshop, another man relates a similar ignorance and concludes with some surprise, "I don't see any reason why I would need to use condoms with my wife." Through these testimonies, Hammer grapples with the dangers of not being fully out in South Africa; she encounters the fledgling steps of a country toward greater awareness of the issues facing its queer community.

With a dual focus on the experiences of her interviewees coupled with Hammer's own perspective on the need for openness to effect real change, the film mainly lets people talk, while Hammer occasionally prompts them with further questions. One of the co-organizers of the festival talks about the issue of having no space reserved for her as a black lesbian. Another person talks about how even those people who live in town are "rural minded." Many of the interview subjects relate cultural and social aspects of South African society that need to catch up with new laws. Although the film laments the various states of misunderstanding that persist, a more positive and active aim—that of naming and allowing expansion into the open spaces of South African culture for the people with whom she talks—is central to the film as well.

To provide her account of this transitional moment in South African history, Hammer enlists the members of the workshop, the organizers of the festival, the queer

community that attended the festival, and others in its near orbit to share their stories and thoughts about queer identity and rights in Africa. It is a great example of maximizing her limited resources to do the work of making this film. The people she meets serve as the subjects, the artistic collaborators, and the audience for her project. By inviting Hammer, and allowing her to teach the workshop that also appears in the film, the founders of the first gay and lesbian film festival in South Africa expanded their mission and facilitated a situation in which its individual spokespeople (that is, the gay and lesbian constituents of their country) might tell their own stories to a larger audience—through their own film projects and through Hammer's.

Much of the film capitalizes on Hammer's time and activities while a guest of the festival, and the last quarter of the film turns fully to the Guguletu workshop for its material. She films the students interviewing each other or telling their stories directly into the camera, and they corroborate the main themes about the need for naming identities and for providing more resources to normalize the presence of gays and lesbians in everyday South African life. Annelie, for instance, talks about how the first time she learned the word "androgynous," "it was as if a world went open for me." Several subjects report not having had a sense of a lesbian or gay option for their relationships because of their lack of exposure to the idea. Justin, a twenty-seven-year-old English-speaking gay man, talks about the lack of role models and exposure to gay culture. Hammer's film directly aims to redress this by making Justin the role model for others who, like him, might be looking for reflections of their own being. In relating the challenges presented to them on a daily basis, Hammer's subjects think through identity issues, especially in relation to cinema, as several members of the workshop note their desire to develop and harness their own filmmaking skills for self-expression in a newly (relatively) progressive environment. The film ends with the workshop participants slowly moving beneath swaths of light and shadow in the workshop room. Making shadows, they reflect how their thoughts have gained somewhat in substance—they have an outline, at least, and filmmaking tools to assist them—for the work of beginning to validate their lives and emerging histories.

The timeliness of Hammer's intervention—she makes her film immediately after the end of apartheid and the introduction of a new constitution granting rights to people who formerly did not have them—makes *Out in South Africa* a fascinating representation of this moment of transition and people living through it. The film also functions as a telling entry in Hammer's oeuvre. It is the most deliberate of her films at adopting documentary strategies for the purpose of investigating gay and lesbian history at a moment when it was in transition and, therefore, more legible as part of history. She would continue to use several of these strategies, only overlaid with more experimental

techniques, in the next two films that took on the same aim—making lesbian history visible—only with important personal variations.

Rewriting History: *Tender Fictions* (1995) and *The Female Closet* (1998)

The final two major films Hammer worked on in the 1990s were *Tender Fictions* and *The Female Closet*. In these films, she investigates the idea of "the invisibility of female artists in an art world dominated by men."[50] Each represents an effort to restore to view hidden, neglected, or forgotten aspects of lesbian history. *Tender Fictions* focuses on Hammer herself while *The Female Closet* attempts to recuperate lost or buried lesbian histories through three specific female artists' biographies from the last century and up to the moment of the film's making. Together, these films combine the methods and themes of *Nitrate Kisses* and *Out in South Africa*. The result is two experimental documentaries that express Hammer's commitment to exposing lesbian experience in cultural history as well as to marshaling autobiography and biography to write women back into history.

Tender Fictions opens with a statement made by a computer-modified voice: "Construct an autobiography before someone does it *for* you." The very nature of this voice announces its own constructedness as part of the project. In fact, the film that follows posits that to construct a story about one's life necessarily culminates in a fragmented, often fictive account of memory through stories told by and about the subject. Autobiography intersects with other lives and with culture at large. The film recounts as well as newly creates Hammer's own history, particularly as an artist and filmmaker. She self-cites her own films—footage from her earliest works from the late 1960s, including images from *Schizy*, *Death of a Marriage*, *Yellow Hammer*, and the footage of her painting in her studio from *Contribution to Light* discussed earlier. These citations remind us of the development of her career and provide visual evidence of her life and work (figure 28).

Immediately her history is marked by a performative aspect—by which I mean it is connected intimately with what Bill Nichols has termed *performative documentary*, which "sets out to demonstrate how embodied knowledge provides entry into an understanding of the more general processes at work in society."[51] Drawing on her own "subjective, affect-laden" perspective as a conduit to meaning, Hammer generates understanding of her growth from child to fifty-six-year-old woman through the lens of personae and performance.[52] From her childhood in which her mother pressed her to perform and aspire to the persona (cute, demure) and stature (famous, financially successful) of Shirley Temple, to her present work and life, Hammer's account

Figures 28, 29. Self-citation and exploration in *Tender Fictions* (Barbara Hammer, 1995)

is inextricably entwined with her emergence as a lesbian artist at a specific stretch of American history. We first see Hammer executing the tap dance steps she learned as a child, shuffle-step-stepping on Temple's star on the Hollywood Walk of Fame. However, as Hammer narrates in voice-over the details of her own self-image modeled more on the agency and action of a Chaplin than a Temple, the film cuts to an image of Hammer from one of her early Super 8 film rolls, in which she is shown pretending to rob an American Express with a Swiss Army knife. She is neither sweet and cute nor girly like Temple; she is a bandit on the run with the loot. Still, although the encouragement she received always to perform might at first sound like a regressive, antifeminist way of growing up, Hammer finds that playing a part—a persona—came to her naturally and did not need to make her a passive person or someone other than herself.[53] Instead, performance suits her as she play-acts in her own films; cross-dresses for Halloween; dons a serious expression, moustache, and bowtie, and attends a party; and puts herself (through filmic manipulations) into the place of people on television, editing and superimposing herself into sequences to play the parts of a nun being interviewed, a man speaking about marriage and its expectations for women, or any number of other characters. Through this role playing, Hammer tries to get a bead on her own person from before coming out as a lesbian and after.[54]

In addition to this performative aspect, Hammer considers theoretical aspects of autobiography, citing artists and scholars like Zora Neale Hurston, Audre Lorde, Hélène Cixous, Sue-Ellen Case, and Roland Barthes, and offering a clever commentary in voice-over about her memories of childhood, marriage, awakening into awareness that she was a lesbian, and emergence as an artist. For example, she cuts from a blurry television image of a talk show in which a woman turns to the show's panelists to ask what they expect from marriage, to an image in a newspaper of two teacups, one with a bowtie and another with ribbons (boy/girl), each winking at the reader over a caption of "Like it lively?" Then she cuts to her own marriage photos and relates a story about how when she returned to her ex-husband to ask for her half of the property they built together, she found her wedding photo with a dozen knives in it, her ex-husband's expression of anger at her for breaking their marriage compact. She combines personal reflections with an abundance of materials from the life around her during her development as a person and artist.

In addition to her collection of fragments from her earlier films and outtakes, Hammer also includes photographs, journals, and drawings from her own collection; new footage of herself and her environment; and voice, sound, or musical fragments that she puts together into a mosaic representing her own life and work. The goal of providing representation is clear from the beginning. Hammer notes the fact that when

she knew she wanted to be an artist, she looked around for models in autobiographies, biographies, and popular culture, and could not find anything about lesbian artists. Her film aims to be a model of that which she had sought. Accordingly, she puts herself into a continuum of lesbian artists who have not received sufficient attention for that vocation. Although she only gestures toward this lineage here, it will become the centerpiece of her next films. Meanwhile, for *Tender Fictions*, after she shows us Shirley Temple's star on the Hollywood Walk of Fame when she is recounting her mother's ambitions for her life, she finds Dorothy Arzner's star. She cites Audre Lorde. Even the title, an allusion to Gertrude Stein's *Tender Buttons*, asserts the lineage to which Hammer's own art belongs.

Within this framework, she showcases her artistic ambitions through many technological and cinema-specific experimentations. She places herself within frames and shifts the color or positive/negative value of the image. (As Stein might say: "The change of color is likely and a difference a very little difference is prepared."[55]) She repeats phrases or stutters images, presenting a kaleidoscope of her life and memories. Something akin to the layers of the 1980s films is in evidence with sequences such as when she is roller skating and the soundtrack repeats snippets of conversations between herself and former lovers, which we learn later come from her interviews with them to find out what they think/thought of her as a lesbian, artist, or lover. The ending of the film likewise punctuates images of herself and text echoing the film's themes (for example, "Avoid Assimilation"), with photo booth photos of her and Florrie Burke, showing Hammer in relation to her partner and her artistic medium (the visible sprocket holes calling attention to the image *on film*) (figure 29), and with blank, black screens, all set to repetitive singing. She provides an account of the milieu of a lived lesbian life through the language of an experimental film artist. She mobilizes the tools of that calling to relate her autobiography.

Hammer includes the voices of her friends and past lovers as well as stories she herself recounts—stories told about her repeatedly by her family as a girl or from her own memory of events, like meeting Lillian Gish and D. W. Griffith when she was a child. Interestingly, many of these are stories Hammer recounts in several other places other than this film—her interviews and journals each put a slightly new gloss on familiar stories told for different purposes. Any differences, however, are of little consequence in the context of a film about the fictive nature of autobiography, the need to control your own narrative (both on the personal level and as part of a community, here of lesbian artists and activists), and the highly subjective nature of experience and memory.

For instance, several of Hammer's stories involve memories of her mother, whom she admired and to whom she felt an attraction. She cites Nancy Chodorow's writing,

noting that lesbians often are working out mother-daughter relations. She recalls that her therapist calls her mother "seductive," and how these memories complicated her notion of lesbian identification as well as her sense of her childhood. She reflects on the way her mother's breasts would perfectly fill the cups of her bra. She recounts mustering the courage to ask her mother if she were a witch. And she feels a keen regret as she remembers not wanting to climb into bed with her dying mother because she felt it would be incest. These memories form a part of the portrait the film sketches of Hammer's background, development, and psyche as a lesbian and as an artist. She relates these memories to the way lesbian couples mirror each other, each recognizing in the other's body shaped like her own a kinship of form and feeling. This in turn leads to reflections on her domestic partnership and the differences between Hammer's earlier promiscuity and later state of romantic commitment. One of only a handful of films that feature Burke for any length of time, *Tender Fictions* presents the love of Hammer's life in photo booth images, in black-and-white grainy photography, and through her voice. In presenting the content of its filmmaker's life, the film also provides elements that reflect that life from the outside, in the broader culture and at home, and that accordingly connect it to the lesbian experience Hammer wanted to meaningfully represent.

Building on her foray into recuperating lesbian cultural history in *Tender Fictions*, in her next long-form documentary film, *The Female Closet*, Hammer offers a glimpse of an as-yet untold history of lesbian artists' experience through the twentieth century. Selecting three artists working across visual mediums—Alice Austen (photographer), Hannah Höch (multimedia, photocollage), and Nicole Eisenman (painting)— Hammer repeats and develops some of the same themes from *Tender Fictions*, including female mirroring in lesbian relationships, creative acts as responses to cultural marginalization, and the role of sex and life in making art. Her subjects' lives and primary periods of activity stretch across the century, from Austen at the turn-of-the-century 1890s to 1900s, to Höch active especially in the 1920s to 1930s, to Eisenman's work in the present day of the film (the 1990s).

The intersection between each artist's lesbian life and the artwork she produces is scrutinized through interviews with historians, artists, curators, and their own words or works in archives and art collections. Hammer is present throughout, asking questions, manipulating footage (for instance, a sequence with Eisenman toggles between negative images, color, and filtered shots), and offering direct or indirect commentary through news clippings and pointed insertion of images. However, the majority of the film allows other voices to direct the representation of lesbian art and artists on offer, sometimes subtly against Hammer's otherwise ostensible argument about the necessity

of outing, recovering, or simply underlining lesbian life and experience as a key element in understanding an artist's output. For instance, several of the historians caution against using current terminology, like lesbian or bisexual, to describe behavior and a lifestyle that historically might have been understood differently. Alice Austen's cross-dressing, read from a historical distance, may have different nuances of meaning then than now. In each section, at least one person suggests that a notion of ambiguity may be more significant to reading the work than sexuality. The film thus addresses the theme of queer art history on multiple levels in which intention, context, form, and circumstance combine in unexpected ways.

Each section has an opening and closing and could stand on its own as a portrait of the artist that forms its subject. The "opening" of each of the three segments is in any case literal; each begins with double doors swinging toward the viewer—the opening of a closet's doors. The first section offers the view of a hidden history of lesbian art through Austen's photography; in fact, it outs Austen, citing her long-term relationship with Gertrude Tate, her images of cross-dressing, and her lifestyle (never married, athletic, independent) as evidence of a buried history of lesbian identity. The film identifies the source of the burial in members of the Friends of Alice Austen House, whom the film portrays as perpetrators of a cover-up of Austen's lesbianism. Through interviews with several people who interacted with Austen House's Board of Trustees as well as footage of interaction with people who adamantly deter Hammer and others from asking any questions about Austen's sexual identity, Hammer builds a case for uncovering a repressed history. One of her most vocal advocates for this position is Amy Khoudari, a historian working on a biography of Austen's life. When Khoudari was denied access to Austen's archive, by her account because they knew she believed Austen to be a lesbian, she summoned the Lesbian Avengers, a lesbian activist group that formed in New York in 1992.[56] Hammer interviews Anne Maguire, one of the founders of the Lesbian Avengers, and films the descent of a large group of Avengers on Staten Island to disrupt an event held in Austen's honor by singing songs and confronting the keepers of Austen's legacy with the charge that they are denying Austen's identity because they are homophobic. An older woman associated with the event angrily tells them to go away, asserting, "she was a photographer. She was not anything else."

The Female Closet, more so than *Nitrate Kisses* or *Tender Fictions*, moves forward through argument. One of Hammer's primary claims here is that the importance and complexity of lesbian history has not been sufficiently advanced in contemporary society, and that artists have suffered lack of exposure, funding, and other opportunities as a result. The middle section on Hannah Höch seeks to rectify the lack of historical

accounts of lesbian artists by focusing on Höch's nine-year relationship with Dutch sound poet Mathilda "Til" Brugman and the mutual creative inspiration these artists afforded each other during their long relationship. The final section, however, shifts in tone somewhat, as a new generation of queer art and artists, represented here by Nicole Eisenman, conveys mystification that art would be anything but made more authentic and more marketable by its obvious expression of sexual identity. Hammer appears alongside Eisenman, asking her questions as she paints "daisy chains of women having oral sex" and other sexual content. In her case, the pendulum has already begun to swing the other way. Hammer meets with multiple expressions of the desire in contemporary art not "to see the totality of an artist's work focused on one particular issue," including sexual identity. In other words, sexual identity is more than accounted for, and now it is necessary to expand a sense of the artist and her work beyond identity issues. That is how Nicola Tyson, founder and curator of Trial Balloon Gallery, a space devoted exclusively to women's artwork, puts it. In discussion about Eisenman's work, Tyson focuses on several qualities—her draftsmanship, satirical outlook, and connection to graphic art—not immediately tied to the sexual background of the work. When she does focus on identity issues, she veers equally toward Eisenman's recovery as a heroin addict and her class background as she does toward her focus on lesbian themes.

That Hammer puts these three sets of lesbian art histories together into a single film demonstrates, despite its essayistic and occasionally didactic qualities, that she is still in the process of *exploring* rather than nailing down both the issue of lesbian history and the formal constraints of documentary. *The Female Closet* is fascinating in the way it seems to undercut Hammer's point at the same time it forcefully asserts it. She consistently puts a pointed opinion out into the center of a sequence—for example, that MoMA is downplaying the bisexuality of Höch's retrospective exhibition—only to provide examples of how she may be overplaying the issue. In that case, she lets a perfectly reasonable-sounding woman who attended the exhibition note that the brochure does in fact make a note of Höch's bisexuality and assert that maybe it wasn't on the wall text because there is less room for context there. She allows certain experts from various fields to demonstrate that the same histories Hammer is interested in redressing are in the process in fact of being redressed. Most importantly, this approach prompts her to muse on the aftereffects of her own pioneering work; she reflects that someone like Eisenman does not have to worry so much about representing a lesbian sensibility because Hammer and others paved the way for her.

Together, *The Female Closet* and *Tender Fictions* combine and repurpose the methods of the other documentary work Hammer began earlier in the decade. They merge the

oblique thematic approach of *Nitrate Kisses* with more direct, conventional techniques of documentary filmmaking like that represented in *Out in South Africa*. Hammer has noted that in the 1990s, she turned again primarily to "identity issues" as a result of finally having both the practice and the theory needed to address such issues under her belt.[57] She was working toward balancing the embodied, subjective, tactile sense of her creative practice since the 1960s with the heady, disembodied, intellectual, and theoretical knowledge that she was spending an increasing amount of time developing (partly because in the 1990s, she did a lot of teaching, through which she developed the critical apparatus for talking about the logic behind various aspects of the work[58]). To demonstrate: in the concluding paragraph of an essay Hammer wrote in late 1990, she explains the unique voice of the writing that precedes this conclusion, which betrays a balancing act between impulses associated with the authoritative, scholarly, research-driven documentarian on one side and the creative, wild, subjective, experiential, affective experimenter on the other. She puts the division into distinctly negative and positive terms, but it is their combination that promises something more fruitful:

> In writing this paper, I have been compelled to write in two voices: the voice of "critical negative theory" and the voice of the affirmative, politic, the voice of the practicing artist. The tension that is unreconciled between these voices is the off-screen space De Lauretis notes. For me today, this is the space where things can happen. This tension, this contradiction, this unreconciliation is the space for the lesbian voice of difference in avant-garde film.[59]

Hammer is citing Teresa De Lauretis's *Technologies of Gender* and draws on its argument that off-screen space holds potential because it actively implies what is "not represented."[60] For Hammer, it signals a way of addressing (and redressing) lesbian invisibility by embracing different ways of being and allowing them to remain unresolved. This issue is, as we have seen, taken up as the subject matter of all of her major films in the 1990s. The work of this decade could be said to bridge the structuralist and documentary impulses of the earlier and later work respectively. As she continues to work in the following decades, she marshals these skills toward securing her legacy as an artist who contains all of these contradictory, richly productive multitudes.

2000-2019

Legacy

In the last two decades of her life, Barbara Hammer continued to produce films, but she also turned more definitively toward shaping her artistic identity for posterity. Her energy, curiosity, and devotion to explorations of the world and her own place in it continued unabated despite her cancer diagnosis in 2006, which shaped the nature of her work and its urgency in the years that followed. Not surprisingly, her art's themes during this late period are unflinching in their look at disease and demise, albeit coupled with the beauty and vitality of her artistic interventions amid those concerns. Moreover, as she began to think about her own mortality, Hammer devoted a good deal of her energy toward securing her work's place in the world she knew she would leave sooner rather than later. Accordingly, this chapter considers both the creative labor of her films in these decades and the administrative and other types of labors she exerted toward establishing her legacy. Both kinds of work provide insight into her motivations—how she saw her own oeuvre and how she wanted it to be received by future generations. Hammer completed several key works during this period. Here, I consider at greater length a handful of films that better illuminate certain aspects of her legacy, including *History Lessons* (2000), *Resisting Paradise* (2003), *A Horse Is Not a Metaphor* (2008), *Maya Deren's Sink* (2011), *Welcome to This House* (2015), and *Evidentiary Bodies* (2018).

Although not all of her films from this period will be discussed at length here, it should briefly be noted that several of these other films help further establish themes or working methods or affirm her status as a respected artist. These include *Lover/Other* (2006), which premiered at the Berlinale International Film Festival in Germany in February 2006 and the Directors Fortnight at the Museum of Modern Art in New York City. As the stature of these openings in venerable institutions demonstrates, the gains she had made in prestige as an artist since the days of screening films in private women's clubs in the Bay Area were significant. *Lover/Other* is a double biography of surrealist artists Claude Cahun and Marcel Moore, lesbians and war resisters who lived on Jersey Isle in the British Isles during World War II. It continues

Hammer's exploration of lesbian histories by concentrating on an extraordinary case study. Another film from this period, *Generations* (2011), further elaborates Hammer's commitment to collaboration (with cofilmmaker Joey Carducci), raising up working artists of another generation. *Diving Women of Jeju-do* (2007) extends the pattern of Hammer's capitalizing on her invitations to travel with her work to make new work out of those experiences (as we saw, for example, with *Out in South Africa*). All of these likewise provide practical examples of how Hammer shaped her legacy.

The innovations of the late work often have to do with expressing ambiguities. Several of the films, including *Devotion: A Film about Ogawa Productions* (2000) and *Lesbian Whale* (2015), are efforts to demonstrate the importance of coming to understand oneself and others from a kaleidoscope of perspectives. Hammer presents a point of view only to meticulously dismantle that view with other ways of looking at a situation, place, or person. Although *Devotion* begins by establishing filmmaker/producer Ogawa Shinsuke's magnetism for drawing together a collective of men and women in Japan for worthwhile political causes (for example, protesting the confiscation of farmers' land by the government for building Narita airport outside of Tokyo in the late 1960s), Hammer's film swiftly shifts to interviews with members of the film collective and in short order condemns Ogawa for his cultist oddities, his thoughtless collection of funds he never means to pay back, and his hierarchical organization of the collective members such that women end up in the kitchen and in supporting roles for the men, who execute the creative labor of filmmaking. The merger of an artist's uncompromising work ethic, political aims, problems with women's rights, and issues with collective living sit uneasily together in the end. Though the film has been seen as damning to Ogawa's reputation—so much so that Hammer reported having been vilified for offering so negative a view of his work[1]—its repeated presentation of photographs and footage of thoughtful, hopeful, politically engaged young filmmakers getting together to make movies is simultaneously more positive—or at least more ambiguous—than that reading allows. It taps into Hammer's own hopes to change the world by offering representations of marginalized people, including the women of the collective. Howsoever they were demeaned by the dominant, male members of the production company, Hammer affords them a space in the history of the collective by making her own film. She redresses, in a small way, some of their suffering and invisibility. In so doing, she calls attention, as she has done in the majority of her work from the beginning of her career, to the unsung, unappreciated, hard-working women toiling for an opportunity to be heard and seen and to create their own work.

Very differently, *Lesbian Whale* also expresses multiple points of view by including a conversation in voice-over by people looking through Hammer's early journals;

Hammer is present and occasionally contributes a thought here and there, but mainly, she allows the film to present new views about the journal's highly personal expressions from her early days of emerging as a filmmaker (it also echoes Hammer's collection of thoughts about Maya Deren by people who knew her at the beginning of *Maya Deren's Sink* [2011]). It animates (literally) the words and drawings Hammer made in the early days of her artistic ambition but according to the vision of those who would help to preserve these traces of her work. Hammer already begins to allow the story about her to be told by others—a way of simultaneously shaping and letting go of her work as she begins to recognize the inevitability of her impending death.

As these films suggest, the key element of change in the postmillennial work by Hammer has to do with the issue of legacy—both of lesbian history and, more urgently, her own. It looks at her past work, aims to shape impressions of it in specific ways, and imagines a future without the artist there to speak for it. And importantly, Hammer's efforts move away from the films—even giving away film projects she had left undone for others to complete in her absence—and toward a sense of how the collection of her work might continue to be relevant for the future. Keeping openness in the work—imagining it lasting longer than its maker, with a kind of life of its own—became one of the primary ambitions in Hammer's last decades, along with making her impact on the field of experimental filmmaking assured beyond the frame of her own life.

History Lessons (2000) and *Resisting Paradise* (2003)

Refashioning the Past for Now and for the Future

Like several of her films (including *Endangered, Sync Touch, Optic Nerve, Shirley Temple and Me*, and *Generations*), *History Lessons* begins with an image that foregrounds the filmmaking process; in this case, a hand touching and holding up film strips, including some leader with the "Picture Start" frame as well as the ensuing countdown numbers, beginning with a repeated number eight. From the beginning, in highlighting a tactile and sensuous relationship to the medium of film, *History Lessons* offers what amounts to an outing through historical footage, so to speak. The images of leader give way to a color illustration of a woman—which we will find later is one example of several lurid covers adorning novels that depict lesbians—overlaid with spots to make it look decayed with time. The film deals with these images of the past and updates them, in a variety of ways, for a new time. *History Lessons* takes as its mission to challenge received notions about lesbians in culture and history. After the opening, the film

moves almost exclusively to found footage sequences that demonstrate the ubiquity of quotidian lesbian scenes in history as well as titillating accounts of domineering lesbians as a hidden threat in society. Mostly, Hammer allows the found footage to speak for itself, offering archival moving images, for instance of Eleanor Roosevelt giving a speech, women doing sports, and lesbian pornography. Interspersed with this footage, Hammer adds images from print media, including news reports and novels about lesbians. And along the way, she puts her own touches on the footage—just as she literally does in those opening images with the film leader—for example, by dubbing her own voice in for Roosevelt, so as to add the issue of lesbian rights to her speech, or by staging a scene of lesbian noir with a woman dressed as notorious crime photographer Weegee (pseudonym for Arthur Fellig), snapping photos to capture lesbians in flagrante delicto (a sequence staged to resemble historical accounts but that comes from the present moment of the film's making[2]). Midway through the film, and fleetingly throughout, Hammer returns to images of herself handling the film strip or looking through film cans for further material, lest we forget the interplay between the lesbian making the film and the remaking of lesbian history there depicted (figure 30).

The cumulative effect of *History Lessons* is to provide evidence of the certain presence of lesbians in our midst. That is, while much of the work of Hammer's films in

Figure 30. Hammer handling the film in *History Lessons* (2000)

the 1970s aimed to make queer people visible at last, primarily by filming them herself, here Hammer points to how lesbian visibility has always been available if a person simply knew to look for it. As the third film in her "Invisible Histories Trilogy" (after *Nitrate Kisses* and *Tender Fictions*), *History Lessons* offers a third way of telling lesbian and gay history.[3] While *Nitrate Kisses* focused primarily on empathic understanding of others and *Tender Fictions* looked to Hammer's own autobiography as a lesbian artist, *History Lessons* reconfigures existing traces of gay and lesbian history and looks at that history through a different lens. Many examples of historical depictions of lesbians, for instance, offer negative images of concupiscent lesbians doing harm to innocent girls and titillating consumers of newspaper stories. Thus Hammer, as she put it, was invested in "flip[ping]" the negative/too-visible versions of lesbians in history and thereby changing the meaning of "movies that portrayed lesbians as lechers, promiscuous. . . . I would not back down from my original intention to expose the negative cinematic history of lesbians!"[4] So not only did Hammer convert the invisibility of queer history into visibility but she also condemned the portrayal of negative stereotypes.

At times, these two registers of intervention are inextricable, in part because of Hammer's intricate editing of the material. For instance, early in the film, she shows young girls exercising out of doors. One says "You like to exercise, don't you? It helps to make you strong." Hammer cuts to young women, also exercising out of doors, in a larger group. In voice-over, a man speaking of exercise tells us, "Of course the heart is a muscle," before going on to note that also, "In fact, it's a great deal more than that." The image shifts to the red cover of a report: "Heart of a Lesbian: Special Report." A drum beats, like a heart, and we see that its source is one of the women in white, drumming while her compatriots do a slow-flowing exercise, rhythmically moving their lithe bodies in wide circles at the hips. A title card interrupts: "And eight years later . . ." The scene shifts again to two women smelling flowers together, then young women riding stationary bikes, with the camera providing close views of their long legs pumping the pedals. Then they are on the open road, riding free. Finally, after a moment we come upon a group of ladies playing tennis, topless. While all of this material is related to girls or young women in states of sporting activities, the shifts suggest how to read the lesbian subtext (or text) Hammer underlines within each scene. The healthy, strong, active girl sustains a positive reading, which is threaded through with suggestive perspectives (for example, close-ups of a young woman riding the stationary bicycle from the rear) and overt linkages to lesbian desire (for example, the "Heart of a lesbian" report). The arbitrary narrative shift signaled by the title card "And eight years later . . ." points to the generative noncontinuity editing Hammer employs to offer different readings of material taken out of one context and

put into her own configuration of the history of moving images. Movement forward happens differently here: a clear arc is sketched from a training sequence (on stationary bicycles) to the activity for which the women had been training (riding out on the road together). The connections are associative rather than sequential. The heart is a muscle, but more, and thus we move from healthy exercise to exercising the right of the lesbian to her desire. Finally, the continuation of the sequence into the footage of topless tennis affirms a point of arrival and the plan for the destination that was there all along. It fits the logic of the sequence (another form of exercise) but shifts its meaning in a way that reveals the intention of the sequence's associations all along.

Hammer's original plan for the project that became *History Lessons* was to deal with negative representations rampant in culture. Simply embracing representation in this case would have a double edge; it might be expedient, but that kind of representation would be potentially deleterious in the long run. It is representation, but it risks being misconstrued. *History Lessons* counts on the audience to understand the ways in which history is being revamped. As Hammer described it:

> This was going to be lesbian history, focused primarily on how we've been eroticized and sexualized and used voyeuristically by a cinema where the producers and directors and audience were men, primarily. That's what this footage had been shot for. But it was footage of lesbian sexuality, which is what I had been working in [since] almost my second film. . . . So, of course I felt a vested interest in it, and of course I thought everybody would understand that I'm going to take this footage and we're going to look at it, so it's not going to be presented as if it's to be used for sexual excitement today. It'll obviously be a critique.[5]

In the process of working on the material, Hammer discovered the difficulty of conveying a subtle message through unsubtle material; because she proposed to use pornography footage (and provisionally titled the project *Porn Doctor*), she nearly lost a grant that would help her to make the film.[6] Thus she used the multiple experimental layers, such as the early sequence with the heart of a lesbian, to complicate the material and interrupt it. Lest the pornography be read here as a negative or voyeuristic representation, Hammer's mode aimed to compensate for it through a joyous co-opting and layering of the material.

The idea for the film endured although Hammer had to change the working title of the film and her description of it. The materials derived from a variety of sources. Hammer credited Anne Maguire, working for the Rick Prelinger Archives, for providing

her with footage. Maguire would specially set something aside if it seemed to contain any lesbian footage when it came into the archive (the underwear models "showing off their underwear to each other," for instance).[7] The Lesbian Herstory Archives provided copies of educational films, including the section of the film that features two teenaged girls who have a relationship one of their mothers deems "unnatural" for its "continual intimacy" and its "concentration of affection." The film also includes clips from popular films; newsreels; sex education, medical and educational films; pornography; and Hammer's own footage, like the section on Weegee and glimpses of herself in the archives or working with the film. Through the film, in a gesture toward updating the codes of sexual history, we see women's body parts measured, GI women marching or looking at laces, and young ladies modeling lingerie for brides. The reconfiguration of this history of images of women working and playing together maintains ambiguity about the types of intimacy they depict. The film's use of found footage and found sound is wide-ranging. Within this landscape of female bodies, hints of lesbian intimacy give way to forthrightly sexual scenes (often, in the pornographic footage, tinged with sadomasochism). At times, the sound provides commentary or counterpoint, such as a male voice-over about healthy, vigorous girls who have vast reserves of energy or songs about dykes or lovers. Sound and images both mainly derive from the past, with Hammer repurposing them for her own designs. The juxtapositions of sound and images through the film create an original creative document that attests to the historical and continuous presence of lesbians, including the layer of presence embodied by the filmmaker.

Although it operates primarily in a documentary mode, mobilizing found footage and piecing together a historical record of lesbians on the march, Hammer's creative contribution in the film may be found in its experimentalism too. Making the film appear degraded, running scenes backward (for instance of a woman walking in a field), including images of the film strip and herself looking through a vault of film reels, all contribute to the film's unique expression of queer sensibility in its present moment. While the film first and foremost concerns history, it also aims to convey a message for the present, such that queer concerns are no less urgent now than then. Hammer effects this message by wielding the tools of an experimental craft she has honed for over thirty years at the time of making *History Lessons*. Following Scott MacDonald's categorization of six tendencies of experimentation characterizing post-1960s avant-garde film, we see that Hammer engages most of them—she operates in an autobiographical register, amply mobilizes found footage, uses the formal experimentation of earlier modes of avant-garde film, and, especially, experiments at the level of generating a new feminist language for expressing ideas.[8] She marshals her full creative vocabulary for expression

threaded *through* the breadth of other people's versions of history. The lessons Hammer conveys have to do with her own film practice as much as the history she is rewriting. In addition to the films to come in the following decade, *History Lessons* looks back on Hammer's concerns as an artist both reflecting and creating the world. These concerns develop toward other ways of framing familiar issues in the films she made during the last two decades of her career, including *Resisting Paradise* (2003).

In an important way, *Resisting Paradise* bears a relationship to the conflicts explored in *Devotion* (2000)—in both cases, Hammer comes to discover a conflict at the heart of her filmmaking ethos between the exigencies of being an artist and the ethics of living as a human in the world, such as it is. Hammer traveled to the south of France in the spring of 1999 for a residency provided by the Camargo Foundation with the intention of working in "a totally experimental" mode, "working with the light of the Mediterranean," filming whatever struck her as interesting in an "unplanned and unstructured" way that wouldn't "need a form."[9] She ended by making a layered account of the role of the artist confronting war and crimes of varying degrees against humanity, weaving the past (circa World War II) and the present, as Domitilla Olivieri notes, "to directly interpellate Hammer's contemporary viewer."[10] Although like *Devotion*, *Resisting Paradise* comes across as critical of the artists who continued working on their art during troubled times, oblivious to the more human concerns of those around them, in the end it expresses a much more complex tapestry of concerns and approaches to art in the midst of worldly interests. When war broke out in Kosovo during Hammer's residency, she wanted to, as she put it, "go to the border and help women and children by taking water to them or comforting them, being of help in whatever way I could."[11] She noted that when the director of the program let her know that she could not break the contract of her residency, she turned her attention again to the film and found an outlet within it for expressing an attitude of resistance she was unable to assert in life; in this way, one might say she mimics the subjects she criticizes in the film in that art is her tool for political and ethical expression. It significantly complicates any censure of artists who, as Hammer put it, are "telling their inane stories about trying to get a yellow cadmium paint, and worried about gasoline prices. Ridiculous."[12] Their art, like hers, is also more entangled in the world than her sometimes dismissal of them suggests.

Resisting Paradise proceeds with divided focus; the difference between Hammer's initiating concerns (experiments with light and color) and the historical, documentary issues she uncovered as a result of wanting to do something in the present moment for a new war maintain an uneasy balance throughout the film. The desire for spontaneity Hammer expressed from the beginning in fact found purchase in the project no less productively despite it having a different origin than she had imagined. The Resistance

Hammer finds when she begins digging into sources in the south of France is decidedly female, and it is composed of vivid characters: Lisa Fittko, a refugee who worked with an American agency to help rescue those fleeing the Germans; Marie-Ange, who personally and at great risk helped "an endless line" of refugees avoid deportation in Cassis during the war by forging their identity cards; and Henri Matisse's wife, whom we learn from the film did work for the Resistance while her husband fretted about his painting "being difficult" amid fears of Nice being on the brink of occupation by the Germans. Hammer homes in on the women of the Resistance in particular, but she may well identify with the fretting artists too. The film remains ambivalent about its initiating question about whether art can exist at a time of war; Hammer's voice-over disappears and the strands of her inquiry blend with new discoveries that have uncertain intentions. One of the structuring impulses of the film is Hammer's questioning of the motivations of some of her interviewees as well as of herself. She worries aloud: what would I have done in the face of war? "Would I have chosen to remain naive, keeping a life enchanted by light?"

In fact, although the language Hammer uses in her voice-over descriptions of Pierre Bonnard and Henri Matisse, whose correspondence she quotes liberally in the film, is primarily one of censure—they are the ones she sees as "remain[ing] naive" and whom she worries she might emulate and fail if called on to rise to a war occasion—the language of the film tells a more nuanced story. While it explores more complex, politically charged terrain than the original aesthetic intention simply to explore the light, the film is indeed also replete with exploration of light and highlights aesthetic elements of the cinema. At several moments, she abstracts the light cinematically or paints directly on frames that capture the beauty of the landscape around her, such that the paint drips down the image. The light replicated and even generated by the painters with paint (therein the mystery of painters who, like Bonnard, master light through pigments) takes unique form in a different medium. That is, in addition to reveling in the way celluloid depends on light, Hammer also obscures the light that might pass through the celluloid by applying paint onto it, drawing attention to her own medium's nature and inverting paint's purpose when applied by the famous painters (blocking rather than producing light effects). While she includes straight documentary techniques such as interviews and texts that are meant to elaborate her themes,[13] she also, for example, blurs images, showing the beautiful effects of manipulated camera movement on images of blossoming trees in the film's opening shots. Her exploration of the politics of southern France depends intimately on laying bare the foundations of her medium and articulating issues through that art form, undercutting any suggestion that art cannot exist in a time of war.

Resisting Paradise resonates with urgent ideas about life versus art. Her attitude toward the questions she asks of her interlocutors indicates a moment when Hammer was questioning the importance of art over human lives and struggles. This point may provide the thematic center of her documentary investigation in Cassis. In a key moment, however, Hammer interviews Henri Matisse's grandson, Claude Duthuit, and the way he discusses his grandfather points to something that would become increasingly characteristic for Hammer in the ensuing years. Hammer asks him, "What did he [Henri Matisse] do during the war?"

> DUTHUIT: He went on painting. There was nothing else to do.
> HAMMER: Do you know why he made that choice?
> DUTHUIT: What choice?
> HAMMER: To go on painting.
> DUTHUIT: Because that was the only thing he knew how to do in life.
> That's all he did, was work. All his life was around his work. . . .
> Painting was not a . . . painting was a trade.

Duthuit understands that for Matisse, the art was his "trade," rather than some other unnamed thing—a calling, perhaps, or a vanity. While one might have been waiting for a grand statement about the importance of art, in fact, Duthuit provides a different kind of justification. A "trade" suggests that painting was the way he survived, and not just financially, but in the world. Hammer makes a similar move when she does not go to Kosovo. She goes on making films as a response to the intense feelings such awful world happenings inspire. That it may have a more lasting effect (if possibly a less person-to-person effect) on the world around her than what she wanted from that moment—or from art—is exactly the kind of exchange necessary for continuing to make art with the limited time allotted to any person then or now. Hammer felt those limits more in the years soon to come, and the tone and subjects of her work reflected those limits even while her work continued to build along the continuum of her long-term interests.

A Horse Is Not a Metaphor. Or Is It?

Although at first Hammer's *A Horse Is Not a Metaphor* (2008) might appear to represent a shift in her work's mood and tense—bringing her recent cancer diagnosis of stage three ovarian cancer to the foreground and looking toward the past in a different way—and although it forges into new territory for her oeuvre on a number of counts, the film also sustains several of the issues that have been important to her work for a long time. For one thing, it explores the fact of her presence in front of the camera as

well as behind it; the film sifts through her image as it is mediated by her own perspective, as she has in many of her other films from *Schizy* (1968) to *Diving Women of Jeju-do*, made just the year before. Her self-image as presented in the film is marked by age and disease, but it is also radiant and prepossessed.

The opening shots show Hammer from behind in overlapping medium to long shots as she wades naked into water, her image doubled and in black and white. This image is then superimposed with the hospital where she is having her cancer treatments, with a view of the chemotherapy drip bag from the perspective of a patient. The blue of the hospital scene bleeds into the first image of Hammer, and the liquid in the drip bag echoes the ripples in the waves Hammer creates as she moves into the water. The natural and medical settings blend into each other, signaling connection. That is, while the film aims to depict an unflinching moment of medical reality, laying bare Hammer's bodily vulnerability as she lies (a moment later) in her hospital bed amid the beeping machines, talking with the nurses about what to expect from this toxic treatment, it also balances that image with the quieter sounds and scenes of nature. Illness and death are, after all, also natural. Many of the scenes of nature's beauty are further enhanced by cinematic manipulations of the image, including slow motion, superimpositions, and motion blurring. The hope for transformation happens by creating a cinematic vision of her disease (figure 31).

Figure 31. Still from *A Horse Is Not a Metaphor* (Barbara Hammer, 2008)

The film's treatment of metaphor likewise serves issues of self-representation and artistic transformation. The associative power of metaphor collapses two different things into one: it transcends the mere similarity that constitutes a simile and joins two things so that each is implicated in the other. Although the title would seem to refuse metaphor as a valid device for understanding the world, the film presents horses aplenty to flout that refusal. Like Kuleshov's experiment, juxtaposing a horse and a woman undergoing cancer treatment in the editing of the film prompts the viewer to make a connection between them.[14] In the opening minutes of the film, Hammer cuts between the chemo drip and a horse five times, just a few seconds each, underlining the correlation. Still, the open-endedness of their connection hews to the ambiguities about art and life Hammer had explored in a different way in *Resisting Paradise*. In what way is a horse related to these images in the hospital? The film drives home cinema's way of bespeaking connection—it says *here is the chemo drip*, then *here is a horse*, again and again and again and once more again—even when one does not speak of the connection otherwise. After establishing this connection, the horse rears, wild-eyed. It may not be itself a metaphor, but according to the kindred principle of *don't think of an elephant*, it acts like one all the same, and leaves it to viewers to connect them in their own way. As I've pointed out elsewhere, the way Hammer edits the title of the film also undermines the negative force of the statement of the title.[15] It divides the words in the title so that the second image shows a horse and reads "a metaphor": the image of a horse looks literally to be labeled "a metaphor." The film has it both ways.

Interestingly, the film would seem to collapse the opposite charges of denial and affirmation—also in metaphorical relation—so that they productively coexist in the midst of the life and death stakes Hammer is grappling with. (A similar denial/affirmation collapse happens in the performance version of *Evidentiary Bodies*, in which Hammer again addresses her cancer, repudiating metaphors for cancer that equate it with war, for example, "cancer is not a battle.") In this film, the power of metaphor for Hammer's thinking about her disease allows her to obviate the ways human disease has been conceptualized in the past. It allows her to imagine a new artistic form to contend with the reality of the disease within the framework of creative expression.

The film elegantly blends Hammer's approaches developed over decades of creative work. It has a facility both with documentary language—she films herself with help from her partner Florrie while she is in the hospital. Her hair is gone, her face is puffy, and her characteristic energy is mostly absent. She comments on the expense of her medical treatment and she details what that treatment involves (the tubes, her nurse

tells her, are like a sprinkler, so the chemo can spread out through her abdomen). As the nurse puts the needle into her skin, Hammer looks away. Like several of her projects, Hammer shows us what we do not normally get to see; we are privy to her private life and pain as she undergoes the treatment for cancer. She documents that process for herself and for the audience, with whom she shares a most vulnerable moment. But in addition to documenting, Hammer also mobilizes the tools of her experimental practice, bringing them to bear on the meaning of the film as a document. For instance, throughout this section, she cuts away to a bronco-riding woman, who dauntlessly holds on astride a bucking horse. Eventually, after a few cuts, she is thrown to the ground in slow motion. As Hammer shows us her scalp, sprouting just a fuzz of hair, she shifts to black and white, then splits the screen into four squares, then nine, and the images shimmer with digital manipulations. She cuts to a horse trotting away and superimposes an image of a split horizon. The image holds movement and a cinematic vitality. The horse runs, and her face is superimposed over it (another connection of two separate shots as one image, presented simultaneously). She walks to a body of water and begins to undress to go in with her dog, who swims around. The semitransparent horse image remains, so it appears that the horse is in the water with her (though it is not). As she walks through the woods immediately after, a new image of the horse is also superimposed, and now she adds a poem to the screen: "i walk undisguised, / a bald ghost of myself, / but, I WALK / Oh, joy is life." The film balances the urge to document her illness and to transform it (and perhaps transcend it) into art.

A Horse Is Not a Metaphor, then, stands at a critical point in Hammer's career: it marks the shift toward an idea of end days that will shape all the work to come, not least of all the work that stands outside of making films, such as building her archive, managing her estate, and thinking about her work's future without her. The denial of a specific association that goes with the horse (it is not a metaphor for what? her cancer? her wild life? her career? or is it that she refuses to tie the horse itself down with the burdens of associations with her life?) means that the film leaves signification open. If it suggests that a horse and a metaphor are at play for understanding, then Hammer leaves the specifics to the spectator. The film itself then becomes a kind of metaphor for the open future it cannot yet imagine/image. The views provided by the camera, for posterity, show us Hammer alone, naked, and just beginning a journey—one that equally steps into nature and embarks on a treatment among the accoutrements of the hospital setting. It marshals the documentary and experimental techniques Hammer mastered over many years of making films in order to deal, obliquely, with the terms of her art for an uncertain future.

Maya Deren's Sink (2011) and *Welcome to This House* (2015): Traces of Film, People, and Places

The films Hammer made during the 2010s as well as the other kinds of work she accomplished in the last years of her life reveal a commitment to issues related to materiality, presence, and preservation. Perhaps no work better encapsulates this focus as well as her film *Maya Deren's Sink* from 2011, centered on the object of the title (figure 32). The provenance of the film was a visit Hammer paid to Anthology Film Archives, where she found that Maya Deren's sink had recently been donated, to be (in some sense) archived. The discovery of the sink gave her the idea for the film as well as access to at least one of the sites where she would shoot it. As Hammer recounts it in an interview with the Museum of Modern Art, she had been visiting Anthology when someone alerted her to the fact that they had Maya Deren's bathroom sink in their hallway:

> So I went out and looked and there was this old bathroom sink . . . with dust and dirt on it and the tubing below and—"what is this?" . . . the woman who lives in the home [where Deren lived] was renovating her bathroom. She wanted to get rid of the sink, and she had a new one coming in, and then she thought, "Oh, this was Maya Deren's sink: somebody would want it." So then, I was able to get her name, and go into her home, and shoot there.[16]

Figure 32. *Maya Deren's Sink* (Barbara Hammer, 2011)

Hammer constructs the film around the artifacts of Deren's existence, which have been pulled like the sink out of their original contexts. She goes back to the places where Deren lived and worked (both in California and on Morton Street in New York City, just around the corner from Hammer's studio), and she attempts to reconstruct the atmosphere of those environments cinematically.

Mentioning the dust and dirt and tubing that come with the sink is suggestive of the debris of the past that Hammer had been thinking about since at least *Resisting Paradise*—as with the angel of history imagined by Walter Benjamin, who looks toward the past while "a storm is blowing from Paradise and has got caught in his wings; it is so strong that the angel can no longer close them. This storm drives him irresistibly into the future, to which his back is turned, while the pile of debris before him grows toward the sky."[17] Accumulating the potentially interminable debris of past lives, projects, objects, and places and trying to make sense of it all appealed to Hammer, but unlike Benjamin's angel, she looked simultaneously toward the past and the future. She began organizing her own archive around the same time as she made *Maya Deren's Sink* and was actively thinking about what parts of the past mattered (answer: almost everything) as she was being buffeted by the winds of her uncertain future in the midst of her illness. Hammer affords a place for the vestiges of Deren—invoking where she worked, the texts she wrote, the films she made, the films she didn't make, and the sink she used—in order to sort through what her work meant to Hammer personally and to film history, which we well know Hammer was determined to reconfigure with a greater number of female players.

Hammer also adds to the memory traces left by Deren by collecting memories of her in fragments of interviews with people who knew her. Hammer considered Deren's work to be foundational for her own films and work life. Even before Hammer made her film about Deren's sink, Deren occupied an important position in the development of her ideas about film art; the film confirms and extends the scope of that position while also ruminating on art more generally. There are many instantiations of Deren's aesthetics and ethos within Hammer's films—from direct homage like the key Hammer removes from her mouth in *I Was/I Am* to more distant echoes, such as Hammer's solicitation of universities to host screenings of and pay for copies of her work to add to their libraries (something Deren did tirelessly in the late 1940s and early 1950s[18]). Hammer reports having first discovered a model for a female-centered aesthetic in filmmaking after a professor screened *Meshes of the Afternoon* in one of Hammer's film classes: "Something was radically different. The screen was filled with images that were created from a different sensibility, an aesthetic I intuitively understood."[19] Although she credited seeing Stan Brakhage's films with conferring on her

the capacity for seeing cinematically, Hammer takes this formative experience with Deren's film as the initiation of her own career: "I knew for certain that I would make film."[20] Hammer claims kinship with Deren in terms of her theorizations of film as well. Hammer writes:

> Deren's elucidation of poetic film and simultaneous time is excellent and the basis of much of my own work. I will give you her words on the poetic film. It is a transcription of that state of being where the intention or "intensification is carried out, not by action, but by the illumination of that moment." The illumination of the moment (the continuous present) means the film's construct is vertical rather than horizontal. It is a poetic construct of developing moments, each one held together by an emotion or meaning they have in common rather than logical action.[21]

Hammer's film holds together in the same way. The illusion of the continuous present is thrown into relief through the film's constant reference to the material and immaterial past, via the body of Maya Deren, her body of work, and remnants of her past. These elements are related thematically and emotionally rather than sequentially. Deren (through projection) and Hammer (through her making of the film) come to occupy the same (figurative and literal) spaces at once.

The heart of Hammer's exploration of her relationship to Deren's work centers on the material object of the sink. Her homage begins with objects that serve as conduits to Deren's past presence, objects that remained after her premature death but that are now in immediate danger of disappearing. The sink—its authenticity as sink and not-yet-symbol suggested by Hammer's observation of "the tubing below"—becomes the central image of her cinematic investigation of the lived environment that contributed to Deren's work. Hammer connects with it because she acknowledges that environment is essential to the shape of her own work (she tells her interviewer that she is sure her whole oeuvre would be different had she lived in a larger studio): "I feel, myself, that what I shoot, and what I've made, depends upon the environment in which I live. . . . What were [Maya Deren's] environments like? And what did she film in them?"[22] Hammer revivifies Deren's world at least partly to help her make sense of her own work's dependence on specific spaces.

In the description of her project, Hammer raises the ghosts of Maya Deren (for a time, Hammer considered titling the film *Ghosting Maya Deren*[23]), which are channeled through this material, useful, left-behind object from Deren's life. It is a reminder that cinema operates always not in the present tense, as some would have it

("The film, silent or sound, has no past or future tense, only the present. It is the nature of the image which tells you at which period of time you are now present."[24]), but in the syntax of pastness—anything filmed and then shown has already happened, if only so long ago as it takes to rewind and project it. Hammer literalizes that ghostliness by "ghosting" Deren's body in several different ways. First, she includes an *unheimlich* double for Deren, actor Bekka Lindstrom, who "plays" Deren, reanimating her. There is a kinship between this figure and Deren's most cited film within Hammer's oeuvre, *Meshes of the Afternoon*, which begins with a mannequin's arm dropping a fake poppy onto the sidewalk. *Meshes of the Afternoon* deals with doubles and imposters and the violent consequences they threaten (one Deren aims to kill another). In Hammer's film, the double of Deren brings the doubles Deren herself mobilized back to a kind of life, again but at a slant to Deren's "real" image in her own films, which is also presented. Her double reads (or seem to compose on the spot) some of Deren's body of written work, apparently reviving Deren's work and work process as well as presence. The other ghosting strategies Hammer uses in her film include projecting footage from Deren's films (as well as photographs and texts from Deren's archive[25]), into the diegesis of *Maya Deren's Sink*. Hammer uses cinematic effects, including superimposition and frames within frames, to project Deren's work and person into her own film's spaces, walking among the people who remember her as they exist in the film's present moment (also now past) in order to raise the ghost of Maya Deren.

It is telling that Hammer was undecided for a time about whether to call her film *Maya Deren's Sink* or *Ghosting Maya Deren*: one emphasizes the materiality of the past that is manifested in the archive (her sink), and one emphasizes the immateriality of the past that is embodied in film (her ghost). Moreover, the tension between the two suggests a framework for thinking about Hammer's project of sorting out issues related to the archive, to homage or inheritance of documentary/experimental strategies, and even to larger questions of cinematic temporality. Three related concepts elaborate the relationships in the film among these issues. First, the film embraces *porosity*, in that the boundaries between times and genres are slippery. The homage film, or the reworking of someone else's film for one's own creative purposes, mobilizes this porosity using documentary and/or archival materials. Second, it adopts a temporal and spatial *proximity* in bringing two disparate times together through persisting objects (the sink as well as the archival material, including the films themselves, belonging to Deren but revivified by Hammer). Finally, the film mobilizes *projection*, literally and figuratively, so that Hammer projects Deren into the present spaces partly to imagine what her past was like and how her work grew out of the particulars of that past. She also projects her own interests into the spaces once occupied by Deren, thereby claiming them as part of her own legacy.

Hammer's film raises several issues. What are the ramifications of what is saved (incidentally/intentionally) or salvaged from filmmakers' lives? What impact do different kinds of materials have for understanding a filmmaker? And how do particular strains of filmmaking practices—here, a feminist, documentary/experimental aesthetic—respond to earlier, pioneering examples? How do they develop, work in homage, interdependence and/or independence from one another? In Deren's case, she deliberately and methodically cataloged her own materials, keeping copious records of her correspondence, pleas for financial assistance, applications for grants, parking violations, poetry fragments, doodles, as well as materials that more directly relate to the filming of her work. Ditto for Hammer, who had the time in advance of her death to compose the contours of her own archive for future artists and researchers. These archival, material objects (including Deren's sink), these fragments she has (and we have) shored against her ruins—make a difference to our understanding of Deren's work and Hammer's reuse of them; they provide a foundation for Hammer's creative exploration of the material and immaterial remains of art as it was made and as it continues to exist after that moment of making. Through Hammer's example, we can see that a palimpsest of artistic activity might be developed where meaning accrues through porosity, proximity, and projection, reanimating the artifacts of an artist's life and oeuvre, which in turn sheds light on the work of one of Deren's artistic heirs.

At the opening of Hammer's film, the idea is raised that maybe "somebody that takes cares of . . . Maya Deren's legacy" would be interested in keeping the sink. Hammer becomes the person who extends that legacy (and the "life" of the sink) by making this film. She echoes cinematic strategies from Deren's work as well, showing the staying power of Deren's work and prolonging her legacy. When we visit the bungalow where Deren briefly lived with Alexander Hammid in 1943, it is introduced to us first by showing the "Botticelli" shot in *Meshes of the Afternoon* (in which Deren appears dreamily at the window in soft focus); her double then appears (though from farther away) in the same window. Hammer visits the stairs that play a role in Deren's film, projecting *Meshes* on the wall while putting Deren's double in the same space. Such examples collapse differences between the two artists, their times, their works, and their spaces—though disparities arise too. For example, shots of the key falling surreally and in slow motion down the steps leading to the bungalow in Deren's film are replaced in Hammer's by superimposed/doubled shots of the key. Also, time has changed other elements of the original mise-en-scène. The tree outside the house (the "original tree," as the new resident boasts) is larger, and the door to the bungalow is one of two doors: an outer metal gate now protects the house. Hammer films its shadows on the steps between it and the original door. These differences animate the

concept of documentary truth as well as presence, absence, and change. Other parts of the film play with issues of presence and documentary authenticity as well: Deren is at the window, then gone, then doubled by an actor to compensate for Deren's absence. Even if the window is the same as the famous "Botticelli" shot of Deren at that window in *Meshes* (and, one might ask, *is* it the same window? has the glass been replaced? is it still grandfather's ax?[26]), the gap between then and the present tense of the film is unfillable (and unfilmable). Most poignantly, the new owner of the house shows Hammer the spot where the chair in which at the end of *Meshes of the Afternoon* Deren is discovered—she reminds us, breathlessly whispering—"dead!" Hammer projects the image of a "dead" (playing dead) Deren as if she were sitting in the new chair in that same spot, and we are reminded of her very real demise outside of the film in this later (the past is piling up in limitless debris) revision of the film.

Ultimately, Hammer draws on the material in Deren's archive (not just the sink but her films, photographs, and texts) to ask about the status of authenticity and experience as preserved within that archive. By considering film fragments, where reality and past time are embedded, and objects (like the sink), where a more tangible reality asserts itself but within imaginative terrain (what was it like for Deren to use this sink?), Hammer points toward a peculiar authenticity in the multiple kinds of reality of the archive. Hammer was well aware of issues of the archive, as she was just beginning the process of cataloging her own copious collection of journals, papers, pamphlets, and film materials into an archive for sale. Thinking through these issues in an article from around the same time, she recalls having read Jacques Derrida's *Archive Fever* "avidly, and thought about his ideas on the impossibility of archiving. According to Derrida, memory of intense feeling and traumatic events cannot be retained and hence cannot be archived. I disagree, as my emotional states of being are often the very basis and inspiration for my films." For a better model, then, Hammer turned to Ann Cvetkovich's *An Archive of Feelings, Trauma, Sexuality, and Lesbian Public Culture*:

> She refers to "films' and videos' archiving capacity to create fantasy and facilitate memory and mourning by aiming for affective power rather than factual truth." . . . My hope is that by sharing such personal and extensive materials from life, my work and I will be understood more fully. . . . Some things about me will always be hidden, and an archive can never reveal everything. There is some grace in knowing that. . . . An archive, then, must be taken at face value and used with caution. Suppositions can be made but not declared. The minutia of today may become the treasures of tomorrow.[27]

Hammer engages these issues in her film about Deren, paying homage through bits of her life and work, and using Deren's work as a key (so to speak) to her own.

Extending these themes, Hammer's last feature-length film, *Welcome to This House* (2015) takes a tour of the homes where the poet Elizabeth Bishop lived and wrote. The film traces Bishop's life and development as a writer, dwelling on Bishop's loneliness, her discovery of her writing gifts, her lesbian loves, and her channeling of all of these elements into her writing. "How she looked at the world," one interviewee declares about Bishop's first home, "was shaped actually inside these rooms." Hammer visits these places and interviews scholars, historians, and those who knew Bishop to make sense of the relationships of place, self, and art in her life and work. As with *Maya Deren's Sink*, Hammer was interested in the role of artists' "environments" for accomplishing their work. While *Welcome to This House* also gathers testimony about many other aspects of Bishop's life, it lingers in her spaces visually and establishes place as key to her praxis.

As we saw earlier in her oeuvre, Hammer was committed to bringing greater visibility to female artists, to claim a place for them in a larger cultural history. This mission may have intensified as she contemplated her own place in that history in terms of shaping her own archive and executing other activities designed to secure it. While Hammer does appear in the film—as a stand-in for Bishop at a couple of points—she otherwise primarily strives to let Bishop's history (and poetry) come to the fore. The soundtrack of the film is rife with poetry, some of which relates directly to the notion of Bishop's homes and a lot of which simply delights in the richness of the language and imagery achieved by this masterful artist. "One Art" is a touchstone for the film, with its emphasis on place and loss, as seen in any excerpt one might choose:

> The art of losing isn't hard to master;
> so many things seem filled with the intent
> to be lost that their loss is no disaster.
>
> . . .
>
> I lost my mother's watch. And look! my last, or
> next-to-last, of three loved houses went.
> The art of losing isn't hard to master.[28]

The form and theme of the poem contribute to the turn at the end, in which the losses incurred truly do wind up being the disaster she denies throughout the poem; however, in the continuum of losses, these "three loved houses" arrive near the middle of the list. For Bishop, anyway, the loss is important but does not match the disaster

of losing a loved one. Similarly, although she and Bishop never knew each other, so the loss is not personal so much as symbolic, Hammer's film dwells on the loss of the artist—and the things she loved that remain when she is gone are the conduit to that lost person, including beloved houses. This echoes Hammer's efforts at the end of her life to think through what her art will be or do when she is not there personally to advocate for it or speak for her intentions.

Certain connections between Bishop's and Hammer's lives and work become apparent slowly through the film, including their uncompromising work ethic. But while such connections are important to the film, Hammer mainly demonstrates interest in Bishop herself. The film is more objective in its approaches than several of Hammer's other documentary works. She finds photographs and letters and documents detailing the stages of Bishop's life, and she presents them with accompanying titles for the experts, place names for the locations, and a clear timeline. She allows others to speak about Bishop and does less to shape the material than she might have in, say, *The Female Closet*, which also seeks to recuperate the legacy of female artists. She also allows Bishop's work to speak for itself with long quotations from her poems. Experimental film form finds expression in aspects of the film, such as Hammer's overlay of photographs from Bishop's moment over film footage of places in the present day of the film, but they call less attention to themselves than the cacophony of layers and experimental manipulations of others of her films that also address (if more obliquely) documentary subjects, like *Sanctus*.

Still, *Welcome to This House* is no anomaly in Hammer's oeuvre, and it provides a clear example of several of the elements characterizing her work as a whole. Greg Youmans has placed the film in a "lineage of domestic films" that demonstrate Hammer's thematic "preoccupation with spaces of domesticity and lesbian intimacy" that goes all the way back to *Schizy* (1968).[29] She delves into the nature of such intimacies recalled by people who knew Bishop from her childhood and into her womanhood and follows them through the often women-only spaces of Bishop's homes, from her early childhood to summers at an all-girls camp on Cape Cod to college at Vassar to homes in Key West, Florida, to a beautiful Brazilian house designed by Lota de Macedo Soares, an architect who was Bishop's lover. Hammer includes several layers of reenactment in the present moment—for instance, by inserting footage of blurry snow when Bishop is tiring of life at Vassar and goes out in the night on an adventure with a school friend; by showing designs for the house in Brazil dissolving into the house itself; or by having her own partner, Florrie Burke, play the young Elizabeth Bishop walking over a bridge—so that the present moment and the history of an artist Hammer much admires blur.

As she began to gather her own archive of materials and traces of the places she had inhabited in her own life, Hammer noted that she wouldn't mind if *Welcome to This House* were her last film.[30] Certainly, it encapsulates several of the signature aspects of Hammer's style—an attention to the minute details in the lives of others as a way of bringing them to life for the viewer, superimposition/optical printing to blend times and places, and a curiosity about the hidden lesbianism of historical figures, to name a few. But one key project was still up Hammer's sleeve after this film: a multiformatted work that attests again to her interest in the body, bringing her work full circle such that it doesn't end so much as continue to wind in a continuous loop.

Evidentiary Bodies x 4

Identifying a last finished work in Hammer's oeuvre and situating it within the context of her legacy is complicated by the nature of her final works. There is an element of continuation and multiplicity in these pieces that eschews the finality required to call something finished. Finality is a slippery notion for Hammer's work as well because multiple versions of single works exist. For instance, not only do some of the same images or footage from her shoot in the countryside for *Dyketactics* appear elsewhere (for instance, in *Truth Is the Daughter of Time*), unbinding the images from the confines of that film, but an alternate version of the film also exists with a soundtrack different from the music of the original.[31] Only near the end of her life did Hammer find and acknowledge this alternate version of *Dyketactics*. It makes use of the music she originally wanted to use for it but was unable to do so because of a dispute with the songwriter. As a supposedly complete art entity, *Dyketactics* as we thought we knew it therefore eschews some of the fixity one often ascribes to artworks. While it rightly serves as an emblem of the lesbian cinema Hammer helped to pioneer and champion, that film also presses outward at the boundaries that define how it has become known.

A more complicated story of multiple versions arrives in the form of the last film that Hammer completed, titled *Evidentiary Bodies*.[32] In fact, there are at least four entities that go by this title and inflect each other's meaning in Hammer's oeuvre (appearing in the following order): a performance piece (November 2016); a major retrospective exhibition (October 2017–January 2018); a film (premiered at the Berlin Film Festival in February 2018); and an installation (June–August 2019). The fact of multiple *Evidentiary Bodies* undermines the clean completeness of the film version. The other *Evidentiary Bodies* that preceded the film, and the final installation of the work titled *Evidentiary Bodies* at the Wexner Center for the Arts that appeared in the summer of 2019, months after her death, suggest a work in constant progress—an unfinished

quality (in the best of senses) that lingers even in the finished film. Who knows but that there may have been a revision or recapitulation of that work in a new form on the horizon, cut short by Hammer's death. The "timelessness" of Hammer's work is not just euphemism; it often in fact aims to recursions and recapitulations of older work in new contexts, or even to project itself out of the confines of time's apparent limits, such as the finality of death or the definitive completion of a creative idea. As is the case for her predecessor, Maya Deren, an aesthetic of incompletion characterizes an important part of Hammer's work process.[33] Like Deren, Hammer repurposes and reimagines work that another artist might deem over and done. *Evidentiary Bodies* is no exception to this order of timelessness. It belongs, at minimum, to a sub-body of her work that mobilizes traces of the past and projects itself into the future. In fact, it may be less time-less and more like supra-temporal, chafing at the boundaries of time and imagining ways creatively to transcend or transmute them. It attempts to push out of all of the frames—temporal, spatial, cinematic—that might otherwise confine it. *Evidentiary Bodies'* variations on an idea expressed through a single title suggest an openness and fluidity to the shape of Hammer's work. The four versions of the piece have commonalities, but each modifies the meaning of the other versions and under-mines the stasis of a single form. That she was making these works in quick succession while considering her own legacy suggests that the multiple versions coexist rather than supplant one another.

Evidentiary Bodies' first manifestation appeared in November 2016 when it became a performance piece and multimedia installation at the Microscope Gallery in Brooklyn, part of a series titled *Dreamlands: Expanded*, organized by Microscope and the Whitney Museum. It included live projection and recorded material, live and recorded music, other sound (for example, on-site voice and singing bowls), and performance by Hammer and several assistants, including her partner Florrie Burke. In keeping with Hammer's interest in her audience, it included a discussion with the artist after the main performance parts (figure 33).[34] The performance divided into ten parts: Entrance, Head, Breath, Chest, Face, Fluids, Bones, Body, Hands, and Dance. After some preamble before she arrived and her entrance/introduction, each beat of the piece centered on an aspect of the body, whether a bodily action or body part, until the work ended by bringing all the parts together in the joyous action of bodies dancing. For each of the sections, words and ideas merged. For "Breath," for example, Hammer more breathed than spoke the word "breath" into the microphone as she moved around the space. A cellist played long, fast strokes that seemed to mimic the word. The rhythm accelerated as the piece continued, with the sounds becoming less and less controlled and no longer formed as words but as cries, until at the end,

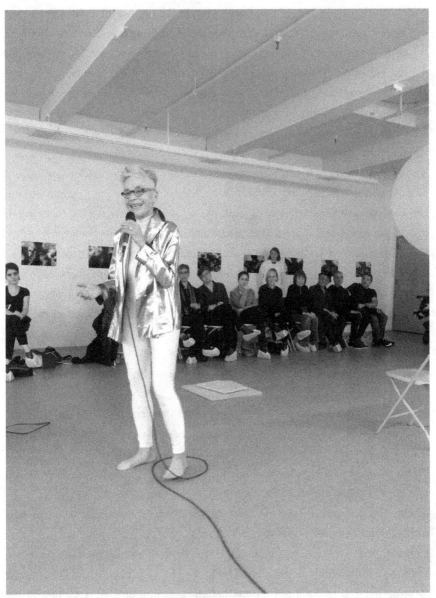

Figure 33. Postperformance discussion with Barbara Hammer (Microscope Gallery, November 2016)

Hammer returned to the single word "breath," now rendered as a meek cry; the cello pulled one last single note and let the sound long resonate without the bow touching the string.

The performance piece at the Microscope Gallery also contained several fragments of earlier work and her archive: X-rays of her own body after her diagnosis of ovarian

cancer, footage from her 1990 film *Sanctus*, and projection of an earlier film white weather balloon dangling from the ceiling or from a moving apparatu her early performance pieces like the ones she did with projecting *Availab* an "Active Annie" [as opposed to a "Lazy Susan" turning table], asking he ___ to move to see the images projected on various surfaces). Each of these she used in palimpsestic relationship to her present body, projecting personal archival images and interacting with them, choreographing these traces of the past to create experiential juxtapositions that underlined interests across her whole body of work over five decades. For example, at the end of the piece, Hammer projected decades-old footage of her dancing with Florrie. She and Florrie then danced in real time in front of the images as they were projected around the walls of the room, making the dancer and the dance—though expressing a distance of years and miles—singular within the performance and akin to the ending of W. B. Yeats's "Among Schoolchildren":

> O chestnut tree, great rooted blossomer,
> Are you the leaf, the blossom or the bole?
> O body swayed to music, O brightening glance,
> How can we know the dancer from the dance?

The issues expressed in the multiplicity of modes in the performance piece version of *Evidentiary Bodies* are familiar as we come to the end of a long career—making lesbian experience visible, exploring both the medical and the sensuous body, projecting presence and absence, exploring or conflating objective and subjective experience, engaging with her audience, and foregrounding the connections between acts of making, remaking, and documenting the world.

The second *Evidentiary Bodies* came in the form of a retrospective of her work at the Leslie-Lohman Museum of Gay and Lesbian Art in New York. This broad retrospective derived from Hammer's creative choices about what and how to foreground her work—a creative, hands-on act of archiving and solidifying her legacy. She worked closely with the curators and director of the museum in presenting the work, an act that foreshadows Hammer's close curation of her legacy over the last several years of her life (we might even say over the course of her whole working life). From this exhibition also came a book titled *Evidentiary Bodies*. Not by Hammer, but a worthy fifth iteration of *Evidentiary Bodies*, it may not be her own work but represents one of the many results of it—one of its afterlives and part of her legacy as well.[35]

The exhibition included several selections of Hammer's films running on loops and playing at the same time on three different walls, each equipped with a few sets of

...eadphones so that multiple visitors could listen simultaneously. It also included a generous sampling of other parts of the Hammer archive: journals, paintings, drawings, parts of installations, costumes, photographs, documentation of performances, and other ephemera (figure 34). The bodies supplied as evidence (as per the title of the exhibition) are multiple and many-faceted—bodies of work, bodies of water, bodies of writing, bodies of lesbian women—and they appear both inside and outside of the films on which much of Hammer's reputation rests. The exhibition itself is also the body of evidence for Hammer's status as an artist: brought together into one space, it attests to a lifetime of work and begins to organize it into a meaningful whole.

Third of the *Evidentiary Bodies* is the piece that fits most cleanly of the four iterations into that reputation: the film from 2018. It finds a ready place at the late end of Hammer's filmography; it is evidence of a long engagement with moving images in Hammer's body of work, bringing the number of finished works to around one hundred (depending on how one counts reiterations of pieces). As a stand-alone film, it differs in obvious ways from the 2016 performance piece of the same title as well as from the exhibition. Some of that difference is attributable to the medium, format, and purpose of each—everything that inheres in a single film text versus multimedia performance versus retrospective exhibition. The works differ in content and structure in other important ways as well. For instance, the film does not prominently include words as with the performance's prologue (which began: "not 'fighting a battle,' but 'living with cancer'"); it is not broken down into distinct parts; it has no dancing with Florrie. And unlike the performance, the film is split for most of its duration into a triptych of images (figure 35). It looks and acts like a different work.

Even so, the similarities are also striking. Like the others, this *Evidentiary Bodies* collects and implicates several other works by Hammer (many of them the same as the earlier *Evidentiary Bodies*) within a new work. Thus the 2016 Microscope Gallery *Evidentiary Bodies* is now itself also embedded into the dynamics of the 2018 film of the same name, as it uses many of the same materials. That is, the 2018 film version includes parts of the cello composition that was played live in the performance and many of the images it used or generated through performance. The film uses elements of the Hammer archive too. For instance, the 2018 film includes images of her body in front of her *Blue Paint Film Scroll*, made in 2015 by taking a strip of 16 mm film (ten inches) and treating it with hydrochloric acid and translucent paint, then printing it at high resolution overnight onto a massive roll of photographic paper, magnifying it into an 18-foot, brilliantly colored format (reprinted as the cover image of this book). This work appears as the full backdrop for all three of the triptychs near the end of the film, connecting the triptych of images into one continuous frame and radically

Figure 34. *Evidentiary Bodies* at the Leslie-Lohman Museum of Gay and Lesbian Art

Figure 35. Still from film version of *Evidentiary Bodies* (2018)

shifting the dimensions of the body in relation to the film strip—swapping big person, little gauge to little person, big gauge. It also appears in the Microscope Gallery performance and the retrospective at Leslie-Lohman; it makes the Hammer rounds, updating or underlining meaning in different ways as it circulates. In the performance piece, Hammer and Burke stand close together with the projector and cast the image of Hammer with the scroll along the walls, making it press beyond its frame boundaries through movement on the level of projection (and also collapsing Hammer's recorded image with Hammer's live presence). At the Leslie-Lohman Museum, it is mounted on the wall without the image of Hammer in front of it, a deconstruction of the artwork's components. Then the film restates similar ideas but in a new form: not until the last image, when she lies on the ground, does Hammer relinquish her place in the frame. It simply continues moving without her and leaves her behind (so the scroll appears on its own, as at Leslie-Lohman). In several senses, the work continues beyond the exertions of the artist. In its articulation of the idea of the artist pushing out of the frame but also being shaped by the necessity of its edges (the sprocket holes of the paint scroll film are visible in all versions), *Evidentiary Bodies* signals the larger issue of Hammer's place working within and, as master of the image on multiple levels, outside of the work. In these ways, all versions of *Evidentiary Bodies* join the echo chamber of allusions and recyclings of previous Hammer works as they become allusions and reused texts themselves.

Finally, the 2018 film was conceived as part of a continuum of ideas that extended beyond the film's parameters into its own future as a new work that would be released into the world only after Hammer's life ended (though she meticulously designed and staged plans for its form). Finishing a two-year residency award at the Wexner Center for the Arts, Hammer planned an exhibition of the film on three channels (separating its three images so that each one would appear on one of three adjoining walls in a square room: front, left, and right). It would also involve one of the key material accoutrements of the performance piece: spectators walk through her X-rays (forming the back wall of the exhibit space) to access the room, an inner sanctum where the three images wrap around the walls to engulf them on three sides while the X-rays make up a fourth wall behind them. In configuration, the projections echo Hammer's multiple film reels showcased at the Leslie-Lohman Museum (on three adjoining walls); in aim, it revises in a new form the invitation all of these works proffer to encounter the interior experience of the artist. This fourth version of *Evidentiary Bodies* was successfully installed at the Wexner in June 2019, three months after Hammer's death. It serves as a component of the set of pieces titled *Evidentiary Bodies* and as the culmination of all the labor that constitutes the earlier versions. Indeed, Hammer suggested

this as her ideal form before any of the other iterations of the work were made, such that the other pieces serve as preludes to it, or sketches in anticipation of the final version. The X-rays through which one passes at the opening of the performance piece and the three-part image for the film serve as attempts to generate the effects of what would become the piece in its final form. She suggested that the film (2018) should not be played on its own once the three-channel installation was accomplished. Still, the fact of the film remains as an individual piece, begging the question of what one does with the intentions of the artist when only her words and the work remain.

Hammer's *Evidentiary Bodies* gives fresh meaning to the idea of a work in progress, for while it is a set of distinct works, with each subsequent iteration Hammer expanded on the possibilities inhering in the one that preceded it. The project resonates with the poet Richard Hugo's assertion that "most poets write the same poem over and over." There is an idea or a form that they return to and explore again and again, pressing on it in different ways.[36] Hammer rewrites an idea in multiple forms. The four versions of *Evidentiary Bodies* offer a unique glimpse into an artist's working method and the evolution of a set of aesthetic and thematic obsessions—and they do something else too. This case of evidentiary bodies illuminates Hammer's work over the past five decades at a key moment when her legacy—looking back over the whole body of work—was in the process of being formed. While scholars and curators engaged with that legacy as it was unfolding, only after her death does time stop for a moment to allow a still look at what all the work might mean together (and even that ending is not absolute, as we will see in a moment). The multiple versions of *Evidentiary Bodies* lend insight into at least four aspects of that work as one begins to take stock of it as a whole.

First: it underlines the ongoing importance of the physical body—especially her own body—to Hammer's work over many decades. Following the earliest of her films to this moment shows the course of a body living, experiencing, thriving, becoming ill, recovering, creating, dancing. If earlier films take as one of their key purposes to make lesbian bodies and experience visible, playful, beautiful, creative, then all of these *Evidentiary Bodies* consider how the changes of time and disease nuance that visibility, playfulness, beauty, and creativity. Consider the difference and similarity between Hammer's doubled bodies in *Double Strength* (1978), in which she and her lover are multiplied, versus the doubled bodies in *Evidentiary Bodies*, which shows Hammer alone, at the end of her life, doubling the same movement, but always with her own selfsame image and spread out across multiple panels.

Second: the multiple versions of *Evidentiary Bodies* underline another meaning of body—the body of work that Hammer for the last years lent a hand in shaping in terms of her vision for its long term reception. The recursions in each *Evidentiary*

Bodies version encapsulate her sense of that body of work through its many shifts according to her interests, available materials, new discoveries, and reworkings of older material into her late practice's particular idioms. Several of the recurring images or methods (for example, mounting the camera on a mobile platform) are taken up again perhaps in part to remind the viewer of the place of this work among other, earlier works. In short, it reminds us of a trajectory of Hammer's creative output. Further, it shows us that the meaning of the work cannot be solidified into a single, static thing; it changes and is deliberatively reconfigured over five decades and undoubtedly will continue to change as contexts for receiving her work change.

Third, related to the fluidity of meaning in her archive's works, these versions of *Evidentiary Bodies* together redefine what counts as evidence. While "evidence" generally connotes something that is fixed and can provide material to illustrate or even prove a claim of some kind, what is evidenced by the collection of works by this title in Hammer's oeuvre is that proof is subjective too and must always be subject to revision based on living through an organic, mutable creative process. In fact, the archive to which the work now belongs is not fixed either and will come to mean different things depending on who encounters it, and when.

Fourth and finally, and in relation to all of these, these works mobilize a relationship between the self and the other, negotiating a way of knowing the interior/subjective aspects of an artist and her artwork while acknowledging the importance of engaging with choate others. Empathy is one of the main themes of all the works; in her performance piece, this fact is highlighted in a statement she issued about the piece, part of which reads:

> I have found no way to completely understand the "other" or be understood by another. I have resorted to film, moving images, and sound as the best path for me to make myself open, vulnerable, giving, sharing, and, yes, unique to my friends and fellow filmmakers, my artist colleagues, and those who love and appreciate creative and experimental making the world over.
>
> I still long for that most intimate of sharing and although I can't crawl inside my lover's skin and experience her from the inside out, I can practice an empathetic listening, repeating back what I have heard and learned, sympathetically embracing "otherness" and difference. Through this "domestic" practice I extend these tools to the audience through performance in film.
>
> This could be empathy.[37]

The work of intimate sharing characterizes the show at Leslie-Lohman as well as the generous and unflinching way Hammer opened herself in her dying days to her

friends and the public—see the "exit interview" she gave Masha Gessen for the *New Yorker* for example or her lecture-performance for the Whitney Museum, an inventive and interactive piece she titled "The Art of Dying."[38] *Evidentiary Bodies*—and the evidence of her own body as conduit for the fact of her art—takes on a new meaning in light of her long goodbye to that body, leaving it behind to be revivified in the (or as the) body of her work. The transfer of that body from self to others becomes complete as the self disappears but still, through the legacy and work, remains.

The palimpsest of art objects that make up the material of all the *Evidentiary Bodies* underlines Hammer's working method as well as her creative process. In its inclusion of parts of early, middle, and recent work, *Evidentiary Bodies* shows that Hammer's works reshape their own initiating ideas about evidence in multiple and multiplying forms. Ann Cvetkovich, remarking on Hammer's *Evidentiary Bodies* exhibition at the Leslie-Lohman Museum, concludes that in her eclectic, vibrant, broadly experimental approach to art, Hammer "has already forged a path for showing how the archive can be a source of art."[39] *Evidentiary Bodies* (4X) as a multilayered, multiformatted work provides a final, bird's-eye view of Hammer's whole career and serves as an emblem for the lasting evidence that comprises a life's body of work.

Conclusion? Further Issues of Legacy

As Margaret Atwood quipped in the wrap-up of her short story *Happy Endings*: "So much for endings. Beginnings are always more fun. True connoisseurs, however, are known to favor the stretch in between, since it's the hardest to do anything with."[40] Undoubtedly, Barbara Hammer also had a lot of fun with her own beginning, discovering in the medium of film and video an artistic home, and she further thrived in the stretch in between. She was also similarly disparaging of endings, if the nature of her own conclusion is any indication. In the final years of her life, she worked tirelessly to secure the terms of her legacy in a variety of ways.

First, Hammer gathered her materials into boxes and began to shop her archive to universities. In the process, she organized the materials by decade, keeping film materials and journals separate from the paper archive she amassed. The boxes lived in her studio until she made the sale, and throughout that time, she worked with assistants to catalog the materials and add other things that she collected along the way. She spent more than a year building a database for the collection.[41] In July 2017, she completed the sale and moved all the materials excepting the films to Yale University, where they are now housed in the Beinecke Rare Book and Manuscript Library. Of their new home, Hammer told Yale,

I am delighted that my archives will live alongside and be in conversation with those of artists such as Georgia O'Keeffe and Gertrude Stein and Alice B. Toklas, among others who experimented in their work, while making important contributions to the social and sexual landscape. Yale's Beinecke Library is among the foremost centers in the world for lesbian and gay archives, with a strong commitment to making primary source material from both the distant and the recent past accessible in the present to inform the future.[42]

While being in such good historical company and making her archives accessible to researchers were central goals in Hammer's ideas for establishing her legacy for the future, the sale also served another purpose important to her: providing funds to create an annual award for a lesbian experimental filmmaker, the Barbara Hammer Lesbian Experimental Filmmaking Grant, a $6,000 award for "self-identified lesbians" to make "visionary moving-image art."[43] Hammer explained on several occasions that a lack of funding for experimental work stymied her at the onset of her career—once she figured out how to make successful applications for grant money, it became easier to get further monies because she had a track record. She hoped the award would help struggling and emerging artists get a leg up in that process.

After the sale of the paper archive, Hammer helped the films find their way to the Academy Archives in Los Angeles, where they have been cared for by archivist Mark Toscano. Toscano has preserved and digitized several of Hammer's films, successfully finding funds (the George Lucas Foundation, for instance) for doing that work at the Academy. His cataloging of the works and restoration of titles that had not been seen since soon after Hammer worked on them (for example, all of the 1960s films) accomplishes an extraordinary service for future researchers and for the continuation of the films' availability for new audiences. Further, working in connection with the Electronic Arts Intermix and Company Gallery, many of the films are available in digital formats, further simplifying future distribution in a changing mediascape.

Having spent so much energy encouraging, mentoring, and securing funds for others, it is not surprising that Hammer would bequeath some of her unfinished work for further activity. Specifically, she made arrangements to have some of her footage made into work by other filmmakers—Lynne Sachs, Mark Street, Deborah Stratman, and Dan Veltri—an afterlife for her work that extends her specific will for the work (by choosing her creative interlocutors) and offers the possibility of further extensions by her openness to the way others might interact with her work. Moreover, she helped secure funding for each film in connection with her residency at the Wexner

Center for the Arts, working in close connection to one of their curators and Hammer's champion, Jennifer Lange. On the one hand, Hammer played a major role in closely shaping her own legacy, and on the other, she let it go, leaving her work to others as a gift she indicated they should work with according to their own practice and in whatever way they pleased. Three of these films have been completed and the fourth is in progress; they are a fascinating testimony to the staying power of a canny artist who trusted the conversation she might have with other artists even beyond her own lifespan.

For *So Many Ideas Impossible to Do All* (2019), for instance, filmmaker Mark Street uses outtake footage Hammer made of Jane Brakhage in 1973 when she went to Colorado to film her for her thesis film *Jane Brakhage*. Street uses the outtakes of the film to show a scene in which Hammer questions Jane while the latter sits atop her stove. Hammer wonders why Jane doesn't look her in the eye, and Jane tells Hammer she didn't want her to come to Colorado and was trying to convey that fact in her letters. The film counters and shifts the meanings of the finished *Jane Brakhage* film, in which Jane is portrayed as nature lover and a woman with a mind and interests of her own—a pioneer in her own right. Street's film shows the behind-the-scenes moment that minutely belies Hammer's film's positivity on one level, and it also gives further elaboration of the history of Hammer's development as a filmmaker, showing footage she did not use in her film and thus revealing some of her creative and thematic choices. The film of course also reflects Street's choices and creative practice; it extends Hammer's work in chronological time and expands it into new thematic territory. Perhaps influenced by Hammer's interest in artists' environments, he filmed outside the apartments Hammer lived in when she was writing to Jane for his film. Also, he cuts in footage of elephant seals combating each other, an image mentioned in one of the letters sent between the two women, but that has no precedent in Hammer's footage. Here it has the added metaphorical impact of underlining fighting for individual territory between the two women in the film. In short, Street's film further complicates and shifts elements of Hammer's legacy by reimagining historical footage and incidents from the point of view of a sympathetic outsider who is also a skilled filmmaker with his own vision.

The set of films made from Hammer's footage recollects the same issues of porosity, proximity, and projection that I have suggested Hammer engaged in *Maya Deren's Sink*. Encouraging others to rework the materials of films she had left behind in whatever way they wanted created a pathway between her works and others in the world that extends her legacy and demonstrates the porosity of influence from Hammer to her peers and vice versa. Through their own practice, the people to whom Hammer entrusted her work bring her archival materials back to new life. The times and places

of Hammer's earlier footage come into play with Hammer's later life and work, as well as with the artists' own time. For example, for Sachs's film, *A Month of Single Frames* (2019), the 1990s, when Hammer filmed the footage, come into new proximity with the 2010s, when she determined to put the raw material for a film into other hands, which comes into proximity with the specific moment of Sachs making the film (2019) as well as both artists' oeuvres at large, which extend beyond any of these moments. Like *Maya Deren's Sink*, these films also project Hammer into a time and place beyond her own earthly existence: they are the revivified traces of a life in art. In Stratman's *Vever (for Barbara)* (2019), when hearing Hammer's voice from sometime in the months before she died (time stamped by the partial loss of her voice due to complications with her illness), we note how both Hammer's and Stratman's work grew out of the particulars of the past. To echo what I've claimed about Hammer's work with Deren's materials, the surviving artists project their own interests into the spaces once occupied by Hammer, thereby claiming them as part of their own legacy.

Finally, Hammer worked to extend her legacy in the final years of her life by saying yes to as many opportunities to stand as a representative of her own work as possible. Even between medical treatments and while ailing, she tirelessly attended and promoted several retrospectives, gallery shows, single screenings, and interviews. In 2010, Hammer took part in the MoMA retrospective of films by Maya Deren alongside four female filmmakers with demonstrated affinities with Deren's example.[44] In 2012, she helped sort out details for her retrospective at the Tate Modern in London—a major show that helped to solidify her career internationally. In 2017, she helped organize the retrospective at the Leslie-Lohman Museum of Gay and Lesbian Art discussed earlier. During all of this decade, she had lectures, screenings, class visits, gallery shows for her photographs and films, and continued to make the work discussed here. She made herself and her work available with extraordinary generosity to scholars interested in her career—an openness that helped bring this book into being. She was committed to doing everything she could to extend the life of her work beyond her own life.

Hammer's legacy seems assured by the attention brought to her work since her death. A year or so before her death, she joked that her spouse had predicted a rise in sales of her DVDs in the wake of her demise.[45] Although I cannot speak to the DVD sales, the interest in Hammer has never been stronger. Since her death, programs featuring a lesser-known film here and there or a large selection of her films have screened in major and minor cities across the United States. All around the world (including Barcelona, South Korea, Argentina), retrospective offerings have popped up. A remarkably prolific filmmaker—as well as writer, photographer, painter, performance

artist—Hammer's work offers a trove of evidence about a vibrantly generative artistic body of work that this book only begins to tap into.

The final chapter presents excerpts from a few conversations over three years of interviews we had together. Like her lecture, "The Art of Dying or, Palliative Art Making in the Age of Anxiety," which she delivered in October 2018, these last words leave us with vivid remnants of the vibrant art practice Hammer embraced for many decades. The depth and volume of her work make her not only a pioneer of queer cinema but also an important artist with a momentous impact whose creative innovations are by no means limited to that earlier distinction. Hammer's legacy makes her as pertinent for the shifting concerns of feminism, art, and culture in the present as she was at the spirited outset of her career.

A FEW LAST WORDS

Hammer on Hammer

The following excerpts are from a series of interviews conducted by the author with Barbara Hammer between April 2016 and January 2019. They have been significantly condensed as well as lightly edited for clarity, and they are loosely arranged by themes, periods, or films.

BH: Well, I'm just going to take off with what you've introduced as a stimulating idea, which is an artist such as myself, or Carolee Schneemann—who has worked longer than I—who've worked for forty to fifty years, being tagged and denotated with a particular group of work, series of work, during one particular period of our lifetime and our lifespan. And that is ridiculous, because I've always said to people that you look at Picasso, and the variety of styles that he went through—his blue period, his pink period, his preconstructivist period, his challenge with Braque to see who was the first to delineate the multiple views of an object. And then he's moving into ceramics, and then the recent sculpture show we saw at MoMA, which blew everybody's mind. How long do you have to be dead before they bring something unlooked-at out of the closet?

And some of my best work has grown with my maturity, and yes, it's all queer, and why is it all queer? Because I have moved from genre to genre. Not exactly genre to genre, but I have moved in my work, rather than staying fixed. If I were still making the films of—*Superdyke*, let's say, since I'm now almost seventy-seven. Gray-haired women performing their age in the streets of New York and demanding to be recognized as visible, rather than the way most women are treated, that are older, as invisible—I would be remaking something that I made in 1975

with a different cast of characters. That doesn't interest me. I'm interested in exploring what comes next in the work. Where are the holes that were left in the last work, that weren't answered? Or what was provoked by my recent recurrence of cancer that I didn't address in *A Horse Is Not a Metaphor*?

The artist isn't living to cement their reputation. That isn't the modus vivendi. It's to be lucky when you have a spark of creativity and imagination and inspiration and desire to know more. And that's always about something you don't know about yet, or something that you failed at in the past, which has opened the door, then to try again. So, this cementing and putting a grave around the artist's feet—I'm seeing a sculpture of myself, and my feet stuck in cement. "1970s Queer Pioneer." Thank you, I accept that, but you only have my feet. The whole rest of my body hasn't been explored. The whole rest of my corps, my body of work, has not been explored. And I invite you to do that!

SK: I'll try!

BH: And I'm glad that you've taken that approach, because—and the same thing goes with visual art. The gallery in New York and the gallery in Berlin, that showed my work—they want the old work. What is it about antiquarian work?

SK: Maybe it just takes time for people to adjust to what it is that you have done before they can even start thinking about what it is that you're doing. . . . I guess it takes others time to catch up with where you are.

BH: It also makes me feel that they can't see the new work. They are fixed in the past, and galleries are thinking about sales. There are a lot of galleries now that are bringing out work from women artists who have been neglected. For some recent shows, the whole focus might be showing the work of women artists from the 1930s, 1940s, 1950s, 1960s, 1970s—visual artists. And many of those women are dead, and so if the gallery has the rights to work, they can set whatever price they want. There's not going to be any more made. So, this is another consideration, the economic consideration of why we get stuck in the past.

But the feeling for the living artist is that the current work isn't being evaluated, critiqued, out for public discussion. And so

you're growing in a vacuum. It's only my own holes and errors and inspiration that lead me [to] the next thing. And that's disappointing, because it would be thrilling to have people respond to something current and see where that might lead.

. . .

But I do want to say about the '70s: there's work that hasn't been available. Things nobody has seen since the '70s, except for in, maybe, a rare screening. So, there's a lot more to say about the '70s.

SK: What would you direct people to in the '70s? What do you feel is missing from people's understanding of your work—if you had to highlight a couple of films from that period, what would you say?

BH: Well, I think that the most important films have been addressed, like *Dyketactics* and *Double Strength* and *Women I Love*. And I think that what hasn't been looked at, partly because I've held it back, are the Goddess films, and that's *Moon Goddess*, and *The Great Goddess*. And *The Great Goddess* I looked at for the first time in ten years yesterday, or two weeks ago, and there's quite an interesting spinning of stories in it, and the developed directorial hand, with the multiple female characters from birth to crone that populate the film in Mendocino, where it was shot.

. . . I wasn't very happy showing the Goddess films because they felt so fixed in essentialism and in identifying a god—or goddess—and I'm not somebody who believes in a unitary person or thing or spirit. I'm a-religious but have my own spiritual connection to life and to breath and to the exterior world—and to people.

So, there was a swirl of activity in the '70s as we recognized that we'd been left out of archaeological history.

SK: How did you encounter that history first?

BH: I am a curious person. And I'm interested in everything.

. . .

SK: Among your interests, it seems like there's a strong intersection between painting and film for you.

BH: Very strong intersection.

SK: Do you feel like there was something in painting versus in film that you were exploring in each, or was there something different about them? What did you want from each one?

BH: OK, so, actually, I have to go back to Bill [William Morehouse], because I think he was correct. He came to me and he said—he brought in a 16 mm projector and he brought in clear leader. That's 16 mm film without any image on it. And he said, "You are more interested in movement than you are in the application of paint to the canvas." And he was right. I was slashing at the canvas. And I began to paint on film. And then I would stretch the canvas but project film on it.

SK: How did you show that?

BH: I showed it only in the classroom, and I showed it with black light. I started working with fluorescent paint and then I had black light so that I could turn the light on and off and make the painting move—not just with the projection but with the color.

SK: How about the work from the 1980s? What hasn't been said about that work yet?

BH: The '80s were interesting. First, I couldn't get shown in San Francisco. My work would not be shown because it was explicitly lesbian and often sexual. And the only place I could show it were coffee houses, lesbian coffee houses in San Francisco, lesbian bars, maybe at a friend's house there would be something like a women's group gathering and I would show Super 8 films there. That was the first time I showed my films, actually. . . .

SK: Did you feel a kind of pressure to make or not make specifically lesbian films?

BH: Only the pressure I put on myself. No, I didn't feel—the community would say, "Give us a narrative." Oh no, what they wanted—the pressure from the audience was, "Give us a story. Give us a narrative with a happy ending."

. . .

So, in the '80s, then, the narrative that I tell is that I moved to New York to challenge the critics of my work who were saying that my work was essentialist. And so it wasn't getting

the recognition by feminist film scholars that I expected. I moved to New York because there's more money for the arts. And I moved to New York because I wanted to be part of a larger community of art makers who worked in other forms as well as film, like painting and sculpture and mixed-media and installation and performance. And I had done performance all my life, as well as film. And drawings and paintings that are now getting recognized.

So, I think the peripatetic movement that you find in the '80s, where I was traveling all over Europe, I was going around the States, I was showing in coffeehouses and cinematheques at universities, was a desire to be known and to put my aesthetics in the world. And probably to find that critique.

Also, for me [the 1980s] was a time of wanting more. Knowing that I had established myself in the Bay Area . . . and not being recognized in the art capital of the world, which was New York at the time. And being frustrated by not being fully known as an artist as well as a lesbian. And not being content. Being happy to be a spokesperson, or a lesbian cultural worker . . . but also feeling unrecognized. And often the lesbian community wasn't articulate around artistic practices themselves, so they wouldn't be able to give me that kind of feedback or criticism.

SK: Were you looking for a wider community at that time too?

BH: Oh, yeah, oh yeah.

SK: Well, tell me more about the women-only performances, what you saw as your audience, and what you were hoping for from them. It's interesting that you put it in terms of not having the apparatus for critique within that community and looking outside of it around this time. Would that be fair to say?

BH: That would be fair, definitely. And I think if you look at this film *Audience*, . . . they're women-only, even though men were in some of the audiences, I think. But then the critique sessions that I set up after the film show—and they were films of the '70s, that we were critiquing—were only women. So that, right there, created some explosions. "Oh, how come you're doing this? We don't think that should happen!" But then that became

the subject to be talked about. And my feeling there was that we still hadn't really developed our voices, and that was the reason for a women-only audience. We're all equals, and we're not secondary citizens. And the social training of niceness and politeness and not speaking forth your mind as a woman, but to listen, could be forgotten. And we could, then, enter in as equals among ourselves to critique these films—like *Multiple Orgasm*.

And that became one of the big subjects, especially in London, England. So, I shot the audiences in San Francisco, in Toronto, Canada, in London, England, and in Montreal. And all around the same period, black and white. I would arrange for cinematographers, audio, women-only crews beforehand, and then with whoever invited me I'd set it up that we'd have our own little room to go into afterward.

. . .

SK: You were speaking earlier of using video synthesizers and effects—how do you get involved with new technologies?

BH: Well, I like to learn new things, so that's always the beginning point. I hear something, and "Ooh, how exciting that would be," and I don't care if it's low-tech, high-tech, or non-tech. How do I do it? How do I make it? And then one thing can lead to another, from that, from just learning that, then a whole idea could be born.

. . .

And then when the AMIGA computer came out, for *No No Nooky T.V.*, I was teaching at Evergreen State College, my favorite school to teach at, in Olympia, Washington, where I taught for a year and a half. And after my first year of teaching there, they'd ordered AMIGA computers for all faculty, I think. But they were going to come in in summer, and I wouldn't get to use it until September. So I talked them into letting me drive one down to California because I still had my loft in Oakland. And I taught myself, then, the Paint program on the AMIGA computer. And the way I did it was—I had a booklet, of course—I had a new affair. And so instead of documenting the affair like I did with [others], I documented it with learning

a new technique, the Paint program for every day, or every time that I saw this woman. . . .

And then at the end I try to marry film and video, because I don't see them as that far apart. I wanted to marry the two and I never had a problem, like some filmmaker purists do, with allowing their films to be digitized. So, from the very beginning when Facets Multimedia in Chicago put out four volumes of my work in the '80s, I said yes. And I got to oversee every film. I got to take film slides of the film frames, and at that time . . . I had a one-inch tape that I got from the masters. I had a submaster of the material. So, I got a lot out of that deal until VHS went its way. Then I could make DVDs, which is what I did, from that one-inch master. And those are the ones that I sell now.

. . .

SK: You're incredibly prolific.

BH: Yes.

SK: Does that seem like an issue for how your work is received?

BH: No. It's like—somebody I met in the elevator today, before I came over here to my studio from where I live, said, "You're always active. You're just so energetic. Where are you going now? Do you have a new film?" I said, "No, my project is my archive. That's what I'm working on now." And I don't have a new film. I have some things, but not a new film. It just always—something new would always be bugging me to make or be interested in making, and this is my work. So, I would go to my studio, wherever it was, and work, nine to five, like a worker. And I was so thrilled one time when I . . . had a loft in Tribeca . . . where I sublet for many years—and I would go out in the streets and there would be other artists. Everybody would go out for—usually going to get supplies or taking a breath of air. And I felt like a real cultural worker. And that's how I saw myself. And even my red jumpsuit from the early '80s, that I used to appear in when I showed my films, has "Cultural Worker" embossed on the back in tie-dye, along with a stuffed appliquéd reel of film made out of canvas. I'll have to show it to you. I have a bag of costumes from my archive here.

SK: Just for a second, if you can leap forward to the present or the recent years—because you've been talking quite a bit about all the labor, the patience, the uncertainty about what [each film is] going to look like. And now, of course, you're mostly doing things digitally, so you can see it. It takes less time, generally. Some things take longer, but a lot of things—these kinds of things, could take a much shorter time.

BH: Yes.

SK: How has that changed your perspective on the labor or the final product? There's less of a surprise at the end.

BH: It seems to still take as long. Well, putting it together. You do your experiments, but they don't necessarily follow the way you want to craft the poem for the audience to hear and see. So, you don't really see it until the end. You might see this experiment. Like, I mentioned the four minutes that I just did last week that are absolutely gorgeous. But how is that going to tie in with [the other parts of the film]? So, how that's used is still a puzzle. So, there's still the experiment. And that can take a really long time. Like, the Bishop film was—was it six months it took me to edit it? And I'm working every day.

SK: Are you saying that the editing is taking longer in part because you can see the parts and want to perfect them?

BH: There are choices. Maybe with film you didn't shoot as much. I mean, I still don't shoot terrible amounts because I'm so film-trained, I think. . . . It depends, also, on what you're doing. *No No Nooky* was made in three months. That's it. A summer project, and it was over in that time. Picture and sound came together, OK.

SK: And that's complicated, technologically complicated.

BH: But really simple, except that I'm shooting with a camera off a video screen. The Paint program's simple, but I had to learn it. So, I have a book going. Every day I'm going from spray-painting to how to merge black and white and color, to how to bring in text, how to change the font. You know me. It was really teaching yourself photoshop. Yeah. And so I got as far as I got. And I didn't finish the Paint program.

SK: Did you ever use it again?

BH: No. I never did. I never taught it, either.

SK: A one-off. You learned a whole program for—

BH: For one film, which is a good reason. And then I returned that to the school.

. . .

SK: It seems to me that one of the radical things about your work is that in a medium that has been privileged as visual, specifically, yours is equally tactile, and especially recently, there is this wave of theoretical work about affect and feeling. And your work is interested in this question early on: how can film be based on touch?

BH: It gets more intellectual in the '90s, when I go into identity politics. But there's still a way to engage the body through the editing structures that I do in *Nitrate Kisses* or *Tender Fictions*. For *Evidentiary Bodies*, there is a connection with the screen beyond the visual, into the somatic. A lot of empathy is about a somatic connection to another. So, I'm hoping in this new piece that—well, I think there'll be a very strong empathetic response too. There couldn't not be.

. . .

SK: You mentioned once that you wished that you had done more teaching.

BH: At that time [the 1980s and 1990s], I really wanted to teach.

SK: Why?

BH: I love giving and I love the interaction, the relational part of it. I don't have children in a dyad, so it meant other people with personal issues, both artistic and their own social dilemmas and emotional dilemmas, that took you outside yourself and you saw what an influence you could be. And the work is to make an influence, so yeah, I really suffered.

. . .

SK: You also spent quite a bit of time going to festivals or entering films into international festivals in the '80s and '90s. Do you want to talk a little bit about the drive to do that?

BH: Yeah. Well, who doesn't love France? And there's a wonderful woman's film festival there that has moved locations, Festival de Films de Femmes, and now it's "de Créteil," which is a suburb

about a 45-minute metro from the center of Paris. And so I've shown there for years and years and years and years. And I think the first film was *Double Strength*. And I know it was shocking to the audience. They hadn't seen nude women swinging on trapezes, and probably not many people have, still! So, it was controversial. . . .

But many times I showed *Lover/Other*, many films there. And they would invite me—it was probably five or six years ago by now—and they would pay my way and I would do a workshop or be on a panel. They would use me in some other auspice besides being there to present a film and do a Q&A. . . . And that way I get my way paid, I get a hotel, I sometimes get an honorarium. . . .

So, that's how I travel. I see the world through film, through filmmaking, or through film festival invitations. And it's been great! I've been everywhere. I've been to Melbourne. I was the first person to show at their wonderful Australian Centre for the Moving Image. It just opened. I was the first person to have a retrospective there. And it's an amazing space. You go in and there are video panels right next to the floor, along the wainscoting. Or up by the ceiling. Different panels in different rooms and different locations as part of the architectural structure, showing different works. And it was the first time I saw a screen that could go all different kinds of formations, always within the rectangle form, and I really wanted to create a work for a moving screen.

. . .

So, yes, place definitely influences my work. Cultural geography as well. You know in *Nitrate Kisses* even, you go into the differences of gay and lesbian histories in those different countries that I go to. Festivals, lovers, and desire. The desire for the unknown, the desire for adventure. How do you have adventure today? No one person in their lifetime can go every place they want to go. I really don't want to go to the moon; I don't care about a space shot, so I don't need to put my savings there. But there's a lot of places I haven't been to that I would like to go to [but] I don't know if I want to make film there.

And often I don't go with the intent of making film, but . . .
something might happen [there] or I might find out something.

SK: Wonderful. . . . It really struck me, being in the archive, how
many different ways you mobilize to get at ideas. You have
poetry, you have photography, you have drawings, you have the
films themselves, you have the process of the films themselves,
a lot of which you're keeping and thinking about and maybe
even repurposing in certain ways. And you have analytical or
theoretical work, where you're thinking through ideas that
you're also working out in practical ways. Can you talk just a
little bit about how those things matter, or is there a hierarchy
of those things? Do they interact? What's the relationship of
all of those different kinds of output of creative energy?

BH: Well, in preparing for our talk today I was looking through
what's in the database of the archive boxes for the '80s, and I
saw I did a lot of performance at that time. And I think I was a
visual artist before I was a filmmaker, but at that time in my life
you were supposed to choose a discipline. And that's what art
schools were focused on. And that's changed. Now you choose
the medium according to what you want to express—an idea or
a feeling or whatever. It may work better in film or performance
or installation. But that wasn't the cultural conditioning that I
had. And so maybe I also felt like my biggest strength out of
all the mediums was film. And so most of my energy went into
filmmaking, but there was always my need to perform, and if
I'm not in the film itself, then I want to be looked at. I want to
have something to give in a performance. I want to have an idea
I'm following out.

SK: Do you feel like there's something that another medium does that
allows you to do something else that you can't do in the films? Do
you need both in order to get to the thing for the film, or do you
need it to process what you've done for the film? Is it before, after,
during? Or, if you prefer, how do your live performances shape
the films that come out of them?

BH: Well, one thing that I don't think film can duplicate, but I've
tried to duplicate it, is the way spray paint falls on paper.
And I've spray-painted film—but it's different because of the

absorption of the paper. And the lack of absorption of the emulsion, or the plastic, that it's just sitting on. And everybody talks about the materiality of cutting and making a collage. The special relationship for a performance—the scariness of it, the fact that it's only done a few times, if at all. How can that be notated for history? Maybe it'll be lost. Another scary element. . . .

So, I have work that hasn't been shown, a lot of it. So, that's why recently galleries—I've gone to them or they've come to me, and then they've discovered there's more work that needs to get out, and one of them is the negatives that haven't even begun to be cataloged. Anyway, so these sit in my closet, and then . . . I have a residency at Marie Walsh Sharpe two years ago, where I'm given this studio for a whole year because I've written a residency saying, "I want to do installation; I can't do it in my little studio. Space makes the artist." And I get it. And so at the end of the year there's a show, and I have to do a show. And so I do a performance with an installation based on medical work imagery. One of the things I do is, I have a little projector this high, hand-held, and I project my body walking through these photographs, which are collages of X-rays and my body. The performance was called "What You Are Not Supposed to Look At."

And I really loved seeing a moving image within a photograph, but in trying to figure that out, there was the problem of multiple projectors around the room on tripods, let's say. But then the viewer gets in the way of seeing it. They want to get close.

And then I have a curatorial visit; a curator . . . comes over and I show her. I'm so excited about this, and I hand-hold the projector of me walking nude within this 20-foot scroll. And: *wow, that's great!* Whether she likes it or not doesn't matter. I love it.

SK: That's from *Evidentiary Bodies*.

BH: Yes. So, *Evidentiary Bodies*, I still don't know if it'll come out sometime as multiple-channel film, video, or single-channel video. There are photographs involved that are stills that are

different from what I've told you. But, working with an assistant in between the cancer treatments—when I would feel well enough she would come over to my studio and shoot me—and so I said, "OK, I want to do something different behind. But I want my whole body there." So, we built the black screen because we didn't have green screen. So, I could take out the black. And first I did it in this costume that I wear, which is a white Lycra form-fitting suit. And the second I said, "I think I'll go nude." So, I walked nude and I just spontaneously did a dance performance.

And so I put that with the film. The film is going one way and I'm going the other way, and it's going to be on a rotary projector during the performance. I think it'll be the last thing, maybe. I don't have it all together yet. Going all the way around the gallery space is really powerful because it turned out perfect. My body fits perfectly in between the sprocket holes, and you see the sprocket holes. And you have this hand-painted landscape. And sometimes, because of the luminosity of the film, it blocks out me. And I'm walking behind a golden glob, or then I'm filled with speckles or crystals. It's not like medically nude, it's almost like my body is being painted, and disappears and comes forth in some ethereal landscape that is always film-notated. So, I feel really thrilled with that.

SK: Tell me more about how you see your work in the world.

BH: I mean, now in Creative Capital when I do professional development, that's one thing they always like me to say, is, "Go for what you want." Ask for what you want. If you want a retrospective, you ask for it. You want a book? You ask for it. I mean, I didn't ask you to write this book, but I definitely wanted a book written. And when somebody else before you had proposed it, I was, "Oh yes, of course, anything I can do." Because it's another way to be known, and to a different group of people. And if you dedicate your life to developing something that was amorphous at the beginning, that you didn't even have words for in the '70s, and you only begin to articulate more formally in the '80s, and then go from there into the '90s, with intellectual development that probably followed from that early

research in the '80s, then why wouldn't you want to be known? And why wouldn't you want your work historicized? You want it saved, you want it looked at, appreciated, and critiqued. And that means negative and positive.

You want to influence the world. You've been influenced by the world, and now you want to influence. It's a give and take.

NOTES

BHI: a series of interviews with Barbara Hammer as conducted by Sarah Keller. These interviews, unless otherwise noted, took place at Hammer's studio at Westbeth Artists Housing, New York City, NY, at various times from 2016 to 2018. The date of the interview is listed with each specific citation.

BHA: the Barbara Hammer Archive. Note that all references to the archive come from when it was uncataloged but in a set of numbered boxes held at Hammer's studio at Westbeth Artists Housing, New York, NY, before it was moved to Yale University's Beinecke Rare Book and Manuscript Library in 2017. Box numbers and folder titles, where available, are listed with each piece of material cited.

Introduction

1 Susan Potter, *Queer Timing: The Emergence of Lesbian Sexuality in Early Cinema* (Urbana: University of Illinois Press, 2019), 2.

2 Masha Gessen, "Barbara Hammer's Exit Interview," *New Yorker*, February 25, 2019, www.newyorker.com/culture/the-new-yorker-interview/barbara-hammers -exit-interview.

3 P. Adams Sitney described the contours of the idea of structural film. See Sitney, "Structural Film," in P. Adams Sitney, ed., *Film Culture Reader* (New York: Cooper Square Press, 2000), 326–49. A decade later, looking back on Sitney's influential formulation, Bruce Jenkins criticized Sitney's influence, arguing that it solidified experimental film practice in the 1970s in an exclusive way that reduced that practice to "a single register." See Bruce Jenkins, "A Case against 'Structural Film,'" *Journal of the University Film Association* 33, no. 2 (1981): 9–14.

4 An ethos of reaching out to intergenerational queer artists and curators characterized Hammer's efforts to secure her legacy, as Staci Bu Shea and Carmel Curtis comment in their introduction to Staci Bu Shea and Carmel Curtis, eds., *Barbara Hammer: Evidentiary Bodies* (New York: Hirmer/Leslie-Lohman Museum, 2018), 11.

5 Karl Schoonover and Rosalind Galt, *Queer Cinema in the World* (Durham, NC: Duke University Press, 2016), 5–7.

6 Clara Bradbury-Rance, *Lesbian Cinema after Queer Theory* (Edinburgh: Edinburgh University Press, 2019), 14.

7 Bradbury-Rance, *Lesbian Cinema*, 11.

8 Bradbury-Rance, *Lesbian Cinema*, 1–15. In her introduction, Bradbury-Rance outlines ways of thinking of the relationship between the terms *queer* and *lesbian*, a topic of interest to Hammer as the contexts for her work changed. While Bradbury-Rance is working primarily with mainstream and narrative texts, her observations usefully preserve an openness and ambiguity to consider the films' "mood of sexual potential" rather than unambiguous representations for these texts, which resonates with Hammer's work on the register of her experiments with lesbian visibility.

9 See Gessen, "Barbara Hammer's Exit Interview." For example: "we don't want to forget the lesbian, and we don't want her to be lost. She might not even be known in twenty years, as a population or as a language. A mode of being, a vocabulary, a particular way we cut our hair—this is going to be lost if there's no lesbian anymore. After a while, nobody will even remember."

10 These journals are part of Hammer's archive, collected by Yale University's Beinecke Rare Book and Manuscript Library. Hammer noted that in the process of taking bids for the sale of her materials, the journals were of particular interest as a portrait of a specific period in cultural history as experienced by one of its prime movers. BHI, February 18, 2018.

11 While she did not compile many collections of her photography for exhibitions, late shows include one at the International Center for Photography, *Multiply, Identify, Her*, in 2018, which displayed work from her earlier performance/photography exhibition *What You Are Not Supposed to Look At* (2014) and a retrospective the same year of her 1970s photographs at Company Gallery, which holds the negatives of the majority of Hammer's photography.

12 Barbara Hammer, wall text description for Leslie-Lohman exhibition, "Selected Performances: 1978–2016."

13 Barbara Hammer, wall text.

14 Hammer documented her performance pieces; details about them may be found both on her website (https://barbarahammer.com/performances/) and in the catalog for her exhibition *Barbara Hammer: Evidentiary Bodies*.

15 Judith Halberstam (see also J. Jack Halberstam), *In a Queer Time and Place:*

Transgender Bodies, Subcultural Lives (New York: New York University Press, 2005), 2. Emphasis mine.

16 Hammer, *Hammer! Making Movies Out of Sex and Life* (New York: Feminist Press at the City University of New York, 2010), 13.

17 Hammer, Notes for a screening of early films at MoMI for Orphans Film Symposium, April 14, 2018.

18 The partial depiction of her body—whether in shadow, a reflection, or a fragmented part—begins this early in her career and continues for many of her films. A related motif is the image of herself filming something, frequently captured not straight on, but through such shadows, reflections, and fragmented images of her person.

19 Jean Epstein, "Magnification," in *French Film Theory and Criticism*, vol. 1, *1907–1929*, ed. Richard Abel (Princeton, NJ: Princeton University Press, 1988), 237.

20 Mark Toscano notes that *Aldebaran Sees*, like a few of Hammer's early Super 8 films, originally had sound on tape (the tape is lost).

21 Hammer, Notes for a screening of early films at MoMI for Orphans Film Symposium, April 14, 2018.

22 Hammer recollected Morehouse telling her: "You are more interested in movement than you are in the application of paint to the canvas." BHI April 21, 2016.

23 Maggie Humm, *Feminism and Film* (Edinburgh: Edinburgh University Press, 1997), 5–8.

24 Judith Mayne, "A Parallax View of Lesbian Authorship," in *Film and Authorship*, ed. Virginia Wright Wexman (New Brunswick, NJ: Rutgers University Press, 2003), 80.

25 Chris Holmlund, "Signature, Translation, and Resonance in Gunvor Nelson's Films," *Framework: The Journal of Cinema and Media* 48, no. 2 (2007): 154.

26 John Sundholm, "The Material and the Mimetic: On Gunvor Nelson's Personal Filmmaking," *Framework: the Journal of Cinema and Media* 48, no. 2 (2007): 168.

27 Gunvor Nelson, quoted in Sundholm, "The Material and the Mimetic," 167.

28 B. Ruby Rich, "In the Name of Feminist Film Criticism," in *Multiple Voices in Feminist Film Criticism*, ed. Diane Carson, Linda Dittmar, and Janice R. Welsch (Minneapolis: University of Minnesota Press, 1994), 27–47.

29 Rich, "In the Name," 27–28.

30 Rich, *Chick Flicks: Theories and Memories of the Feminist Film Movement* (Durham, NC: Duke University Press, 2004), 1.

31 One of the more influential disparagements of the personal stems from W. K. Wimsatt and M. C. Beardsley's "The Intentional Fallacy," a text with a long shadow over many decades of literary analysis that essentially casts doubt on any aspect of the personal that might find its way into analysis, though its primary target was the assertion that an author's intentions could be discerned or incorporated into a consideration of their texts. W. K. Wimsatt and M. C. Beardsley, "The Intentional Fallacy," *Sewanee Review* 54, no. 3 (1946): 468–88. At a more oblique and yet more comprehensive angle, acolytes of Roland Barthes's "The Death of the Author" eliminated not just the intention of the author but the author *tout court* in considerations of texts, arguing that the text and the author were different entities altogether and should be divorced in any analysis of the artwork. This line of thinking has influenced criticism across the arts during the decades in which Hammer began to make films. Roland Barthes, "The Death of the Author," in *Image-Music-Text* (New York: Hill and Wang, 1977), 142–48. Some scholars, as Virginia Wright Wexman points out, questioned the rise of structural and textual substitutions for human authors at just the moment when marginalized voices began to emerge in film production. See Wexman, introduction to *Film and Authorship*, 2.

32 For an introduction to the alternative narrative context and these issues, see Patricia White, *Women's Cinema, World Cinema* (Durham, NC: Duke University Press, 2015), 4–8.

33 Feminist film theory tended to distance itself from the personal as well as the notion of pleasure, as Laura Mulvey's well-known essay "Visual Pleasure and Narrative Cinema" illustrates: "It is said that analyzing pleasure, or beauty destroys it. That is the intention of this article." For Mulvey, this destruction is necessary in order to dismantle the structural system of classical film narration that marginalizes and objectifies women.

34 Hammer, "Maya Deren and Me," in *Maya Deren and the American Avant-Garde*, ed. Bill Nichols (Berkeley: University of California Press, 2001), 261.

35 It should be noted that Hammer must have seen *Meshes of the Afternoon* after making *Contribution to Light*; all the same, her sense of recognition of a common language in the film when she did see it suggests a perspicuous kinship of sensibilities. Hammer comments both directly and cinematically on *Meshes of the Afternoon* in her film *I Was/I Am*. Deren's interest in and use of mirrors in her work, particularly in *Meshes of the Afternoon*, the unfinished film *Witch's Cradle*, and her Haitian film project, are discussed in Sarah Keller, *Maya Deren: Incomplete Control* (New York: Columbia University Press, 2014).

36 Liza Béar, "Agnès Varda," *Interview Magazine*, May 22, 2009, www
 .interviewmagazine.com/film/agnes-varda. Varda elaborates on the mirror as
 complex metaphor for her most self-conscious films in another interview for the
 AV Club on June 30, 2009, https://film.avclub.com/agnes-varda-1798216943.

37 Ellis Hanson, introduction to *Out Takes: Essays on Queer Theory and Film*, ed.
 Ellis Hanson (Durham, NC: Duke University Press, 1999): 1.

38 Hammer, "For an Active Cinema," in *Hammer!*, 131.

39 Jane Ursula Harris, "Lesbian Whale: An Interview with Barbara Hammer,"
 Paris Review: The Daily (blog site), December 2015, www.theparisreview.org/
 blog/2015/12/14/lesbian-whale-an-interview-with-barbara-hammer/.

40 Hammer made a film in this same period titled *Moon Goddess* (1976), which
 she described as being about "creative inspiration," conflating women, the
 moon, and the notion of a natural deity.

41 Hammer, "Feminist Phenomenology as Content and Method in *Jane Brakhage*
 and Creative Work Since: *Menses, Dyketactics, Women's Rites,* and *Psychosyn-
 thesis*: A Composite Creative Work for an M.A. in Film by Barbara Hammer,
 December 1975." Hammer archive, Box 4. Folder: SFSU 7.

42 Sara Ahmed, *Queer Phenomenology: Orientations, Objects, Others* (Durham,
 NC: Duke University Press, 2006), 178.

43 Patricia White, *Uninvited: Classical Hollywood Cinema and Lesbian Represent-
 ability* (Bloomington: Indiana University Press, 1999). See especially White's
 discussion of lesbian cinephilia, intertextuality, and identification for audience
 engagement with images of lesbians on screen: 29–60.

44 Keller, *Maya Deren: Incomplete Control*, 1–28.

45 Eve Kosofsky Sedgwick, *Touching Feeling: Affect, Pedagogy, Performativity*
 (Durham, NC: Duke University Press, 2003), 8.

46 Ahmed, *Queer Phenomenology*, 179.

47 Some materials have multiple homes including Company Gallery, Canyon
 Cinema, Lightcone, and the KOW gallery.

48 Hammer, "For an Active Cinema," 128.

1. 1970s

1 Hammer had already received a master's degree in English literature from San
 Francisco State in 1963. She earned her master's in film in 1975.

2 Jung identifies Sensation, Intuition, Thinking, and Feeling as four primary psy-
 chological functions; they combine into personality types depending on which
 function a person favors. Hammer's quotation comes from the transcript of

the interview for Smithsonian Archives of American Art, March 15–17, 2018, with Svetlana Kitto, 34.

3 Terry Castle, *The Apparitional Lesbian: Female Homosexuality and Modern Culture* (New York: Columbia University Press, 1993).

4 For an introduction to the key issues of feminist film theory as it emerged, see E. Ann Kaplan's collection *Feminism and Film* (Oxford: Oxford University Press, 1997).

5 Laura Mulvey, "Visual Pleasure and Narrative Cinema," *Screen* 16, no. 3 (1975): 6–18.

6 See Mary Ann Doane, *The Desire to Desire: The Woman's Film of the 1940s* (Bloomington: Indiana University Press, 1987) and Teresa de Lauretis, *Technologies of Gender: Essays on Theory, Film, and Fiction* (Bloomington: Indiana University Press, 1987). Later scholars, including Judith Butler in *Gender Trouble: Feminism and the Subversion of Identity* (New York: Routledge, 2006), in reviewing 1970s–1980s feminist theoretical positions, took them to task for reiterating masculinist orthodoxy.

7 Patricia White, "Lesbian Minor Cinema," *Screen* 49, no. 4 (2008): 411.

8 Sarah Keller, *Maya Deren: Incomplete Control* (New York: Columbia University Press, 2014), 1–23.

9 Bradbury-Rance, *Lesbian Cinema*, 9.

10 Sophie Mayer, *Political Animals: The New Feminist Cinema* (London: I. B. Tauris, 2016).

11 I should note that the film is not imagist in P. Adams Sitney's sense. In Hammer's film, it is a kaleidoscope of images that speak to a single idea; Sitney's notion of imagism refers to films he saw as being structured around a single image that speaks (almost metaphorically) for the film. While the overall effect may be similar in a sense, the means for achieving it look quite different. See P. Adams Sitney, "Imagism in Four Avant-Garde Films," in *Film Culture Reader* (New York: Cooper Square Press, 2000), 187–200.

12 A similar technique occurs in Deren's film, though for Deren the match on action linking disparate places focuses less on the movement of the camera and more on the connection between the subjects being linked.

13 The original comes from Maya Deren's *An Anagram of Ideas on Art, Form, and Film* (Yonkers, NY: Alicat Press, 1946), 11. She is explaining the "'horizontal' processes of memory": "By 'horizontal' I mean that the memory of man is not committed to the natural chronology of his experience—whether of an

extended period, a single event, or a compulsive reaction. On the contrary, he has access to all his experience simultaneously."

14 Language was important to Hammer's notion of feminism. For instance, she rewrote history into "herstory" when she formed her "Herstory Archive."

15 Hammer, "A Comparison of Maya Deren's *Meshes in* [sic] *the Afternoon* with Barbara Hammer's *I Was . . . I Am*." BHA, Box 3. Folder titled SFSU, 4. Dated by Hammer "approximately 1972 or 3." It's interesting to note that both Hammer and Deren fought against reading the symbology of their films in specific ways. Both preferred openness.

16 Hammer, "A Comparison."

17 BHI April 21, 2016.

18 In Hammer's archive, there is a clipping of a published article (with no publishing information, however) signed "Agressa," which Hammer notated in pen "pseudonym for BH early 70's." BHA, Box 3. Folder titled Writing by BH.

19 Hammer, "Feminist Phenomenology as Content."

20 Hammer, "Feminist Phenomenology as Content."

21 Hammer, "Feminist Phenomenology as Content."

22 Susan Sontag, "Notes on 'Camp.'" *Partisan Review* 31 (4): 515–30.

23 Hammer, "Creative Work for an M.A. in Film: My Work since *Jane Brakhage*." Hammer archive, Box 4. Folder titled SFSU 6.

24 Pamela Robertson, *Guilty Pleasures: Feminist Camp from Mae West to Madonna* (Durham, NC: Duke University Press, 1996), 18.

25 I am grateful to Mark Toscano for walking me through the brilliant and arduous process Hammer undertook to accomplish this feat without an optical printer.

26 Hammer, "Feminist Phenomenology as Content."

27 Checkerboarding the images means that at certain points, one of the rolls would have images while another would be clear; the clear image would not register when they were printed together.

28 Alexandra Juhasz, "Barbara Hammer," in *Women of Vision: Histories in Feminist Film and Video*, ed. Alexandra Juhasz (Minneapolis: University of Minnesota Press, 1997), 81.

29 Harris, "Lesbian Whale."

30 Laura U. Marks, *The Skin of the Film: Intercultural Cinema, Embodiment, and the Senses* (Durham, NC: Duke University Press, 2000), 183–90.

31 Juhasz, "Barbara Hammer," 81.

32 Hammer, "Feminist Phenomenology as Content."

33 Jennifer Barker, *The Tactile Eye: Touch and the Cinematic Experience* (Berkeley: University of California Press, 2009), 23–25.

34 Mulvey, "Visual Pleasure," 11.

35 Jennifer Peterson reads the juxtaposition between the landscape and the woman's pleasure in a way that highlights the complex and important role of nature in Hammer's work: the landscape "serves not just as a backdrop for Hammer's portraits of women's bodies (in a traditional figure-ground opposition characteristic of a long tradition of landscape painting) but as a space of emancipation, pleasure, and potentiality for women." Jennifer Peterson, "Barbara Hammer's *Jane Brakhage*: Feminism, Nature, and 1970s Experimental Film," *Feminist Media Histories* (Spring 2020): 73.

36 Hammer frequently recounted the story of a projectionist in Florida who refused to screen *Double Strength* when he saw its depiction of naked women: she entered the booth, explained her work to him, and he screened it. BHI, August 24, 2016.

37 Hammer, "Pornography, Censorship, and Sex in the Movies." a paper written for her course Film History II. Dated March 1973. Box 4. Folder titled SFSU 2, p. 6.

38 This attribution stood for Hammer for years: she repeats the story in multiple interviews, including in the Élisabeth Lebovici's interview, "The Screen as the Body: Barbara Hammer," in *Mousse* 32 (2012), http://moussemagazine.it/barbara-hammer-elisabeth-lebovici-2012 and in BHI, April 21, 2016.

39 The primary objection as Hammer recalled it was that at under ten minutes, *Jane Brakhage* was too short to serve as a thesis film, although she also questioned her committee's ability to appreciate the feminist content of her films at the time. BHI, April 21, 2016. By her account, she wrote an additional paper, "Feminist Phenomenology as Content," to accompany the film in order to have it count as her thesis.

40 Peterson, "Barbara Hammer's *Jane Brakhage*," 88–89.

41 Roberto Assagioli, *Psychosynthesis* (New York: Viking, 1965), 5.

42 Personal conversation with Barbara Hammer, January 20, 2019, home of Florrie Burke, New York City.

43 BHA, Box 3.

44 At one point, Hammer noted that she conceived of the plants as corresponding to the specific women in the film: "The onion references a woman who made me cry a lot, the broccoli represents a woman with multiple arms (or

so it seemed), but the artichoke was the winner because she could go forward or backward; there was always more to unpeel! The artichoke was homage to a great artist who is now unfortunately deceased, Gloria Churchman. She was a shy artist, she drew and painted, and we made *Moon Goddess* (1976) together, which was the first time I started projecting onto inflated balloons." Jarrett Earnest interview with Barbara Hammer for *Brooklyn Rail*, posted on Dennis Cooper's blog, "Barbara Hammer Day," May 19, 2018, https://denniscooperblog.com/barbara-hammer-day/.

45 Andrea Weiss, *Women I Love, Double Strength*, Lesbian Cinema and Romantic Love, *Jump Cut* 24–25 (March 1981): 30.

46 BHI, April 17, 2017.

47 BHA, Box 2.

48 See Susan Stewart, *On Longing: Narratives of the Miniature, the Gigantic, the Souvenir, the Collection* (Durham, NC: Duke University Press, 1984), 151–69.

49 Peterson, "Barbara Hammer's *Jane Brakhage*," 70.

50 Youmans, "Performing Essentialism: Reassessing Barbara Hammer's Films of the 1970s," *Camera Obscura 81* 27, no. 3 (2012): 117–22.

51 Judith Mayne, *The Woman at the Keyhole: Feminism and Women's Cinema* (Bloomington: Indiana University Press, 1990), 90.

52 Juhasz, introduction to "Barbara Hammer."

53 BHI, April 21, 2016. After traveling to ancient sites like Lesbos and Ephesus, Hammer began thinking about the goddess imagery rampant in certain Bay Area feminist circles. For a time, her production company was called "Goddess Films," and it would seem for a time she proudly espoused a mystical connection between nature and women.

54 Peterson, "Barbara Hammer's *Jane Brakhage*," 73.

55 Thomas Waugh, "Men's Pornography: Gay vs. Straight," in *Out in Culture: Gay, Lesbian, and Queer Essays on Popular Culture*, ed. Corey K. Creekmur and Alexander Doty (Durham, NC: Duke University Press, 2006), 324–25.

56 In this treatment, Hammer drew from Maya Deren's writings about simultaneity, including her *Anagram* (Hammer, "A Comparison of Maya Deren's *Meshes in* [sic] *the Afternoon* with Barbara Hammer's *I Was/I Am*").

57 Patrick Keating, *The Dynamic Frame: Camera Movement in Classical Hollywood* (New York: Columbia University Press, 2019), 5.

58 Youmans, "Performing Essentialism," 120. Youmans is drawing on Thomas Waugh's reading of Bill Nichols's notion of "performative documentary." Thomas Waugh, "Walking on Tippy Toes: Lesbian and Liberation Documentary

of the Post-Stonewall Period, 1969–1984," in *The Fruit Machine: Twenty Years of Writings on Queer Cinema* (Durham, NC: Duke University Press, 2000), 250.

59 "Touching and Receiving: A Lesbian Aesthetic." In *Hammer!*, 123.

60 "Double Strength," media release by Terry Sendgraff dated August 30, 1977. In BHA, Box 3.

61 Krystyna Mazur, "Choreographing the Lesbian Possibility: Barbara Hammer's *Double Strength*," in Bu Shea and Curtis, *Barbara Hammer: Evidentiary Bodies*, 48, 51.

62 It demonstrates the foundations of cinematic movement based on still images bearing the impression of motion by running twenty-four frames per second through the projector.

63 Mark Toscano, "Barbara Hammer and the Mutability of Film (Observations from an Archivist)," in Bu Shea and Curtis, *Barbara Hammer: Evidentiary Bodies*, 27.

64 BHI, April 18, 2017. "We decided that skin was our covering. . . . Furthermore, part of our development was our muscles and our body to be able to do these exercises on suspended apparati. And we wanted that to be visible. So we performed in the nude."

65 EAI catalog description, provided by Hammer, www.eai.org/titles/15880.

2. 1980s

1 Hammer's archive also contains several write-ups of her activities along these lines, ostensibly for grant, teaching, and/or festival applications.

2 Hammer added parts to the film as she interviewed more audiences. The 1982 version had only the San Francisco audience.

3 BHA, Box 4.

4 J. D. Rhodes, "This Was Not Cinema: Judgment, Action, and Barbara Hammer," *Film Criticism* 39, no. 2 (2014–15): 131.

5 Rhodes, "This Was Not Cinema," 134.

6 BHA, Box 4, 1980s. Typed letter from Gorbman dated April 7, 1984. Hammer's response is dated April 25, continuing May 2, 1984.

7 In the early 1980s, in addition to her film *Audience*, she drafted the essays "Towards an Active Audience," "For an Active Cinema," and several letters/notes, reflecting her engagement with the question of audiences.

8 Gorbman was writing a piece about Hammer for *Jump Cut* ("Recent Work of Barbara Hammer: Body Displaced, Body Discovered" *Jump Cut* 32 [April

1987]: 12–14) and asked questions about *Audience*'s dynamics of "the relationship between filmmaker, film, and audience." "Towards an Active Audience" and Letter, Barbara Hammer to Claudia Gorbman, dated April 25, 1984, and continued (including the quotation) on May 2, 1984. BHA, Box 4.

9 Hammer, "For an Active Cinema," *Fuse Magazine* 5 (1981 or 1982), reprinted in *Hammer!*, 128.

10 Hammer, "For an Active Cinema," 128.

11 Barbara Hammer Archive 1980s, Box 4. Scott MacDonald recalled to me that Hammer was flustered at an early screening he invited her to give at Utica College when she learned that the audience would be mixed male and female. A best guess as to date would put this around the 1980–81 academic year (postcard inviting her for that season, dated February 1, 1980, same box).

12 Erika Balsom, "No Masters: The Cinema of Peggy Ahwesh," Frieze.com, November 6, 2017, https://frieze.com/article/no-masters-cinema-peggy-ahwesh.

13 William Wees, "No More Giants," in *Women and Experimental Filmmaking*, ed. Jean Petrolle and Virginia Wright Wexman (Urbana: University of Illinois Press, 2005), 22–23.

14 One example of an alternate filmmaking model that mobilized theory is Laura Mulvey and Peter Wollen's *Riddles of the Sphinx* (1977), an effort to apply theory to undermine narrative structures that inhibit women in and outside of the film. Mulvey's and Wollen's film screened the week after Hammer's films on a program at Cornell Cinema's "The Expanding Cinema" series titled "New Feminist Cinema," which ran through October 1982.

15 See Catherine Elwes's chapters on structural film in her book *Installation and the Moving Image* (New York: Columbia University Press, 2015), 104–41.

16 BHA, Box 4.

17 Hammer's opening remarks and plan for the session are in her archive. BHA, Box 4.

18 Abigail Child, typed seminar paper for presentation at the Second Annual Gay and Lesbian Film Festival. BHA, Box 4.

19 Barbara Hammer, typed paper for presentation at the Second Annual Gay and Lesbian Film Festival. BHA, Box 4, 4 pp.

20 Hammer, typed paper for presentation at the Second Annual Gay and Lesbian Film Festival.

21 Youmans notes that Hammer's uses of found footage and archival materials are especially relevant a bit later when in the 1990s she turns increasingly

to documentary subjects. Greg Youmans, "Audacious Appropriations: Barbara Hammer's First Half Century," *Found Footage* 2 (May 2016): 10–13.

22 Sitney, "Structural Film," 327.

23 Hammer, "Introduction: Ever since I became an artist, I had wanted to move to New York City," in *Hammer!*, 110.

24 P. Adams Sitney, *Visionary Film: The American Avant-Garde 1943–2000*, 3rd ed. (Oxford: Oxford University Press, 2002), 351–52.

25 Hammer, interview at the St. Louis Women's Film Festival, March 1979. Cited in Jacqueline Zita, "The Films of Barbara Hammer: Counter-Currencies of a Lesbian Iconography," *Jump Cut* 24–25 (March 1981): 31–32, www.ejumpcut .org/archive/onlinessays/JC24-25folder/BarbaraHammerZita.html.

26 Miriam Hansen, "Room-for-Play: Benjamin's Gamble with Cinema," *October* 109 (Summer 2004): 8–10.

27 Barbara Hammer, notes for Presentation at 2nd Annual Gay and Lesbian Film Festival. BHA, Box 4.

28 Toscano, "Barbara Hammer and the Mutability of Film," 28–29.

29 Scott MacDonald, letter to Barbara Hammer. Dated and postmarked November 30, 1984. BHA, Box 4.

30 Hammer, letter to Claudia Gorbman, dated April 25, 1984. BHA, Box 4.

31 MacDonald, letter to Barbara Hammer.

32 Robin Pogrebin, "Galleries to Mount Joint Carolee Schneemann Exhibition," *New York Times*, January 14, 2016, www.nytimes.com/2016/01/15/arts/design/ galleries-to-mount-joint-carolee-schneemann-exhibition.html?_r=0.

33 Hammer, letter to Claudia Gorbman.

34 Chuck Kleinhans, "Barbara Hammer: Lyrics and History," in *Women's Experimental Cinema: Critical Frameworks*, ed. Robin Blaetz (Durham, NC: Duke University Press, 2007), 172.

35 Hammer's website lists this as her last artist's statement. https://barbarahammer .com/about/statement/.

36 In early résumés in her archives, she listed performance pieces beginning in 1977 with "Double Strength," and "Ropes" at the Skylight Studio in Berkeley, California. Barbara Hammer, "Bio-Filmography," circa 1980. BHA, Box 5. She later described performance-based work done with Sendgraff at the studio and out in the world, for instance, when they were riding motorcycles from San Francisco to Portland, Oregon: "we went by a huge lot filled with old tires. And we stopped our bikes and went and performed. And so there's a bunch of stills that I have that are in my art archive, not for sale. And I'm throwing

them; she's got them over her head. We're doing work that we learned in her studio, like she does in the tree. That's all performative, acrobatic, physical work that comes out of the exercises that she developed and led us on. . . . [We] performed in Skylight Studio, which was a studio in Berkeley. . . . And she had these suspended trapezes. And we did one piece where we had a tire suspended and we had a huge rope that we climbed up as far as we could. That was hard. And I remember for that, I wore a motorcycle helmet, a leather vest, and no underwear. That was—I remember that was my costume. I don't know if it was just for the rope climb or for the whole performance. Sometimes we would perform in the class, just spontaneously." BHI, April 18, 2017.

37 Hammer, "I think I've always wanted to live up to my name," in *Hammer!*, 12.

38 Hammer, "I think I've always wanted," 14.

39 BHI, February 19, 2018.

40 Ron Gregg, "Making Lesbians Visible: The Experimental Documentaries of Barbara Hammer as Queer Archive," in Bu Shea and Curtis, *Barbara Hammer: Evidentiary Bodies*, 19.

41 Hammer's idea that became *Pools* was originally to tour the twenty or so pools designed by Julia Morgan. She interviewed Morgan's biographer and made plans to visit several pools. However, in the end, she visited only three (these two at the Hearst estate and one at the Berkeley Women's Club) and decided to focus on the Hearst estate. BHI, February 19, 2018.

42 Hammer, "Change of Location," in *Hammer!*, 157.

43 Hammer, cited in Zita, "The Films of Barbara Hammer: Counter-Currencies."

44 See interview with Alexandra Juhasz from 2019 in *Brooklyn Rail* for Hammer's account of the way this issue still drives her work over thirty years later, https://brooklynrail.org/2017/12/film/IN-CONVERSATION-BARBARA-HAMMER-with-Alexandra-Juhasz.

45 *Camerawoman* (1980) was a performance piece for which Hammer planned a detailed narrative component, which looks very much like a plan for a film she never made. The details of the project are in BHA, Box 4. Details and photographs of the performance piece may be found at https://barbarahammer.com/performances/.

46 Roswitha Mueller worked on experimental film (eventually she would write a book on Valie Export) as well as feminist film theoretical issues in her long-term editorship of the journal *Discourse*.

47 The year it was chosen, the rest of the Biennial was shifting toward more familiar and staid choices in the wake of having been perceived as too in thrall to

the new in recent iterations. As Michael Brenson put it in his *New York Times* review: "Stung by savage criticism of the last Biennial, and convinced that contemporary art is in a very different place than it was two years ago, the Whitney has assembled a very different show. It is self-consciously serious, often illuminating, predictably uneven and unusually tame." Michael Brenson, "Art: Whitney Biennial's New Look," *New York Times*, April 10, 1987, www.nytimes.com/1987/04/10/arts/art-whitney-biennial-s-new-look.html.

48 John Hanhardt, quoted in film description for EAI website, www.eai.org/titles/optic-nerve.

49 For example, Hammer noted that *Schizy* won an honorable mention at the Sonoma State Super-8 Film Festival in the early 1970s (BHI, August 13, 2018); she won her first Jerome Foundation grant (for $12,000) in 1983, soon after relocating to New York.

50 Hammer frequently recounted the fact that when she was around five or six years old, her grandmother introduced her to Lillian Gish and D. W. Griffith when she worked as a cook for either Griffith or Gish (she recalls it differently in different contexts [e.g., in *Hammer!* p. 11, it is Griffith; in *Tender Fictions*, it is Gish]). She credited her grandmother with being a role model: "By observing her, I learned that some people do just what they want to do for their entire lives. That appealed to me" (*Hammer!*, 11). At a minimum, her grandmother is the subject of *My Babushka*, *Optic Nerve*, and a key witness to Barbara's life in *Home*.

51 "Dear Will," letter dated September 20, 1984. BHA, Box 5.

52 BHI, April 21, 2016.

53 Rizvana Bradley, "Ways of the Flesh: Barbara Hammer's Vertical Worlds," in Bu Shea and Curtis, *Barbara Hammer: Evidentiary Bodies*, 58.

54 Film-Makers' Coop catalog, http://film-makerscoop.com/catalogue/barbara-hammer-optic-nerve.

55 John Powers, "A DIY Come-On: A History of Optical Printing in Avant-Garde Cinema," *Cinema Journal* 57, no. 4 (2018): 71–95.

56 Powers, "A DIY Come-On," 91–92. Hammer did indeed love the printer. On multiple occasions, she lamented that when she first planned to attend film school, she had wanted to study at the San Francisco Art Institute but could not afford to do so; the primary reason she gave for preferring the Art Institute was because they had an optical printer.

57 Informally, Hammer once recounted to me the story of a fire at her apartment on the West Coast that prompted her to have to decide what she could save: the optical printer was at the top of the list.

58 BHI, April 21, 2016.

59 AMIGA advertising, see http://theamigamuseum.com/amiga-models/amiga-1000/.

60 T. S. Eliot, *Four Quartets*, in *The Complete Poems and Plays, 1909–1950* (New York: Harcourt Brace Jovanovich, 1971), 119.

61 Cineprobe (MoMA) Screening Film program, Monday, November 25, 1991, New York, NY. BHA, Box 5, Program files.

3. 1990s

1 The museum was established in the 1940s, but was called the George Eastman House until 2015, when it changed its name to the George Eastman Museum.

2 James Sibley Watson Jr. "The Films of J. S. Watson Jr. and Melville Webber, Some Retrospective Views (I)," *University of Rochester Library Bulletin* 28, no. 2 (1975), https://rbscp.lib.rochester.edu/3507.

3 Watson, "Films of J. S. Watson."

4 "The Ten Best," *Movie Makers*, December 1931, 657–58.

5 Miriam Posner, "Flesh Made Light: Investigating X-Ray Films," Miriam Posner's blog, posted September 20, 2012. In this, some of Posner's initial work on medical filmmaking, she suggests a provocative link among Hammer, Watson, and filmmaker/theorist Jean Epstein and their interest in this truth.

6 He conveys this information in *Dr. Watson's X-Rays*.

7 Jean Epstein, "Cinema Seen from Etna," in *Jean Epstein: Critical Essays and New Translations*, ed. Sarah Keller and Jason N. Paul (Amsterdam: Amsterdam University Press, 2012), 291.

8 Oliver Gaycken, *Devices of Curiosity: Early Cinema and Popular Science* (Oxford: Oxford University Press, 2015), 5.

9 The possibility of making X-rays was discovered in 1895—the same year as the first exhibition of cinema—by German professor of physics Wilhelm Roentgen.

10 Jon Gartenberg, cited in Film-Makers' Coop publicity for *Sanctus*, https://film-makerscoop.com/catalogue/barbara-hammer-sanctus.

11 Tanya Sheehan, *Doctored: The Medicine of Photography in Nineteenth-Century America* (University Park: Pennsylvania State University Press, 2011).

12 Ara Osterweil, "A Body Is Not a Metaphor: Barbara Hammer's X-Ray Vision," *Journal of Lesbian Studies* 14 (2010): 195.

13 Matthew Burbidge, "Reviews: Barbara Hammer," *Frieze* 155, May 18, 2013.

14 BHI, April 21, 2016.

15 Natania Meeker and Antónia Szabari point out that *Germination d'un haricot*

has not been located; they wonder whether the footage usually ascribed to it and that appears in Dulac's experimental film *Thèmes et variations* (1928) comes from another film made by Jean Comandon. Meeker and Szabari, *Radical Botany: Plants and Speculative Fiction* (New York: Fordham University Press, 2020), n70.

16 Bill Nichols, *Introduction to Documentary*, 2nd ed. (Bloomington: Indiana University Press, 2010), 33.

17 Her teaching syllabi during this recent period reflect this interest in theory. Hammer took full-time jobs at Columbia College Chicago, Evergreen State College, and the School of the Art Institute Chicago as well as intermittent employment at several other collegiate institutions from the mid-1980s through the 1990s to boost her income and also to afford herself the opportunity to work with students within her vocation of making art in moving images. By this time she was reading a good deal of feminist film theory; for instance, her course syllabi include work by Teresa de Lauretis, Judith Mayne, and Tania Modleski.

18 Hammer, one-page project description for an application to the Center for New Television 1986 Regional Fellowship Program. BHA, Box 5, 1980s. Hammer requested $2,150 for shooting the film, which she received. The application is dated January 27, 1986. She made another application the following year for the Paul Robeson Grant, requesting $2,500 for distribution of the finished product. Finally, she also made an application for a performance/installation of the piece from the New Langton Arts Interdisciplinary Project Grant program for a two-channel video presentation with "electrically backlit hysteric commentary" and "two video monitors combining audio and visual misrepresentation and distortion of AIDS in the press" and "a woman moving out of the film projection dressed in black simply and quietly naming names for many, many minutes, the names of those deceased from AIDS." Application dated February 5, 1987.

19 Draft of a project proposal for the 1990 New Langton Arts/Multi-Cultural Arts Consortium/Artists' Trust Grant Program for Interdisciplinary Artists. Hammer did not date (or perhaps submit?) the proposal, requesting $5,500 for the project.

20 Jenni Olsen, "Hammer's Herstory," *The Advocate*, June 20, 2000, 103.

21 Ann Cvetkovich, "The Artist as Archivist, the Archive as Art," in Bu Shea and Curtis, *Barbara Hammer: Evidentiary Bodies*, 39.

22 BHI, August 13, 2018.

23 *Nitrate Kisses* was awarded a Frameline Completion grant and was partially funded by the National Endowment for the Arts. It premiered at the Toronto Film Festival and was nominated for the Grand Jury Prize at Sundance. It won the Polar Bear Award at the Berlin Film Festival and the Best Documentary Award at the International Women Filmmaker Festival in Madrid.

24 BHI, April 17, 2017.

25 Gwendolyn Audrey Foster, "Barbara Hammer, an Interview: Re/Constructing Lesbian Auto/Biographies in *Tender Fictions* and *Nitrate Kisses*," *Post Script* (Winter–Summer 2015): 117+. *Academic OneFile*, http://link.galegroup .com/apps/doc/A465808783/AONE?u=mlin_b_umass&sid=AONE&xid= ae3afb47.

26 National Endowment for the Arts, Annual Report 1991, 105. www.arts.gov/ about/annual-reports.

27 Articles of Incorporation, Independent Television Service (ITVS). *Current*, September 22, 1989, https://current.org/1989/09/independent-television-service -inc-articles-incorporation-1989/.

28 Hammer related to me that "as soon as this [the Congressional approval for grants to independent filmmakers] went in, I was sure I was going to get funding." BHI, August 24, 2016.

29 In Foster, "Barbara Hammer, an Interview."

30 Foster, "Barbara Hammer, an Interview."

31 Barbara Hammer and Holly Willis, "Uncommon History: An Interview with Barbara Hammer," *Film Quarterly* 47, no. 4 (1994): 7–13.

32 BHI, August 24, 2016.

33 Hammer noted, "I still wanted to shoot it in the fragmentary style because I was reading Walter Benjamin at the time and [was] very influenced about his ideas of telling history through fragments. And . . . most of what I was going to find from the past was fragmentary anyway—there was no homogeneous narrative. Then I would fragment the contemporary lovemaking, because [of] another reason: I didn't want it voyeured. So, that fed into the film as a sense that we can know things from little bits of information." BHI, August 24, 2016.

34 BHI, August 24, 2016.

35 Hammer and Willis, "Uncommon History," 10.

36 Hammer's dedication to Vito Russo, author of *The Celluloid Closet: Homosexuality in the Movies*, in her film *Vital Signs* shows her respect for Russo; like him, she was attuned to the practice of drawing attention to the representation

of queerness. As Russo claims in his introduction to the revised edition of the book: "The big lie about lesbians and gay men is that we do not exist. . . . We have cooperated for a very long time in the maintenance of our own invisibility. And now the party is over." Vito Russo, "Introduction: On the Closet Mentality," in *The Celluloid Closet: Homosexuality in the Movies*, rev. ed. (New York: Harper and Row, 1987).

37 Adrienne Rich, "It Is the Lesbian in Us," in *On Lies, Secrets, and Silence: Selected Prose, 1966–1978* (New York: Norton, 1979), 199–202.

38 Gregg, "Making Lesbians Visible," 19–20.

39 Rich, "In the Name," 29–30.

40 Chris Holmlund and Cynthia Fuchs, "Introduction: Seeing and Speaking 'Differently,'" in *Between the Sheets, in the Streets: Queer, Lesbian, Gay Documentary*, ed. Chris Holmlund and Cynthia Fuchs (Minneapolis: University of Minnesota Press, 1997), 1–2.

41 Holmlund and Fuchs, "Introduction," 2.

42 Lawrence Chua, "Unusually Moving Pictures," *Artforum International* 31, no. 9 (1993): 17.

43 Jesse Helms, *Here's Where I Stand: A Memoir* (New York: Random House, 2005).

44 For an extended discussion of the simultaneously redemptive and dangerous quality of women's laughter, see Margaret Hennefeld, "Death from Laughter, Female Hysteria, and Early Cinema," *Differences* 27, no. 3 (2016): 45–92.

45 Willow Maclay, "Lust, Caution: Barbara Hammer's *Nitrate Kisses*," *Vague Visages*, December 7, 2015, https://vaguevisages.com/author/willowcatelyn/.

46 The development and filming of *Nitrate Kisses* roughly coincides with the wide negative publicity drawn to Andreas Serrano's *Piss Christ* and Robert Mapplethorpe's *The Perfect Moment* in 1989 and the NEA Four controversy, a case of four artists whose accepted grant proposals were rejected based on a veto by the NEA chairman, John Froynmayer, in 1990.

47 C. Carr, *On Edge: Performance at the End of the Twentieth Century*, rev. ed. (Middletown, CT: Wesleyan University Press, 2008), 243.

48 Hammer saw these three films as a triptych, calling them her "Invisible Histories Trilogy." Lebovici, "Screen as Body: Interview with Barbara Hammer."

49 The film is short for feature-length theatrical release, but at fifty-one minutes is exactly the right length for release on television with commercial breaks. Whether Hammer had this in mind is not known to me, but a whiff of this as an intention comes in the form of the television-based grant she had applied for in connection with *Nitrate Kisses* just two years earlier.

50 Hammer, in Lebovici, "Screen as Body: Interview with Barbara Hammer."

51 Nichols, *Introduction to Documentary*, 201.

52 Nichols, *Introduction to Documentary*, 201.

53 Rizvana Bradley notes that Hammer's tendency to play various personas in her films is an effort toward "a more complicated and nuanced critical, queer feminist presence within film." In playing types, Hammer "gestures outward and emphasizes the morphological proximity of the self to multiple personas." "Ways of the Flesh: Barbara Hammer's Vertical Worlds," 58.

54 Note that Hammer was well versed in the notion of masquerade at this time, a connection on which she plays here. Her reading list for a feminist film course at Columbia College Chicago included Mary Ann Doane, "Film and the Masquerade," for instance.

55 Gertrude Stein, "A Substance in a Cushion," in *Tender Buttons* (New York: Dover, 1997).

56 Amy Khoudari eventually published her research as a biography, *Looking in the Shadows: The Life of Alice Austen* (iUniverse, 2006).

57 BHI, August 23, 2016.

58 As *Nitrate Kisses* and *Tender Fictions* demonstrate, Hammer was reading widely in feminist, queer, literary, aesthetic, and cultural theory, including works by Roland Barthes, Walter Benjamin, Hélène Cixous, Michel Foucault, Nancy Chodorov, and others.

59 BHA, Box 7.

60 Hammer, "Invisible Screen: Lesbian Cinema," *Video Guide* 10, no. 5 (1990): 14. Copy in BHA, Box 7.

4. 2000–2019

1 See https://odorusaru.wordpress.com/2017/11/14/barbara-hammer-and-ogawa-shinsuke/, "Barbara Hammer and Ogawa Shinsuke," which provides an account of Hammer's presentation of the film for the Japanese Society in New York City on November 11, 2017.

2 Hammer again restages this scene in one of her very last film projects, *History Lessons Redo: The Meat Market*. This later project revisits the location where she shot the noir scenes in *History Lessons* in order to retrace some of the disappearance of queer culture in the former meat packing district of the neighborhood near the new Whitney Museum on Gansevoort Street. As Matt Wolf has commented in his program notes to the first screening of the film for the Whitney Biennial in 2019, "These images show Hammer and a jubilant group of queer

friends reclaiming forgotten lesbian history by reenacting 1920s crime scene photographs by Weegee in the pregentrified Meatpacking district. . . . It is a reminder that vanishing legacies surround us, and that we have an opportunity to recognize and preserve the past before it is gone." https://whitney.org/2019-biennial/invisible-monuments.

3 Hammer consistently characterized these three films in this way, and that formulation is echoed in many writings about the films. See Hammer, "*Tender Fictions*," *Hammer! Making Movies Out of Sex and Life*, 242, and, for example, J. D. Rhodes, "Film Is Thinking: A Conversation across Distance," *world picture* 7, 1–6.

4 Hammer, "Censorship," in *Hammer!*, 228.

5 BHI, August 24, 2016.

6 Hammer noted that the board for the New York State Council on the Arts objected, among other things, to the word "Porn" in the title; when she was applying for the grant, *History Lessons* went by the provisional title *Porn Doctor*. She changed the title and got the funding. BHI, August 24, 2016.

7 BHI, August 24, 2016.

8 Scott MacDonald, "American Avant-Garde Cinema from 1970 to the present," in *American Film History: Selected Readings 1960 to the Present*, ed. Cynthia Lucia, Roy Grundmann, and Art Simon (Malden, MA: Wiley, 2016), 241–58.

9 BHI, April 17, 2017.

10 Domitilla Olivieri, "On *Resisting Paradise*," in Bu Shea and Curtis, *Barbara Hammer: Evidentiary Bodies*, 74.

11 BHI, April 17, 2017.

12 BHI, April 17, 2017.

13 One of the themes *Resisting Paradise* explores concerns Walter Benjamin's final days and failed effort to escape France during the Occupation. In addition to telling this story, Hammer cites Benjamin in the film, pressing his words into service for thinking through the issues of life versus art.

14 To put it simply, the Kuleshov effect happens when two shots are edited together and, just by their juxtaposition, prompt the viewer to make a connection between them. For example, when the film cuts between the passive face of actor Ivan Mosjoukine (even entirely out of context) and a bowl of soup, the viewer supposes *hunger* is being suggested.

15 Sarah Keller, *Anxious Cinephilia: Pleasure and Perils at the Movies* (New York: Columbia University Press, 2020), 122–23.

16 Hammer, "Modern Women: Barbara Hammer on Maya Deren," MoMA inter-
 view (2010), www.youtube.com/watch?v=3pTVbQilDqY.

17 Walter Benjamin, "On the Concept of History" (1940). In *Walter Benjamin: Selected Writings*, vol. 4, *1938–1940*, ed. Howard Eiland and Michael W. Jennings (Cambridge, MA: Harvard University Press, 2003), 392.

18 Hammer cites Deren as an influence in this regard in "Maya Deren and Me," 264. Deren's archive contains lists of universities where her films were shown, primarily through her own legwork. See Vévé Clark, Millicent Hodson, and Catrina Neiman, eds., *The Legend of Maya Deren*, vol. 1, *Part 2 (1942–1947): Chambers* (New York: Anthology Film Archives, 2006), 630–31.

19 Hammer, "Maya Deren and Me," 261.

20 Hammer, "Maya Deren and Me," 261.

21 Hammer, "Use of Time in Women's Cinema," in *Hammer!*, 86. For further information on Deren's notion of vertical versus horizontal ways of structuring moments in film, see "Poetry and the Film: A Symposium with Maya Deren, Arthur Miller, Dylan Thomas, Parker Tyler, Chairman Willard Maas, Organized by Amos Vogel (October 28, 1953)," in P. Adams Sitney, ed., *Film Culture Reader* (New York: Cooper Square Press, 2000), 171–86.

22 Hammer, "Modern Women: Barbara Hammer on Maya Deren."

23 Hammer, "Modern Women: Barbara Hammer on Maya Deren."

24 Alexander Sesonske's "Time and Tense in Cinema," *Journal of Aesthetics and Art Criticism* 38, no. 4 (1980): 419–26.

25 These include, especially, Deren's *An Anagram of Ideas on Art, Form, and Film* and prints from her photographic series, made mainly before she started making films, reminding us of Hammer's prefilmmaking career foray also into another medium, in her case painting.

26 Also known as the Theseus paradox, the thought experiment concerning grandfather's ax asks whether an ax ceases to be "grandfather's ax" as subsequent parts of it have to be replaced.

27 Hammer, "The Ephemeral Archive," in *Hammer!*, 262–63.

28 Elizabeth Bishop, "One Art," in *The Complete Poems, 1927–1979* (New York: Noonday Press/Farrar Straus and Giroux, 1994), 178.

29 Panel Proposal, Laura Stamm, Greg Youmans, Ron Gregg, and Sarah Keller, "Feminist Transpositions: Barbara Hammer's Layering of Lives and Selves," for Society for Cinema and Media Studies Annual Conference 2019, Seattle, Washington, March 2019.

30 BHI, April 17, 2017.

31 Tonally the two versions differ; in the content, the second version's lyrics (which would have been the first version had Hammer been able to secure the rights to the music) corroborates the theme of the images, putting it in the category of films *for women* that Hammer was trying to avoid by refusing the request by the songwriter of the second version (Alix Dobkin / Lavender Jane) that, if she were to give permission to Hammer for using her music, the film must not be shown to men. (Dobkin later reconsidered.)

32 It is possible to consider *History Lessons Redo* (made right around the same time as *Evidentiary Bodies*) or any of the films that she retouched in the final months of her life as alternates.

33 Keller, *Maya Deren: Incomplete Control*, 1–28.

34 Hammer blossomed with any audience with whom I witnessed her interact—from this performance, to artist talks at galleries, to postscreening discussions, to college Q&A sessions. Her desire to engage with her audience is also discernible in her work, from *Audience*, to *Would You Like to Meet Your Neighbor*, to her lecture "The Art of Dying," to any of the films that include her interviewing voice. She was curious about how people engaged with the work specifically and was endlessly curious about what made people tick in general.

35 The idea of "afterlives" of an artist's work comes from Lucy Fischer, who talks about the idea in relation to works inspired by Maya Deren's films, such as Janelle Monáe's "Tightrope" video. See Fischer, "Afterlife and Afterimage: Maya Deren in 'Transfigured Time,'" *Camera Obscura 84* 28, no. 3 (2013): 1–31. For Hammer's work, the afterlives are more intentional; by donating her footage to colleagues, Hammer planted seeds she hoped would sprout after she was gone.

36 Richard Hugo, *The Triggering Town: Lectures and Essays on Poetry and Writing* (New York: Norton, 1979), 15.

37 BHA, Box 8.

38 Gessen, "Barbara Hammer's Exit Interview." See also "The Art of Dying or (Palliative Art Making in the Age of Anxiety)," which Hammer performed at Temple University, at Yale, and at the Whitney Museum, in New York City, https://whitney.org/WatchAndListen/39543.

39 Cvetkovich, "Artist as Archivist," 42.

40 Margaret Atwood, "Happy Endings," in *The Story and Its Writer*, ed. Ann Charters, 9th ed (Boston: Bedford/St. Martin's, 2015), 27–29.

41 BHI, July 25, 2017.

42 Michael Morand, "Barbara Hammer Archive Adds to Beinecke Library Collections of LGBTQ Creativity," September 17, 2017, https://beinecke.library .yale.edu/article/barbara-hammer-archive-adds-beinecke-librarys-collections -lgbtq-creativity.

43 Administered by Queer Art, the grant began at $5,000 but was increased to $6,000 just before Hammer's death in 2019. See www.queer-art.org/hammer -grant. Past winners are Alli Logout in 2019, Miatta Kawinzi in 2018, and Fair Brane in 2017. Several finalists are also announced at the time of granting the award, giving artists a boost in publicity for their work.

44 This exhibit was titled *Maya Deren's Legacy: Women and Experimental Film*, which ran from May 15 to July 23, 2010.

45 BHI, July 25, 2017.

BARBARA HAMMER FILMOGRAPHY

Details at https://barbarahammer.com/films/

2018

Evidentiary Bodies, three-channel HD video, Color/Sound, 9:30 min.

2015

Welcome to This House, HD video, BW & Color/Sound by Joan La Barbara,
 79 min.
Lesbian Whale, HD, BW & Color, 7 min.

2011

Maya Deren's Sink, HD video, BW & Color/Sound by Meredith Monk, 30 min.

2010

Generations, 16 mm film, BW & Color/Sound, 30.5 min.

2008

A Horse Is Not a Metaphor, DVD, BW & Color/Sound by Meredith Monk,
 30 min.

2007

Diving Women of Jeju-do, Video/DVD, BW & Color/Sound, 30 min.

2006

Lover/Other, Video, BW & Color/Sound, 55 min.

2003

Resisting Paradise, 16 mm film, BW & Color/Sound, 80 min.

2001

My Babushka: Searching Ukrainian Identities, Video, 53 min.

2000

History Lessons, 16 mm film, Color/Sound, 66 min.

Devotion, A Film about Ogawa Productions, Video, 84 min.

Dyketactics X 2, 1974/2001, 16 mm, Color/Sound, 8 min.

1998

The Female Closet, 1998, Video, Color/Sound, 58 min.

Blue Film No. 6: Love Is Where You Find It, 8 mm film, Color/Silent, 3 min.

1995

Tender Fictions, 16 mm film, BW & Color/Sound, 60 min.

1994

Out in South Africa, Video, Color/Sound, 51 min.

1993

Shirley Temple and Me, Video, Color/Sound, 3 min.

Save Sex, Video, Color/Sound, 1 min.

1992

Nitrate Kisses, 16 mm film, BW/Sound, 67 min.

1991

Vital Signs, 16 mm film, Color & BW, Sound, 10 min.

Dr. Watson's X-Rays, Video, Color/Sound, 22 min.

1990

Sanctus, 16 mm film, B/W & Color, Sound by Neil B. Rolnick, 18.5 min.

1989

Still Point, 16 mm film, Color/Sound, 9 min.

1988

Endangered, 16 mm film, Color/Sound by Helen Thorington, 17.5 min.

Drive, She Said, 16 mm, Color/Silent (24fps), 3.5 min.

Two Bad Daughters, Video, Color & BW/Sound, 12 min. (Made with Paula Levine)

T.V. Tart, Video, Color, Sound, 12 min. (Performance & Film)

History of the World According to a Lesbian, Video, Color/Sound, 22 min.

Bedtime Stories, I, II, III, Video, Color/Sound, 33 min.

1987

Place Mattes, 16 mm Film, Color/Sound by Terry Setter, 8 min., 1978/2018.

No No Nooky T.V., 16 mm Film, Color/Sound, 12 min.

1986

Snow Job: The Media Hysteria of Aids, Video, Color/Sound, 9 min.

1985

Optic Nerve, 16 mm film, Color/Sound by Helen Thorington, 16 min.

Hot Flash, Video, Color/Sound, 17 min.

Would You Like to Meet Your Neighbor? A New York Subway Tape, Video, Color/Sound, 13 min. (Installation/Performance tape)

1984

Doll House, 16 mm film, Color/Sound, 4 min.

Tourist, 16 mm film, Color/Sound, 3 min.

Parisian Blinds, 16 mm film, BW & Color/Silent (24fps), 6 min.

Pearl Diver, 16 mm film, Color/Sound, 5 min.

Bent Time, 16 mm film, Color/Sound by Pauline Oliveros, 22 min.

1983

Audience, 16 mm, BW/Sound, 32 min.

Bamboo Xerox, 16 mm film, BW/Silent (24fps), 8.5 min. (Installation & Film)

Stone Circles, 16 mm film, BW & Color/Sound, 11 min.

New York Loft, 16 mm film, Color & BW/Sound, 8 min.

See What You Hear What You See, 16 mm film, BW/Sound, 3 min. (Installation and Projection)

1982

Pond and Waterfall, 16 mm film, Color/Silent (24fps), 15 min.

1981

Sync Touch, 16 mm film, Color/Sound, 10 min.

Pools, 16 mm film, Color/Sound, 5.5 min. Made with Barbara Klutinis.

Pictures for Barbara, 16 mm film, Color/Sound, 8 min.

The Lesbos Film, 16 mm film, Color/Sound, 27 min.

Machu Picchu, 16 mm film, Color/Silent, 6 min.

1980

Our Trip, 16 mm film, Color & BW/Sound, 4.5 min.

Arequipa, 16 mm, BW & Color/Silent (24fps), 8 min.

1979

Available Space, 1978–79, 16 mm film, Color/Sound, 11 min (film/performance)

Dream Age, 16 mm film, Color/Sound, 12 min.

Natura Erotica, 16 mm, Color/Silent (24 fps), 5 min.

Take Back the Night March on Broadway 1979, 16 mm, Color/Sound, 3 min.

1978

Double Strength, 16 mm film, BW & Color/Sound, 15 min.

Haircut, 16 mm film, Color/Silent (24fps), 4.5 min.

Sappho, 16 mm film, Color/Sound, 7 min. (Made with six students at the Women's Building in Los Angeles)

Home, 16 mm film, Color/Sound, 13 min.

1977

Eggs, 16 mm film, Color/Sound, 10 min.

The Great Goddess, 16 mm film, BW/Sound, 25 min.

1976

Multiple Orgasm, 16 mm film, Color/Silent, 5.5 min.

Women I Love, 16 mm film, Color/Sound, 22.5 min.

Stress Scars & Pleasure Wrinkles, Video, Color/Sound, 20 min.

Moon Goddess, 16 mm film, Color/Sound, 14 min. Made with Gloria Churchman.

Superdyke Meets Madame X, 1/2″ video, 16 mm, BW/Sound, 19.5 min. Made with Max Almy.

1975

Psychosynthesis, 16 mm film, Color/Sound, 6 min.

"X", 16 mm film, Color/Sound, 8 min.

Superdyke, 16 mm film, Color/Sound, 18 min.

Truth Is the Daughter of Time [*Women's Rites*], 16 mm, Color/Sound, 8 min.

San Diego Women's Music Festival, 16mm, Color/Silent (24fps), 6 min.

Guatemala Weave, 16 mm, Color/Silent (24fps), 13 min.

1974

Dyketactics, 16 mm film, Color/Sound, 4 min.

Menses, 16 mm film, Color/Sound, 4 min.

Sisters!, 16 mm, Color/Sound, 8 min.

Jane Brakhage, 16 mm film, Color/Sound 10 min.

1973

A Gay Day, 16 mm film, Color/Sound, 3 min.

X, 16 mm, Color/Sound, 8 min.

I Was/I Am, 16 mm film, BW/Sound, (first 16 mm film), 7 min.

1972

A Brakhage Song, 8 mm, Color/Silent (18fps), 3 min.

Yellow Hammer, S 8 mm film, Color/Silent, 3 min.

Song of the Klinking Kup, S 8 mm film, Color/Silent, 3 min.

1970

White Cassandra, color, silent (24 fps), 4:08 min.

Traveling, S 8 mm film, Color/Silent (18fps), 25.5 min.

Marie and Me, 8 mm film, Color/Silent (18fps), 11.5 min.

Elegy, S 8 mm, Color/Silent (18fps), 4 min.

Play or "Yes," "Yes," "Yes", BW and Color / Silent (18fps), 11:16 min.

1969

Death of a Marriage, Color/Silent (24fps), 3:09 min.

Cleansed II, Color/Silent (24fps), 7:43 min.

Aldebaran Sees, Color/Silent (24fps), 3.5 min.

Clay I Love You II, Color/Silent (24fps), 5.5 min.

1968

Contribution to Light, Color/Silent (original 18fps / 2018 version is 24fps), 3.5 min.

The Baptism, color, silent (18fps), 9.5 min.

Barbara Ward Will Never Die, S 8 mm film, Color/Silent (18fps), 3.5 min.

Schizy, S 8 mm film, Color/Silent (24 fps), 4 min.

SELECTED BIBLIOGRAPHY

Ahmed, Sara. *Queer Phenomenology: Orientations, Objects, Others*. Durham, NC: Duke University Press, 2006.

Balsom, Erika. "No Masters: The Cinema of Peggy Ahwesh." Frieze.com, November 6, 2017. https://frieze.com/article/no-masters-cinema-peggy -ahwesh.

Barker, Jennifer. *The Tactile Eye: Touch and the Cinematic Experience*. Berkeley: University of California Press, 2009.

Barthes, Roland. "The Death of the Author." In *Image-Music-Text*, 142–48. New York: Hill and Wang, 1977.

Béar, Liza. "Agnès Varda." *Interview Magazine*, May 22, 2009, www .interviewmagazine.com/film/agnes-varda.

Benjamin, Walter. "On the Concept of History" (1940). In *Walter Benjamin: Selected Writings*. Vol. 4, *1938–1940*, edited by Howard Eiland and Michael W. Jennings. Cambridge, MA: Harvard University Press, 2003.

Bradbury-Rance, Clara. *Lesbian Cinema after Queer Theory*. Edinburgh: Edinburgh University Press, 2019.

Burbidge, Matthew. "Reviews: Barbara Hammer." *Frieze* 155, May 18, 2013.

Bu Shea, Staci, and Carmel Curtis, eds. *Barbara Hammer: Evidentiary Bodies*. New York: Hirmer/Leslie-Lohman Museum, 2018.

Butler, Judith. *Gender Trouble: Feminism and the Subversion of Identity*. New York: Routledge, 2006.

Carr, C. *On Edge: Performance at the End of the Twentieth Century*. Rev. ed. Middletown, CT: Wesleyan University Press, 2008.

Castle, Terry. *The Apparitional Lesbian: Female Homosexuality and Modern Culture*. New York: Columbia University Press, 1993.

Chua, Lawrence. "Unusually Moving Pictures." *Artforum International* 31, no. 9 (1993): 17.

Creekmur, Corey K., and Alexander Doty, eds. *Out in Culture: Gay, Lesbian, and Queer Essays on Popular Culture*. Durham, NC: Duke University Press, 2006.

De Lauretis, Teresa. *Technologies of Gender: Essays on Theory, Film, and Fiction*. Bloomington: Indiana University Press, 1987.

Deren, Maya. *An Anagram of Ideas on Art, Form, and Film.* Yonkers, NY: Alicat Press, 1946.

Doane, Mary Ann. *The Desire to Desire: The Woman's Film of the 1940s.* Bloomington: Indiana University Press, 1987.

Elwes, Catherine. *Installation and the Moving Image.* New York: Columbia University Press, 2015.

Fischer, Lucy. "Afterlife and Afterimage: Maya Deren in 'Transfigured Time,'" *Camera Obscura 84* 28, no. 3 (2013): 1–31.

Foster, Gwendolyn Audrey. "Barbara Hammer, an Interview: Re/constructing Lesbian Auto/biographies in *Tender Fictions* and *Nitrate Kisses.*" *Post Script* (Winter–Summer 2015).

Gaycken, Oliver. *Devices of Curiosity: Early Cinema and Popular Science.* Oxford: Oxford University Press, 2015.

Gessen, Masha. "Barbara Hammer's Exit Interview." *New Yorker,* February 25, 2019, www.newyorker.com/culture/the-new-yorker-interview/barbara-hammers -exit-interview.

Gorbman, Claudia. "Recent Work of Barbara Hammer: Body Displaced, Body Discovered." *Jump Cut* 32 (April 1987): 12–14.

Halberstam, Judith (see also J. Jack Halberstam). *In a Queer Time and Place: Transgender Bodies, Subcultural Lives.* New York: New York University Press, 2005.

Hammer, Barbara. *Hammer! Making Movies Out of Sex and Life.* New York: Feminist Press at the City University of New York, 2010.

———. "Maya Deren and Me." In *Maya Deren and the American Avant-Garde,* edited by Bill Nichols. Berkeley: University of California Press, 2001.

———. "Modern Women: Barbara Hammer on Maya Deren." MoMA interview (2010), www.youtube.com/watch?v=3pTVbQilDqY.

———, and Holly Willis. "Uncommon History: An Interview with Barbara Hammer." *Film Quarterly* 47, no. 4 (1994).

Hansen, Miriam. "Room-for-Play: Benjamin's Gamble with Cinema." *October* 109 (Summer 2004): 3–45.

Hanson, Ellis, ed. *Out Takes: Essays on Queer Theory and Film.* Durham, NC: Duke University Press, 1999.

Harris, Jane Ursula. "Lesbian Whale: An Interview with Barbara Hammer." *Paris Review: The Daily* (blog site). December 14, 2015, www .theparisreview.org/blog/2015/12/14/lesbian-whale-an-interview-with -barbara-hammer/.

Hennefeld, Margaret. "Death from Laughter, Female Hysteria, and Early Cinema." *Differences* 27, no. 3 (2016): 45–92.

Holmlund, Chris, and Cynthia Fuchs. "Introduction: Seeing and Speaking 'Differently.'" In *Between the Sheets, in the Streets: Queer, Lesbian, Gay Documentary*, edited by Chris Holmlund and Cynthia Fuchs. Minneapolis: University of Minnesota Press, 1997.

Humm, Maggie. *Feminism and Film*. Edinburgh: Edinburgh University Press, 1997.

Jenkins, Bruce. "A Case against 'Structural Film.'" *Journal of the University Film Association* 33, no. 2 (1981): 9–14.

Juhasz, Alexandra. "Barbara Hammer." In *Women of Vision: Histories in Feminist Film and Video*, edited by Alexandra Juhasz. Minneapolis: University of Minnesota Press, 1997.

———. "In Conversation: Barbara Hammer." *Brooklyn Rail*, January/December 2017, https://brooklynrail.org/2017/12/film/IN-CONVERSATION -BARBARA-HAMMER-with-Alexandra-Juhasz.

Kaplan, E. Ann, ed. *Feminism and Film*. Oxford: Oxford University Press, 1997.

Keller, Sarah. *Anxious Cinephilia: Pleasure and Perils at the Movies*. New York: Columbia University Press, 2020.

———. *Maya Deren: Incomplete Control*. New York: Columbia University Press, 2014.

Khoudari, Amy. *Looking in the Shadows: The Life of Alice Austen*. iUniverse, 2006.

Kitto, Svetlana. "Oral History Interview with Barbara Hammer." Transcript. Smithsonian Archives of American Art. March 15–17, 2018.

Kleinhans, Chuck. "Barbara Hammer: Lyrics and History." In *Women's Experimental Cinema: Critical Frameworks*, edited by Robin Blaetz. Durham, NC: Duke University Press, 2007.

Lebovici, Élisabeth. "The Screen as the Body: Barbara Hammer." *Mousse* 32 (2012), http://moussemagazine.it/barbara-hammer-elisabeth-lebovici-2012.

MacDonald, Scott. "American Avant-Garde Cinema from 1970 to the Present." In *American Film History: Selected Readings 1960 to the Present*, edited by Cynthia Lucia, Roy Grundmann, and Art Simon, 241–58. Malden, MA: Wiley, 2015.

Maclay, Willow. "Lust, Caution: Barbara Hammer's *Nitrate Kisses*." *Vague Visages*, December 7, 2015, https://vaguevisages.com/2015/12/07/.

Marks, Laura U. *The Skin of the Film: Intercultural Cinema, Embodiment, and the Senses*. Durham, NC: Duke University Press, 2000.

Mayer, Sophie. *Political Animals: The New Feminist Cinema*. London: I. B. Tauris, 2016.

Mayne, Judith. "A Parallax View of Lesbian Authorship." In *Film and Authorship*, edited by Virginia Wright Wexman, 76–86. New Brunswick, NJ: Rutgers University Press, 2003.

———. *The Woman at the Keyhole: Feminism and Women's Cinema*. Bloomington: Indiana University Press, 1990.

Mulvey, Laura. "Visual Pleasure and Narrative Cinema." *Screen* 16, no. 3 (1975): 6–18.

Nichols, Bill. *Introduction to Documentary*, 2nd ed. Bloomington: Indiana University Press, 2010.

Olsen, Jenni. "Hammer's Herstory." *The Advocate*, June 20, 2000, 103.

Osterweil, Ara. "A Body Is Not a Metaphor: Barbara Hammer's X-Ray Vision." *Journal of Lesbian Studies* 14 (2010): 185–200.

Peterson, Jennifer. "Barbara Hammer's *Jane Brakhage*: Feminism, Nature, and 1970s Experimental Film." *Feminist Media Histories* 6, no. 2 (2020): 67–94.

Potter, Susan. *Queer Timing: The Emergence of Lesbian Sexuality in Early Cinema*. Urbana: University of Illinois Press, 2019.

Powers, John. "A DIY Come-On: A History of Optical Printing in Avant-Garde Cinema." *Cinema Journal* 57, no. 4 (2018): 71–95.

Rhodes, J. D. "Film Is Thinking: A Conversation across Distance." *world picture* 7 (Autumn 2012): 1–6.

———. "This Was Not Cinema: Judgment, Action, and Barbara Hammer." *Film Criticism* 39, no. 2 (2014–15): 131.

Rich, Adrienne. "It Is the Lesbian in Us." In *On Lies, Secrets, and Silence: Selected Prose, 1966–1978*, 199–202. New York: Norton, 1979.

Rich, B. Ruby. *Chick Flicks: Theories and Memories of the Feminist Film Movement*. Durham, NC: Duke University Press, 2004.

———. "In the Name of Feminist Film Criticism." In *Multiple Voices in Feminist Film Criticism*, edited by Diane Carson, Linda Dittmar, and Janice R. Welsch, 27–47. Minneapolis: University of Minnesota Press, 1994.

Robertson, Pamela. *Guilty Pleasures: Feminist Camp from Mae West to Madonna*. Durham, NC: Duke University Press, 1996.

Russo, Vito. *The Celluloid Closet: Homosexuality in the Movies*. Rev. ed. New York: Harper and Row, 1987.

Schoonover, Karl, and Rosalind Galt. *Queer Cinema in the World*. Durham, NC: Duke University Press, 2016.

Sedgwick, Eve Kosofsky. *Touching Feeling: Affect, Pedagogy, Performativity*. Durham, NC: Duke University Press, 2003.

Sheehan, Tanya. *Doctored: The Medicine of Photography in Nineteenth-Century America*. University Park: Pennsylvania State University Press, 2011.

Sitney, P. Adams. "Structural Film." In *Film Culture Reader*, edited by P. Adams Sitney, 326–49. New York: Cooper Square Press, 2000.

———. *Visionary Film: The American Avant-Garde, 1943–2000*, 3rd ed. Oxford: Oxford University Press, 2002.

Stewart, Susan *On Longing: Narratives of the Miniature, the Gigantic, the Souvenir, the Collection*. Durham, NC: Duke University Press, 1984.

Sundholm, John. "The Material and the Mimetic: On Gunvor Nelson's Personal Filmmaking." *Framework: The Journal of Cinema and Media* 48, no. 2 (2007): 165–73.

Watson, James Sibley, Jr. "The Films of J. S. Watson Jr. and Melville Webber, Some Retrospective Views (I)." *University of Rochester Library Bulletin* 28, no. 2 (1975), https://rbscp.lib.rochester.edu/3507.

Waugh, Thomas. *The Fruit Machine: Twenty Years of Writings on Queer Cinema*. Durham, NC: Duke University Press, 2000.

Wees, William. "No More Giants." In *Women and Experimental Filmmaking*, edited by Jean Petrolle and Virginia Wright Wexman, 22–44. Urbana: University of Illinois Press, 2005.

Weiss, Andrea. *Women I Love, Double Strength*. Lesbian Cinema and Romantic Love. *Jump Cut* 24–25 (March 1981): 30.

Wexman, Virginia Wright, ed. *Film and Authorship*. New Brunswick, NJ: Rutgers University Press, 2002.

White, Patricia. "Lesbian Minor Cinema." *Screen* 49, no. 4 (2008): 410–25.

———. *Uninvited: Classical Hollywood Cinema and Lesbian Representability*. Bloomington: Indiana University Press, 1999.

———. *Women's Cinema, World Cinema*. Durham, NC: Duke University Press, 2015.

Youmans, Greg. "Audacious Appropriations: Barbara Hammer's First Half Century." *Found Footage* 2 (May 2016): 7–15.

———. "Performing Essentialism: Reassessing Barbara Hammer's Films of the 1970s." *Camera Obscura 81* 27, no. 3 (2012): 117–22.

Zita, Jacqueline. "The Films of Barbara Hammer: Counter-Currencies of a Lesbian Iconography." *Jump Cut* 24–25 (March 1981): 31–32.

INDEX

Page numbers in italics refer to images

University of Rochester Medical Center, 95

ABOUT THE AUTHOR

SARAH KELLER is associate professor of art and cinema studies at the University of Massachusetts Boston. Her research focuses on experimental form, film experience, and feminist issues in cinema. She is coeditor of *Jean Epstein: Critical Essays and New Translations* and author of *Maya Deren: Incomplete Control* and *Anxious Cinephilia: Pleasure and Peril at the Movies.*